THE DISCOVERY OF SPAIN

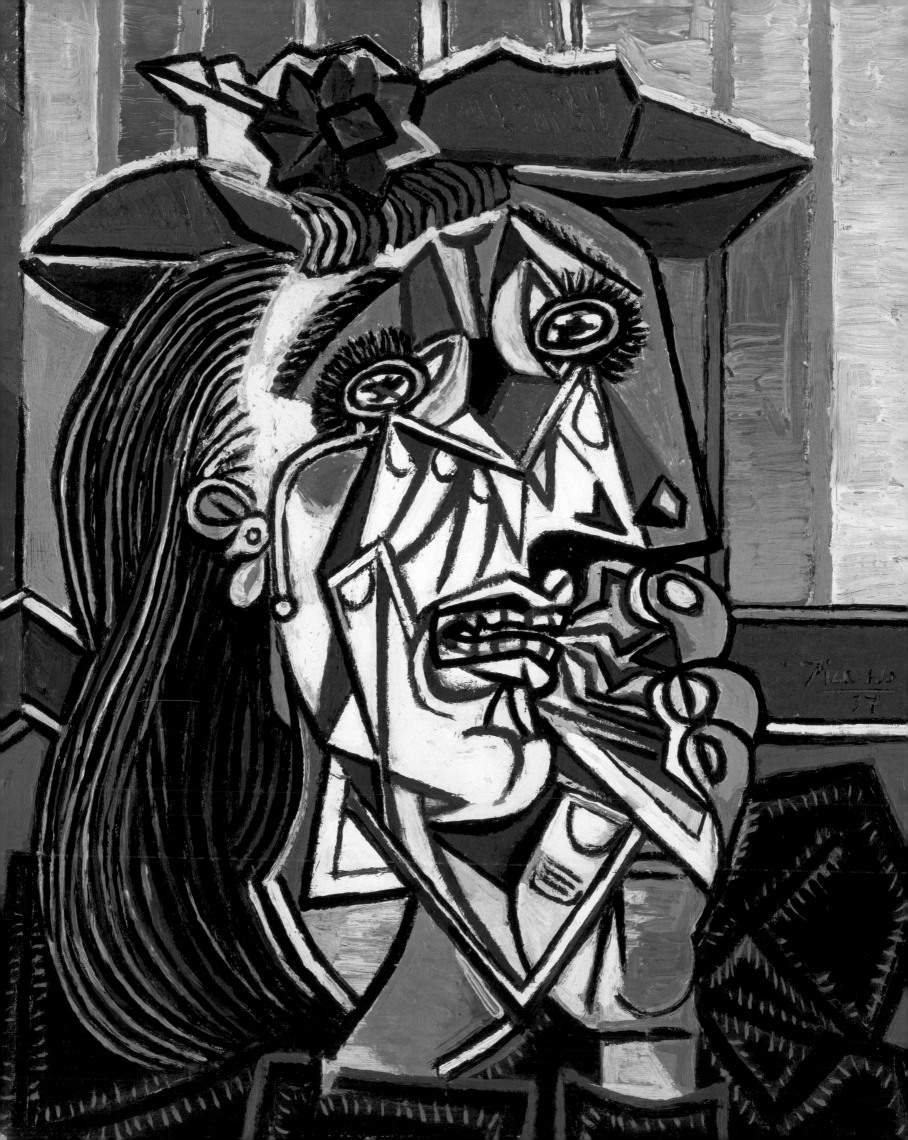

CHRISTOPHER BAKER
DAVID HOWARTH
PAUL STIRTON
WITH
CLAUDIA HEIDE
MICHAEL JACOBS
HILARY MACARTNEY
AND
NICHOLAS TROMANS

THE DISCOVERY OF SPAIN

BRITISH ARTISTS AND COLLECTORS

GOYA TO PICASSO

NATIONAL GALLERIES OF SCOTLAND

EDINBURGH · 2009

Published by the Trustees of the National Galleries of Scotland
to accompany the exhibition, *The Discovery of Spain: British Artists
and Collectors, Goya to Picasso,* held at the National Gallery Complex,
Edinburgh from 18 July to 11 October 2009.

ISBN 978 1 906270 18 6

Editor: David Howarth
Exhibition organiser: Christopher Baker
Exhibition selectors: Paul Stirton and David Howarth
Production: Christine Thompson
Picture research: Olivia Sheppard

Designed and typeset in Fleischmann and Magma by Dalrymple
Printed on Perigord Matt 150gsm by Die Keure, Belgium

Front cover: El Greco *Lady in a Fur Wrap, c.*1577–80 (detail) [87]
Back cover: Arthur Melville *A Mediterranean Port (Pasajes)*, 1892 [109]
Frontispiece: Pablo Picasso *Weeping Woman*, 1937 [127]

The proceeds from the sale of this book go towards supporting
the National Galleries of Scotland. For a complete list of current
publications, please write to: NGS Publishing at the Scottish
National Gallery of Modern Art, 75 Belford Road, Edinburgh
EH4 3DR or visit our website: www.nationalgalleries.org

SUPPORTERS OF THE EXHIBITION

FRIENDS MEMBERSHIP
Come and join us

NATIONAL GALLERIES OF SCOTLAND

GOBIERNO DE ESPAÑA

MINISTERIO DE CULTURA

ESPAÑA

LENDERS TO THE EXHIBITION

Her Majesty The Queen
(The Royal Collection Trust)

The Abbot of Downside

The Lord Bishop of Durham,
Auckland Castle, County Durham

Aberdeen Art Gallery & Museums
Collections

The Robert Gordon University, Aberdeen

Hospitalfield, Arbroath

Birmingham Museums and Art Gallery

Fitzwilliam Museum, Cambridge

Amgueddfa Genedlaethol Cymru –
National Museum of Wales, Cardiff

McManus Galleries & Museum, Dundee

University of Dundee

The Bowes Museum, Barnard Castle,
County Durham

Royal Scottish Academy Collections,
Edinburgh

Culture and Sport Glasgow (Museums)

Hunterian Museum & Art Gallery,
University of Glasgow

The British Museum, London

Dulwich Picture Gallery, London

The Fleming-Wyfold Art Foundation,
London

Imperial War Museum, London

National Gallery, London

National Portrait Gallery, London

Royal Academy of Arts, London

Tate, London

Victoria and Albert Museum, London

Wellington Collection, Apsley House,
London

Whitworth Art Gallery, the University of
Manchester

Henry Moore Foundation, Much Hadham

Perth Museum and Art Gallery

Private Collection at Mount Stuart

and other Private Collections

Spain, if visited by some of our artists would, I am persuaded, open new, astounding and unexamined treasures to their view ...

These words were written in 1760 by Edward Clarke, a chaplain to the British ambassador to Spain. His prophecy was to be fulfilled throughout the nineteenth and early twentieth centuries by British artists, who along with contemporary collectors, delighted in the novelty of studying Spanish art and culture. It is the purpose of this ambitious exhibition to recapture something of the thrill they experienced, and to travel back to an age before mass tourism, when Spain for most British people was not visited, but seen through the work of pioneering painters, printmakers, photographers and publishers.

Creating such a far-reaching survey has required the assistance and dedication of a number of distinguished collaborators, led by scholars from Edinburgh and Glasgow universities. David Howarth has helped formulate the shape of the exhibition from the outset and has edited this accompanying book; while Paul Stirton has steered the selection of loans and made numerous invaluable contributions to the planning process. They have both provided illuminating essays for the book, which are complemented by studies from Nicholas Tromans, Claudia Heide, Hilary Macartney and Michael Jacobs (all of whom also made valuable suggestions about loans). Collectively their work makes a major contribution to the study of cultural relations between Britain and Spain, and we are most grateful to them. For the National Gallery of Scotland the exhibition has been organised by the Gallery's deputy director, Christopher Baker, who has overseen the process of securing loans and installing and interpreting the exhibition. We are extremely grateful to him for his scholarship and skilful management of this project.

Any project of this ambition is heavily dependent on the precedent of other exhibitions and books, which all the contributors wish to gratefully acknowledge. These include important surveys, ranging from the National Gallery, London's exploration of the taste for Spanish paintings in Britain (1981) and the *Manet Velázquez* exhibition at the Musée d'Orsay, Paris, and the Metropolitan Museum of Art, New York

(2003), to the Imperial War Museum's exhibition on the Spanish Civil War (2002). Many of the individual travellers, authors and artists discussed as part of *The Discovery of Spain* have also become the subject of exemplary studies in recent years.

Lenders across the United Kingdom have been exceptionally generous, and it is a pleasure to record our sincere thanks to all those listed opposite who have allowed us to borrow a remarkable range of outstanding works of art. Exhibitions on this scale require not only significant loans but also substantial financial support, and in this case it has been provided through the assistance of the Friends of the National Galleries of Scotland, the Spanish Ministry of Culture, the Spanish Tourist Office and the University of Edinburgh. In the current austere economic climate their largesse is especially appreciated. We would also particularly like to thank the Spanish Consul-General in Edinburgh, Sr. Federico Palomera Güez.

Projects such as *The Discovery of Spain* involve the skill and collaboration of many colleagues across the National Galleries of Scotland and beyond. Those who particularly deserve our thanks include Patricia Allerston, James Berry, Keith Braithwaite, Hannah Brocklehurst, Dawson Carr, Rosalyn Clancey, Laura Condie, Patsy Convery, Robert Dalrymple, Maria Devany, Susan Diamond, Bill Duff, Patrick Elliott, Gabriele Finaldi, Lee Fontanella, Susan Godfrey, Graeme Gollan, James Holloway, Nye Hughes, Valerie Hunter, Susan Jenkins, Nicola Kalinsky, Julie Lautredou, Lorraine Maule, Elinor McMonagle, Helen Monaghan, Keith Morrison, Jan Newton, Alastair Patten and the Art Handling Team, Nicholas Penny, Antonia Reeve, Jacqueline Ridge, Christine Riding, Mariam Rosser-Owen, Xavier Salamon, Sarah Saunders, Olivia Sheppard, Ann Simpson, Selina Skipwith, Helen Smailes, Will Snow, Joanna Soden, Leigh Stevenson, Lesley Stevenson, Christine Thompson, Aidan Weston-Lewis, Lucy Whitaker and Ross Wilson.

John Leighton
Director-General, National Galleries of Scotland

Michael Clarke
Director, National Gallery of Scotland

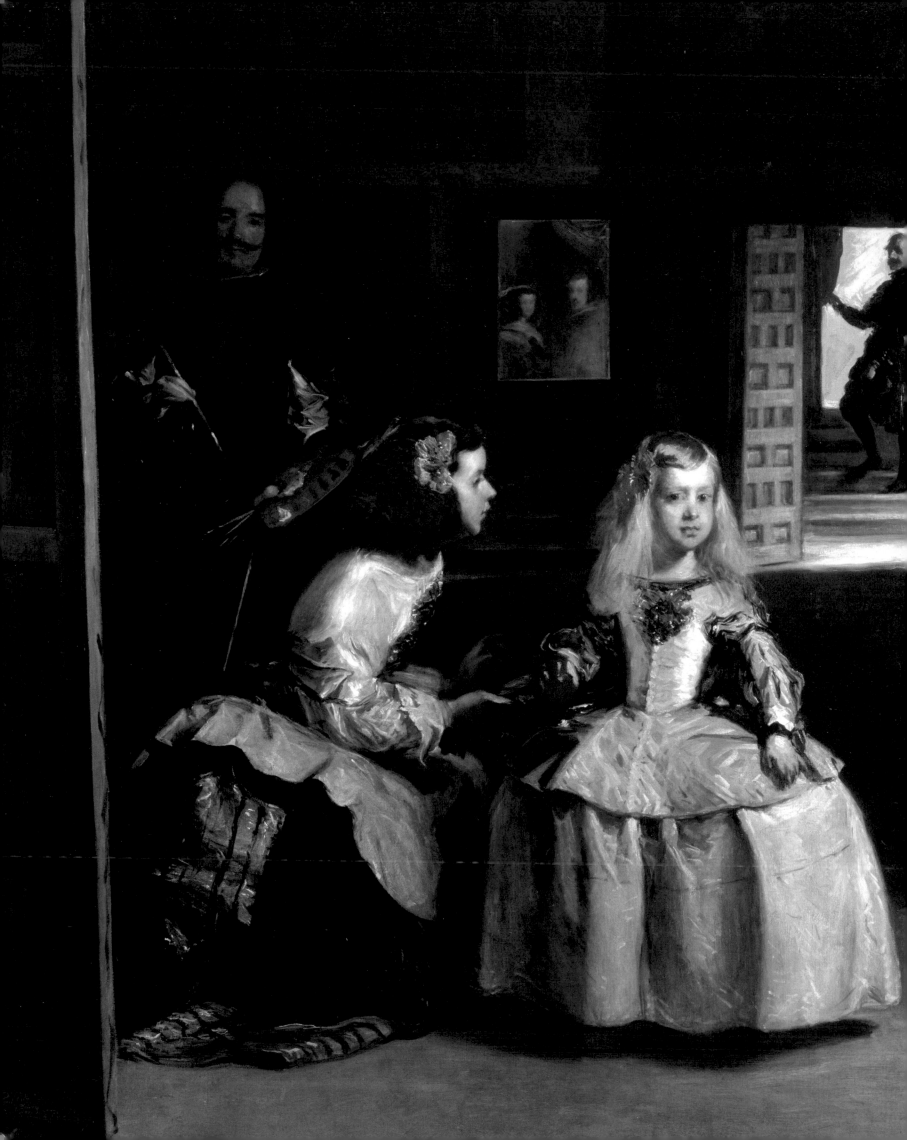

THE DISCOVERY OF SPAIN: INTRODUCTION

CHRISTOPHER BAKER

In 1828 the Scottish painter Sir David Wilkie memorably described southern Spain as the 'wild, unpoached game-preserve of Europe'. He was implying that he saw the country at that moment as a mysterious land of opportunity, where one could hunt for cultural riches. For Wilkie himself this proved to be the case, as he delighted in the study of Velázquez's paintings, which he considered 'all sparkle and virtuosity', succeeded in buying an example of the seventeenth-century master's work, and by adding Spanish subjects to the range of themes he depicted, invigorated his career.

Wilkie's visit to Spain came at a key moment in the history of the British perception of the country. From the mid-eighteenth century, awareness of the history and culture of Spain had been growing among the reading public, as letters, travelogues and works of art history about Spain were published in English, and individuals undertook tours. But old prejudices were still potent. Much of the contact between the two countries in the past had been diplomatic and military, and only rarely led to an exchange of ideas or imagery. The Pyrenees formed a formidable physical barrier with the rest of Europe, which was matched by one of perception. Spain was invariably considered a threatening power, a stronghold of Catholicism, a bastion of cruelty and sensuality, or more often than not as simply unknown – and therefore frightening.

These crude stereotypes were examined and gradually broken down as the nineteenth century progressed. One of the key reasons for this was the fact that after years of misconceptions and distrust Britain and Spain came to share a common cause – they were unified in opposition to the ambitions of Napoleon Bonaparte. The French Imperial army invaded Spain and a war of independence (which the British called the Peninsular War) was fought (1808–1814). British forces played the decisive role in defeating the French and this resulted in a wider appreciation in Britain of Spanish culture.

The Discovery of Spain charts the development of this phenomenon, and considers how prejudice was transformed into fascination, and ultimately respect. It highlights the pioneering taste of individual artists and collectors who changed the way in which Spain was depicted and consequently understood in Britain. The period covered is one of profound change, extending from the Peninsular War to the Spanish Civil War (1936–39). In terms of Spanish art it can be seen as running from the age of Goya to that of Picasso, while British reactions to the experience of Spain over the same period, evolve from the works of David Wilkie to those of Edward Burra. Clearly the full story of one country's perception of another's culture across such a span of time could not possibly be comprehensively plotted through an exhibition, but key chapters in the narrative may be highlighted, and that is the approach that has been adopted here.

The complexity of the themes explored in *The Discovery of Spain* may be suggested by considering at the outset one image from the middle of the period scrutinised [2]. This is a view of an artist's studio by the Scottish painter John Ballantyne. It comes from a series of studies he made of contemporary artists at work. In this case we are allowed a glimpse of a sumptuous interior in London, and a taste of High Victorian comfort and eclecticism: the walls are hung with tapestries, a display of arms is suspended above the doorway and, although this is a working studio, the overall impression is

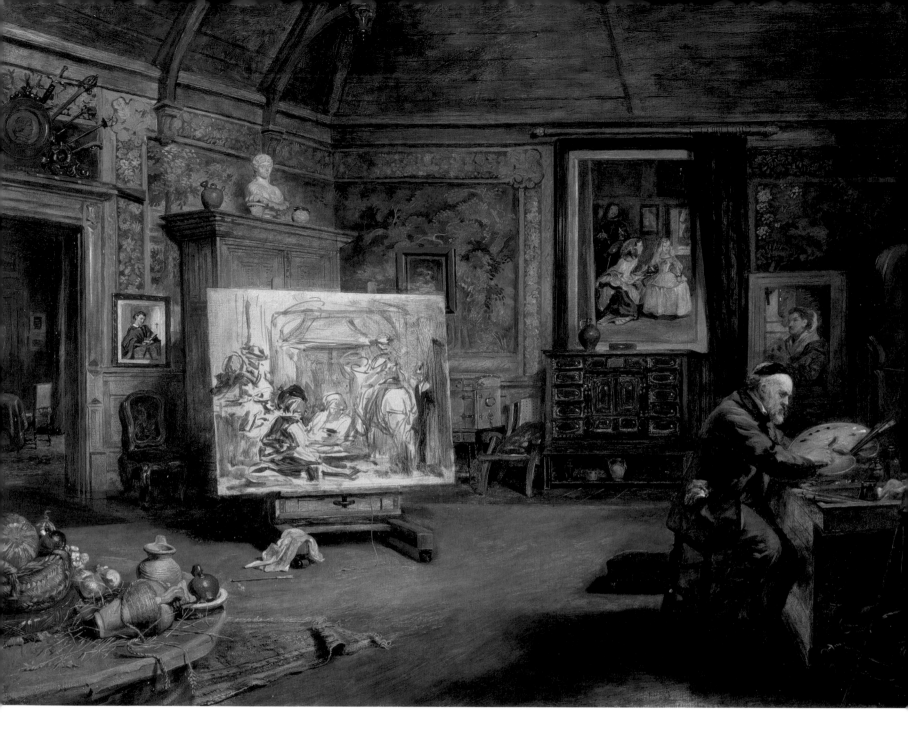

2　John Ballantyne　*John Phillip in his Studio*, c.1864
Scottish National Portrait Gallery, Edinburgh

one of richness and indulgence. There are hints everywhere of the artist's particular preoccupations: in the foreground is an arrangement of rough earthenware and fruit and vegetables, laid out on straw, intended to prompt us to think of still lifes, such as those that feature in the early works of Velázquez, his so-called *bodegones* painted in Seville. While on the far wall, reverentially protected by a curtain, is a partial copy of *Las Meninas*, the greatest of all Velázquez's court portraits, created towards the end of his career in Madrid [1]. Propped on the easel is an unfinished canvas depicting Spanish *contrabandistas* – a romantic evocation of brigands and smugglers, which the artist, who prepares his palette, is presumably to soon resume work on. He is John Phillip, a painter whose

passion for Spanish culture defined his work and career, created a sensation in the galleries of mid-nineteenth-century Britain, and earned him the sobriquets 'Phillip of Spain' and 'Spanish Phillip'.

Ballantyne's depiction of Phillip's studio dates from about 1864. It illustrates two of the threads from which the British perception of Spain had been woven: a respect for the art of its Golden Age – the seventeenth century – and a fascination with what were perceived as the picturesque aspects of Spanish popular culture, explored here through the theme of *contrabandistas*. Such subjects were far from being merely the preoccupation of painters and art historians; three years later Sir Arthur Sullivan's first opera *The Contrabandista* was performed

in London. It was not a great success, but is none the less indicative of the growing fashion for exploring Spanish subjects. That fashion was not simply confined to the Victorian preoccupation with melodrama and sentimentality: the painter Arthur Melville later took up the theme of *contrabandistas* in one his finest works in oil - a gloriously sun-drenched and abstracted canvas of 1892, which heralds the riches of British Modernism's relationship with Spain.

This vogue for all things Spanish was inspired by a rich web of enthusiasms: the building of collections of Spanish art (both private and public), the growth of travel

literature, a burgeoning interest in Spanish history, and the work of artists such as David Roberts and John Frederick Lewis, who like Wilkie and Phillip, thrilled at the splendour and variety of Spanish art and life. By depicting the country's architecture, costumes and customs they conveyed their excitement back to exhibition goers, collectors and buyers of prints and books in Britain.

The Spain that was depicted for the British in the nineteenth century was, of course, distilled to suit the tastes of its recipients. It was a highly selective view of the country, which chiefly portrayed it as a rich amalgam of Catholic and Moorish influences, and tended to focus either on especially flamboyant forms of ritual and entertainment, or iconic buildings – the great cathedrals of cities such as Seville and the Alhambra at Granada. The latter gave an irresistible taste of the glories of Islamic architecture. Particular Spanish artists who especially appealed to British sensibilities, such as Murillo, were also given great prominence in visual and written commentaries. These heavily edited impressions are encapsulated in Benjamin Disraeli's exclamation of 1830: 'Oh, wonderful Spain. Think of this romantic land covered in Moorish ruins and full of Murillo.'

The 'romantic land' continued to entice and delight British travellers, and offer what was seen as a far more adventurous escape than the well-worn routes through Italy. It also gradually became the subject of more rigorous study. Notable landmarks in this respect include Richard Ford's *A Hand-Book for Travellers in Spain and Readers at Home* (1845), William Stirling's *Annals of the Artists of Spain* (1848) and Owen Jones's *Plans, Elevations, Sections and Details of the Alhambra* (1842–5). Spain – both ancient and modern – was also documented through the outstanding photography of Charles Clifford. The effect of these specialists' work was widely felt, as, for example, in the later nineteenth century Owen Jones's studies profoundly influenced Victorian interior design, and William Stirling's work underpinned a growing respect for Velázquez, which took the form of further scholarly study, and the creation of paintings that defer, either through their compositions or aspects of technique, to his skill.

The sober tonality which characterises a number of these Velázquez-inspired works provides a marked contrast with the various ways in British artists reacted to the direct experience of Spain from about 1900 onwards. Taking advantage of an improved infrastructure, which allowed for more rapid travel across the country, they pursued different enthusiasms. So, for example, Arthur Melville, Joseph Crawhall and William Nicholson became fascinated by the rites and spectacle of the bullfight, while Dora Carrington and David Bomberg focused on the drama of rural and urban views. Underpinning them all, however, was a desire to convey the searing heat and light experienced during a southern Spanish summer. The vibrant hues explored earlier by Lewis and Phillip were no longer confined to details of costume or architecture, but in these modern works become the defining quality of the land itself.

The Discovery of Spain is primarily concerned with such external views of the country. The distance that exists between them and the insights of Spanish artists is, however, a vital consideration in any project of this sort. It is demonstrated at the outset and conclusion of the exhibition where Spanish and British works have been set side by side. At the beginning, the very different reactions of Goya and Wilkie to the struggle against Napoleon are considered. Goya was sensitive to the visceral horrors of war, while Wilkie was seduced by heroism and presented the struggle for freedom as compelling and decorous theatre, acceptable to his audience at home. At the end of the exhibition a parallel contrast is played out, as the reactions of Picasso to the Spanish Civil War are placed alongside the reactions of British artists. Picasso proved himself a worthy heir to Goya when confronted with harrowing conflict, creating images which resonate today as emblematic of all warfare. But British artists of the 1930s, such as Edward Burra and Wyndham Lewis, explored the darkness of the era when Spain tore itself apart by using references to medieval conflict. This was an entirely legitimate form of commentary, although, perhaps, one that added new stereotypes, rather than peeling old ones away.

Today Spain is a modern, democratic, multicultural and technological nation. From the British perspective, it has become one of the most popular of all destinations for travellers: the tentative and often dangerous journeys of the 1820s and 1830s have been superseded by the trouble-free flights of millions of tourists. The country's climate, regional variety and rich culture provide an endlessly fascinating backdrop for leisure, scholarly study or artistic pursuits. Amid all this, however, vestiges of the powerful imagery explored and enriched during the nineteenth and early twentieth centuries by British painters continues to flavour our expectations and discoveries.

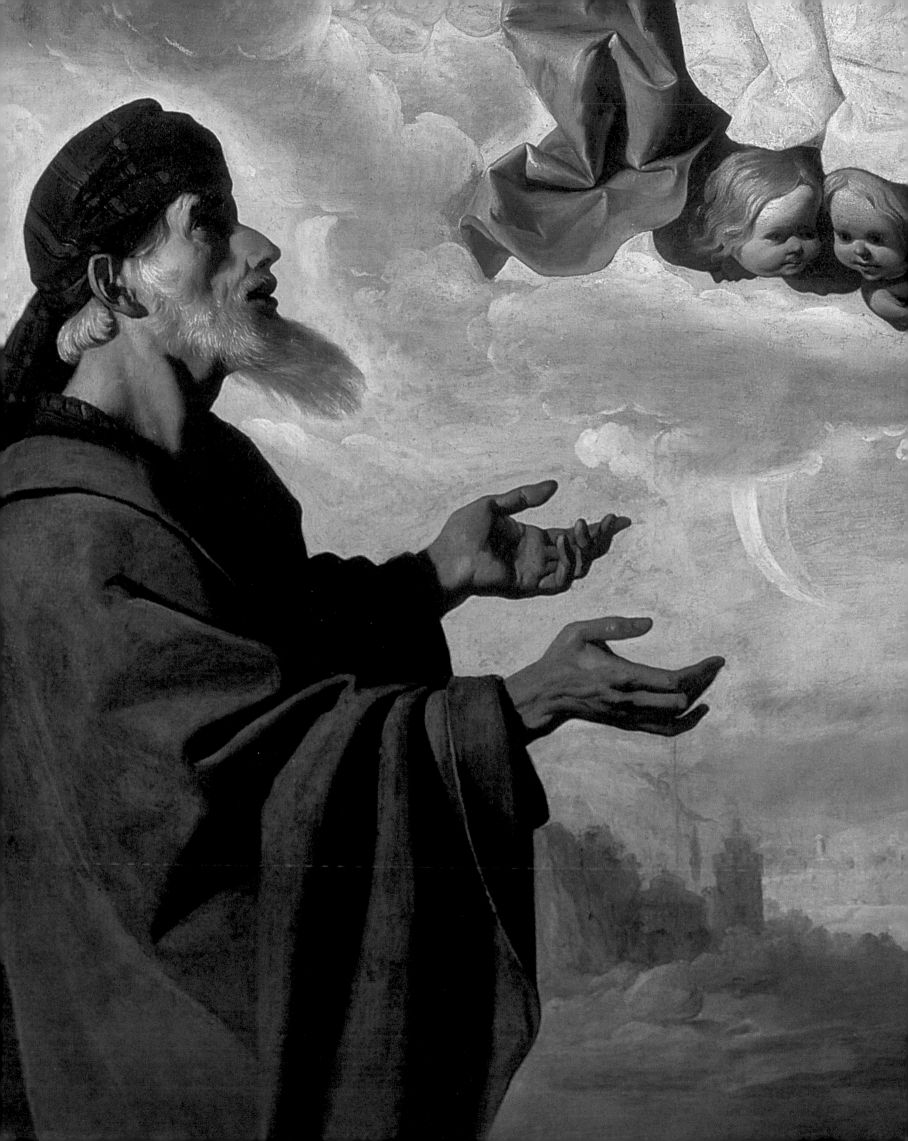

THE QUEST FOR SPAIN
DAVID HOWARTH

Some years after peace had been established between Britain and Spain in May 1605 following hostilities which had begun with the Spanish Armada, a courtier wrote to the English agent in the Spanish Netherlands: 'I am entreated by a friend to help him to a book in Spanish called or written by one Don Couixetto de la Mancha [*Don Quixote*]; they say it is to be had in your parts'.[1] Over three hundred years after it was unclear whether *Don Quixote* was a writer or a book, a confusion which would have amused its author Cervantes (1547–1616), George Orwell (1903–1950) was lambasting what he called the 'soft-boiled' British intelligentsia for their wholesale misunderstanding of the Spanish Civil War (1936–39). It is the purpose of this book to consider the strange encounters between two cultures, so different yet so powerfully attracted, and to identify multiple 'discoveries' of Spain by the British.

In 1623, eleven years after the muddle over *Don Quixote*, it was the turn of Charles, Prince of Wales to be deluded. But now it was delusions about love, not books about love, which was at issue. Charles, masquerading as 'Jack Smith', arrived incognito in Madrid with his favourite, the Duke of Buckingham as his brother 'Tom', for an adventure which might have come from the pages of *Don Quixote*. After a long ride from London, Charles had convinced himself that he was going to marry the Spanish Infanta. The Spanish thought otherwise: they prevaricated, refused, and finally humiliated the party of four Englishmen whose appearance in Madrid had been wholly unexpected. For Charles however, there had been one positive aspect to this fiasco. Seven months in the Spanish capital between March and September 1623, studying collections, even, perhaps, sitting to Diego Velázquez,

gave him an unrivalled exposure to art.[2]

For close on two hundred years thereafter, the British did not go anywhere near Spain if they could avoid it. The country was regarded as primitive and dangerous. Some resided as ambassadors, others as entrepreneurs, politicians, priests, refugees and most conspicuously, soldiers. The War of the Spanish Succession (1701–14), was a conflict centred on the rival Bourbon (French) and Habsburg (Austrian) claims to the Spanish throne, following the death in 1700 of the Spanish king, Charles II. The Jacobite Duke of Berwick, natural son of James VII and II, headed the army of the Bourbon Philip of Anjou, who would later emerge victorious, and succeed as Philip V (1700–1746), while the Earl of Peterborough commanded the troops of the unsuccessful Habsburg pretender, the archduke Charles. Peterborough had been described by Queen Mary as 'mad, and his wife madder'. But if he was unstable he was also creative. When young, Peterborough had enjoyed an intimate friendship with the philosopher John Locke, and in later life would become both an inspiration for Jonathan Swift and patron of Alexander Pope. In Spain, Peterborough proved a brilliant military tactician who could pull off the most unlikely victories.

Both sides in the War of the Spanish Succession had numerous Irish in their corps: the so-called 'Wild Geese'. They were Catholic officers who had fled Ireland after the defeat of James VII and II at the Battle of the Boyne in 1690. But one Irishman in particular who made a notable contribution to Spain did so in the sphere of peace and not the profession of arms. Richard Wall (1694–1778) survived his early experience in the Spanish navy, rose to become a notably successful Spanish ambassador to London,

and Secretary of State to Ferdinand VI (1746–1759). After the accession of the Enlightenment Bourbon king, Charles III (1759–1788), Wall was pensioned off with the Soto di Roma, the royal hunting lodge near Granada, which would later be presented to Arthur Wellesley, 1st Duke of Wellington (1769–1852). Wall installed fine English furniture, and as a noted agricultural 'improver' drained 4,000 acres while laying out walks. At Soto di Roma, he reinvented himself as a tourist attraction and was visited by the few British in Andalusia.

One such was Henry Swinburne who travelled in Spain with Sir Thomas Gascoigne during the reign of Charles III. Swinburne was well connected and he was rich: the Austrian Emperor Joseph stood godfather to his son, whilst Rome's most fashionable portraitist, Pompeo Batoni, painted him in Italy. Swinburne was a dilettante and the fruits of his observations were published as *Travels through Spain in the Years 1775 and 1776* (1779). The book was illustrated with Swinburne's own drawings of Roman and Moorish architecture. Swinburne was the first British writer to do well out of the country with his easy, undemanding publications.[3] Swinburne's works were in marked contrast to the altogether more substantive contribution to an understanding of pre-Renaissance Spanish architecture which, slightly later, was made by the distinguished Irish architect, James Murphy. Murphy turned his scholarly attention first to Portugal with the appearance in 1795 of *Plans, elevations, sections and views of the church at Batalha*. Dedicated to just one famous church, Murphy on Batalha made a contribution to the history of European, not merely Iberian, architecture. Whereas Swinburne left Spain to take a lucrative government sinecure in the West Indies, Murphy immersed himself in the country by living for nearly ten years in Cadiz from where he conducted further researches into Moorish architecture. These appeared under the title: *The Arabian Antiquities of Spain* (1815). Unfortunately, it is not recorded how either Swinburne or Murphy reacted to what Wall had imposed upon the Alhambra, the great Moorish palace in Granada, then the most famous building in Spain. When in power, Wall had responded enthusiastically if insensitively to

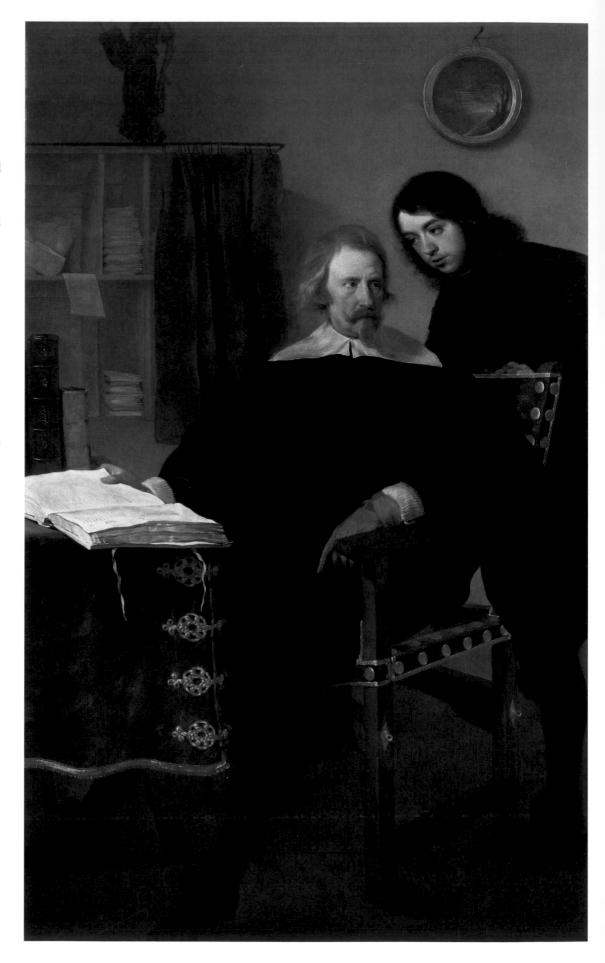

4 Unknown Spanish artist
Portrait of Sir Arthur Hopton, 1641
Meadows Museum, Southern Methodist University, Dallas

a perennial conservation challenge by having the entire palace re-roofed in red tiles.

Britons made an impact on both peace and war in eighteenth-century Spain, but what of the impressions made on them? Swinburne's book was to be found in a gentleman's library not his coach because there was little or no tourist traffic in Spain. Nevertheless, for those forced to live there, some became deeply interested in art. Of these the most distinguished early enthusiast for Spanish painting was Lord Grantham (1738–1786), a notably successful British ambassador to Spain, to whom reference will be made later. By contrast, for those at home, it was only with the advent of Romanticism that the Iberian Peninsula became interesting. Even then, interest was confined to the 'other', the exotic Islamic Spain. The material culture of the country as a whole remained largely a matter of indifference until the advent of photography, the travel agent, Thomas Cook, and the railway. Mechanisation was to expose the most underdeveloped country in Europe to some degree of scrutiny, but still, relatively few visited compared with those who had been going to Italy since the reign of Queen Anne. British ambassadors in Spain felt sequestered: at one and the same time, neglected by compatriots and denied intellectual stimulus. The British discovery of Spain always remained partial and occluded. The fog of misapprehension would never entirely disperse. At best, fog thinned to mist.

Nevertheless, there had always been a few connoisseurs of Spanish painting. Sir Arthur Hopton, British ambassador at the court of Madrid, observed Velázquez at first hand. Hopton presented Charles I with Spanish still lifes: an interest in this peculiarly Spanish genre, which would not be revived in Britain until the late twentieth century. Hopton also sat for one of the most ambitious double portraits produced during the Golden Age of Spain. [4]. But this was an exception. Important examples of Spanish painting were very largely absent from British collections in the early Stuart period.[4] Bartolomé Esteban Murillo was, however, admired from an early date. Exceptionally, Sir Robert Walpole, Britain's first prime minister, owned superb examples of his work, and thereafter, Murillo's reputation went from strength to strength. But Murillo actually came to be appreciated less for his

'Spanishness' than for what was thought to be his affinity with Italian and Flemish art. It was a point which would be insisted upon many years later in the first monograph in English on the painter, published in 1819. This slim volume, something of a pathfinder in the historiography of Spanish art, was the first free-standing study in English devoted to any Spanish artist. Improbably enough it was written by a Captain Edward Davies, former captain in the First Regiment of Life Guards, and veteran of the Peninsular War (1808–14), which the Spaniards themselves called either the 'War of Independence' or the 'Patriotic War'. Davies liked to refer to his hero Murillo, as 'the Spanish Van Dyck'. It was as if Davies was embarrassed for pressing the merits of a painter who had always been thought to have had a gentler aesthetic than his Spanish contemporaries. Davies was engaged as much in an exercise of apologetics as he was in gaining converts: he continuously plays down what is 'Spanish' about Murillo.

Before Davies, Murillo had been important to Thomas Gainsborough. Best known as a society portraitist, Gainsborough also painted peasant scenes inspired by Murillo's pictures of young children, seemingly innocent amidst obvious urban deprivation. Such imagery inspired Gainsborough to transpose beggars in the blazing sun of Seville into threadbare children clutching firewood in a wet English countryside. How these Murillos, which inspired Gainsborough, were actually understood by the British who bought them is not clear.[5]

Gainsborough was the earliest British artist to have been directly influenced by Spanish art. By contrast, British writers seeking creative effects had long been closely aware of Spanish literary genres, whilst others had used political and social tensions between the nations to make explosive copy. Thomas Middleton's play *A Game at Chesse* of 1624, had caused mirth and embarrassment and performances were stopped by the Privy Council after only nine days. It was halted on the personal order of James VI and I because the 'Black Knight' represented Count Gondomar, the Spanish ambassador whose influence over the king was greatly resented after the humiliation of the 'Spanish Match', as Charles I's amorous misadventures came to be termed. John Fletcher, the

celebrated playwright and contemporary of Middleton, co-wrote with Shakespeare, *Henry VIII*. Fletcher can be assumed to have been sympathetic to, if not the author of, the positive portrayal of Catherine of Aragon it contains. Thereafter, it was Fletcher himself who went on to establish the genre of the 'Iberian comedy'.

Distinguished writers of the Scottish Enlightenment were though, rather more preoccupied with issues of Spanish history, economics and sociology than with Golden Age literature. William Robertson, consolidated his reputation as an historian with a magisterial account of Charles V (1769),[6] a three-volume study which brought fan mail from Catherine the Great in St Petersburg and Thomas Jefferson in Virginia. Concurrently, Adam Smith in his *The Wealth of Nations* (1776), conducted a post-mortem on the Spanish economy after two centuries of inflation triggered by New World wealth.

Among the Romantics, William Wordsworth and the poet laureate Robert Southey were the first to become concerned with the internal politics of the Peninsula. Their ideological commitment anticipated passions which would be generated in Britain by the Carlist civil wars of the 1830s. This savage internecine conflict centred upon rivals to the throne of Spain which had been vacated upon the death of Ferdinand VII. Just before expiring and against all the odds, Ferdinand, by his third wife María Cristina, had fathered a daughter who would eventually succeed to the throne as Isabella II (1843–1868). However, at the death of Ferdinand in 1833, his brother, the pretender Don Carlos, had disputed Isabella's right to the throne and heading a party of Ultra Conservatives, provoked the onset of fighting which would ravage northern Spain for most of the 1830s. The fighting between the 'Carlists' and the 'Cristinos' was no less savage than in the more famous Spanish Civil War. But what distinguished the Carlist Wars from the Spanish Civil War, was the vast presence of British volunteers. The British government authorised the raising of a 'British Auxiliary Legion' to fight for the Cristinos. It has been estimated this may have consisted of as many as 12,000 men.

Nearly thirty years earlier, Iberia had become the principal theatre of Napoleon's aggression. By 1807 Sweden and Portugal

were the only nations which defied the French policy of 'Continental Blockade' whereby European ports were closed to British shipping. The so-called 'Peninsular War' began when Portugal sided with Britain. A French army occupied Portugal in November 1807, and Napoleonic forces seized Pamplona and Barcelona in February 1808. In March a French army occupied Madrid, and in June 1808, Napoleon's brother Joseph was imposed on the Spanish throne, thereby precipitating a mass rising all over Spain. A British expeditionary force including Arthur Wellesley (later Duke of Wellington) landed in Portugal. Sir John Moore (1761–1809) as commander of a British army then invaded Spain. After a see-saw campaign, Moore was forced north into Galicia where he made a stand against massed French attacks. Moore was killed but had held the French long enough to allow most of the British army to disembark from the port of Corunna. In April 1809, Wellesley arrived back in Lisbon to take charge of British and Portuguese forces. Over the next five years and despite setbacks, allied armies with decisive interventions from 'guerillas', gradually rolled back the French. Many bloody and sometimes indecisive battles finally tipped the balance, and culminated in Wellington's decisive victory at Vitoria on 21 June 1813 when the allies routed a combined French force under Joseph Bonaparte and Marshal Jourdan. The Peninsular War eventually ended when having advanced as far as Toulouse, on 12 April 1814, Wellington received news of the abdication of Napoleon.

How the great military campaigns of the Peninsular War moulded British perceptions of the Peninsula, still remains to be researched. Robert Southey's *History of the Peninsular War* (published between 1823 and 1832) a book which did as much to elevate the reputation of the Duke of Wellington as it did to promote an understanding of its ostensible subject matter was the most far-reaching cultural monument to the campaign. However, it would seem that eight years of march and counter-march across the Peninsula had little impact on taste in architecture, decoration or collecting. Few were interested in the towns upon which they were billeted. The contrast with the British fascination for France, even during a period of titanic conflict, could hardly have been more marked. With the temporary cessation

of hostilities at the Peace of Amiens (1802–3), many flocked to Paris, among them William Hazlitt a famous critic and amateur artist of real talent. On return, Hazlitt painted his memorable portrait of his friend and fellow writer Charles Lamb [101]. This was based on what he had observed of Titian and Velázquez at the Musée du Louvre.

Shortly after the Peninsular War, an important cache of Spanish paintings did come to Britain. But this was all an accident. Pictures belonging to Napoleon's brother, Joseph, were captured after the Battle of Vitoria (1813). The Spanish regime knew that Wellington was interested in painting and therefore presented them to him.[7] As it became clear however, just how much Joseph had taken from the Spanish royal collection, Wellington became uneasy. He was eager, certainly, to claim what could be proved as having been purloined from elsewhere, but loathe to embarrass the recently re-installed Ferdinand VII, or indeed himself, by appearing to take the Spanish royal patrimony. When, however, he was told restitution would cause offence, he changed his mind. But intriguingly, Wellington's attitude had been conditioned by pre-existing admiration for Italian painting. He simply could not look at Spanish art on its own terms. This is no surprise: the British did not have the capacity to see Spanish art as anything other than a sub-set of the 'Italian Schools'. Such myopia was epitomised by what Wellington had to say about the Vitoria pictures when writing to his brother, Sir Henry Wellesley, the British minister in Madrid:

My dear Henry,

From the cursory view which I took of them the latter [pictures] did not appear to me to be anything remarkable. There are certainly not among them any of the fine pictures which I saw in Madrid, by Raphael and others; and I thought more of the prints and drawings, all of the Italian school, which induced me to believe that the whole collection was robbed in Italy rather than Spain.[8]

By the chance of war rather than through any enlightened exercise of connoisseurship, a significant holding of Spanish art thus became available to the British. This included an outstanding portrait of a man, perhaps a depiction of José Nieto by Velázquez [71]. Although superb Spanish paintings came to Wellington's London home, Apsley House,

including *The Waterseller of Seville* [66], the masterpiece of Velázquez's Seville years, these had little immediate effect on taste. Nevertheless, when young and impressionable, Richard Ford (1796–1858) certainly benefited from his first exposure to the Spanish art at Apsley House. Later he would become the most distinguished writer in English on Spain and its treasures.

In addition to the Apsley House holding, there was at this time, a shrine to Spanish painting deep in the Dorset countryside. At his house, Kingston Lacy, the baronet Sir William Bankes, profiting from the disruption of the Peninsular War, had created a 'Spanish Room'. Here amongst other Spanish and Italian treasures hung what was long taken to be nothing less than Velázquez's *modello* for *Las Meninas*. However, in modern times, this erstwhile talisman of Spanish art, once described by an admiring painter as 'the theology of art', is now thought to be a *ricordo* by the Velázquez pupil, del Mazo.

The Peninsular War generated visual heroics: pictures of the great battles won by the British army, and even a somewhat absurd vision of Wellington himself as a latter-day Hannibal, crossing not the Alps but the Pyrenees. Notwithstanding, British artists who recorded the Peninsular War are of interest only to historians of battles and enthusiasts for military uniforms. Francisco de Goya famously, albeit briefly, encountered Wellington to record the likeness now in the National Gallery in London [18]. But that portrait small in scale, as is pointed out in a separate essay, remains a surprisingly haunted, even intimate image. By contrast, Jacques-Louis David (1748–1825), sublime propagandist for Napoleon, believed in the vanity of war, whilst the low-key, tentative, likeness of Wellington, anticipates Goya's settled belief that fighting was never heroic. Through his *Disasters of War* prints [23–6], Goya defined the 'war crime' – which the celebrated English writer Aldous Huxley would describe in his *Goya's Complete Etchings* (1943), as the 'unplumbed depths of original sin and original stupidity'. But though Goya today scores like a hot rake over the international conscience, he remained almost unnoticed in Britain until long after most Peninsular War veterans had died. It was only when William Stirling (1818–1878)

started to publish extensively on Spanish art in 1848 that the graphic work of Goya really began to be appreciated for its intrinsic artistry. Before then, some had been pleased with Goya because they thought he shared their widespread anti-French feelings, but the fact remained, Goya had failed to affect the British connoisseur.

For all its apparent vividness, Goya's achievement in *The Disasters of War* was certainly not an exercise in propaganda, and not at all what might be termed a 'Spanish' response to the horrors many other Spaniards were proud to call the 'Patriotic War'. For Goya, these terrible etchings had nothing to do with patriotism. Although it is generally accepted that the *Disaster* images came out of Goya's experience of seeing the brutality of the French siege of Saragossa in October 1808, principally they were an act of the imagination.[9] What Ford in the context of another later conflict on Spanish soil would describe as the 'unchangeable character of war' was for Goya a timeless commentary on warfare.

It is a curious irony that for many important creative figures who have established images of Spain at critical moments, the country was a discovery of the mind not the recollection of actual experience. Some of the most celebrated artists who have helped immortalise the people and their culture, have done so through empathy and not direct witness. Goya was in Madrid for almost all of the Peninsular War, and certainly never fought, whilst during the Spanish Civil War, Pablo Picasso remained safely in Paris. Before Picasso, James McNeill Whistler had worshipped Velázquez without ever making it to the Museo Nacional del Prado in Madrid, whilst Francis Bacon, who notoriously could not forget the famous primary *Innocent X* by Velázquez, in the Doria Pamphili Palace in Rome, saw it only as a photograph during the period when he was painting variations on a Spanish theme, though he may well have known the reduced head and shoulders version belonging to the Wellington collection at Apsley House.[10] As for writers in English about Spain, W. H. Prescott, the pre-eminent nineteenth-century historian

of the Golden Age, who though blind made more money than any other historian has ever made out of the country, never left Boston.

The Peninsular War had been a conflict of attrition not romance. It lacked decisive battles like the Armada or Waterloo. So there are no great Victorian canvases to celebrate the battles of Salamanca or Vitoria. Lady Butler, described as the 'Florence Nightingale of the Brush' because of her identification with the private soldier in her canvases, was for a time an enormously popular battle painter. Her *Steady the Drums and Fifes!: the 57th (Die-Hards) Drawn up under Fire on the ridge at Albuera*, though exhibited at the Royal Academy in 1897, never achieved that place in the popular imagination which *Scotland for Ever!* had done: a painting celebrating the charge of the Royal Scots Greys at Waterloo.

Curiously, however, it was the one epic defeat that the British suffered during a six-year campaign, which provoked the most lasting monument to the British in the Peninsula. The disastrous retreat to Corunna of a large British army, in which 5,000 soldiers died of starvation, cold, or enemy action, the Dunkirk of the Peninsular War, occurred in January 1809 when the British under Sir John Moore, halted Marshal Soult, described by Ford as, the worst of Spain's 'persecutors and picture plunderers' [5]. The manoeuvre enabled the evacuation from the Peninsula of 27,000 troops. Moore's stand at Elvina, which resulted in his own death, provoked the celebrated poem, *The Burial of Sir John Moore at Corunna*. The verses were composed by the Irishman Charles Wolfe (1791–1823), thereafter condescendingly, if with hindsight accurately, referred to as 'the

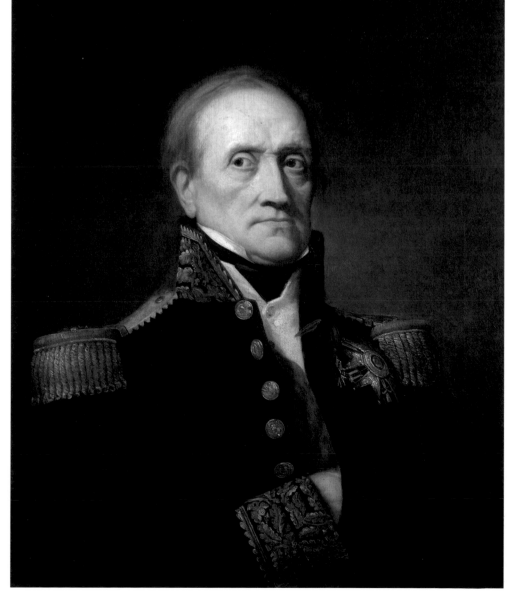

5 George Peter Alexander Healy
Portrait of Marshal Soult
Wellington Collection, Apsley House, London

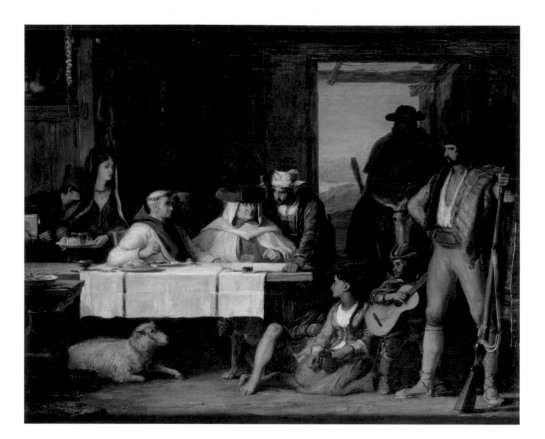

with Clifford's rather less romantic panoramas of public amenities currently or recently under construction during the reign of the new Isabella. All was an act of faith that good works promoted by Isabella would persuade the subjects of that other European queen, Victoria, that Spain not only had an unsurpassed cultural heritage, but was fast proving to be a progressive, industrious and industrialised nation [58, 60].[11]

Although Clifford appeared on the scene too late to exploit old battlefields, what he did do was to make the most of a growing British passion for southern Spain. It was never a British identification with Catholic Spain which generated a positive interest in the country but rather, the very reverse. It was what was most alien about nineteenth-century Spain, those aspects of a vestigial culture which were most remote from a British, even European experience, which paradoxically drew the British closer. Clifford made a tidy income from incandescent visions of the Alhambra that provided the less well off in Britain, unable to afford a painted view, such as a sprightly watercolour by John Frederick Lewis [55], with something to hang in the front parlour. Clifford's was a vision which closely approximated to Richard Ford's seductive prose poem:

But to understand the Alhambra, it must be lived in, and beheld in the semi-obscure evening, so beautiful of itself in the South, and when ravages are less apparent than when flouted by the gay day glare. On a stilly summer night all is again given up to the past and to the Moor; then, when the moon, Dian's [sic] bark of pearl, floats above it in the air like his crescent symbol, the tender beam heals the scars, and makes them contribute to the sentiment of widowed loneliness. The wan rays tip the filigree arches, and give a depth to the shadows and a misty undefined magnitude to the saloons beyond, which sleep in darkness and silence broken only by the drony flight of some bat.[12]

But we must not exaggerate the pull of Andalusia, even though it was acknowledged by many across Europe to be the most picturesque region of the entire continent. J.M.W. Turner, the most famous painter of

one-poem poet'. It remains the most famous poetic description of British commitment to Spain and is much better known than any English poem provoked by the Spanish Civil War of 1936–39. Byron described it as 'the most perfect ode in the English language'; a view with which history has not concurred. Nevertheless, it did come to be embalmed in *The Oxford Book of English Verse*. The rat-tat-tat of its drumbeat rhythm can be sensed as we march past each stanza:
*We thought as we hollowed his narrow bed
And smoothed down his lonely pillow,
That the foe and the stranger would tread o'er
 his head,
And we far away on the billow!*

The Peninsular War was and would remain the biggest military commitment made by the British on mainland Europe, until the sending of the British expeditionary force to France in 1914. The struggle in Spain against Napoleon was seen by contemporaries as a modern Trojan War. But for all the heroism there was no annual remembrance and no commemoration such as the yearly banquet for Waterloo hosted by Wellington at Apsley House. There, at a house grandly referred to as 'No 1 London', scarlet generals ate off dinner services donated by the grateful governments of Portugal and Spain. The tone for such occasions was set by *The Wellington*

Shield, a huge silver centre piece inspired by Homer's description of the 'Shield of Achilles' in *The Iliad* [7]. Shortly after Waterloo, Walter Scott had hurried over to Belgium to acquire French cavalry helmets picked off the field of battle. These came to be hung like stags heads around Scott's famous romance of the Middle Ages, his home Abbotsford in the Scottish Borders. By contrast, there were no guides waiting for the British tourist at Salamanca and Vitoria, Wellington's most decisive Spanish battles.

The Spanish campaign was largely forgotten. However, the new Spain that gradually emerged was being documented even whilst the passing of the old was regretted by some. Charles Clifford, though English, became the leading photographer of Spain and opened his shop in Madrid, the *Daguerrotipo Ingles*, where customers could view his most splendid offering, the *España Monumental*. This was a gigantic exercise in propaganda for the Spanish Queen Isabella II on the part of her English court photographer, an ardent royalist. The work contained much material from the Golden Age, the age of the first Isabella, known as Isabella of Castile (1479–1504), wife of Ferdinand of Aragon (1479–1516), the conquerors of Granada. In enormous albums, historical views were interleaved

nineteenth-century Britain, did not visit Spain, whilst his apologist, John Ruskin, though he had strong views about Spanish subject matter, as when he declared that Lewis 'had been eminently successful in his seizing of Spanish character', never set foot in the country.

Some major British painters certainly did, and they made strenuous efforts to assimilate the 'Spanish School'. Sir David Wilkie, a leading painter of Regency England, declared his adoration of Velázquez shortly after his arrival in Madrid in 1827, though he would later admit to being unable to capture his elusive genius. As with Wellington's difficulties in judging Spanish pictures on their own terms, Wilkie ruefully confessed he could never rid himself of his passion for his favourite Italian artists. Nevertheless, failure was relative. Wilkie came home to London in 1828 and a 'Spanish triumph'. Among a number of Spanish-inspired themes with which he created a sensation, was *The Defence of Saragossa* [21]. Exhibited at the Royal Academy, London, in 1829, it was promptly bought by that notable connoisseur George IV. The picture soon established itself as the most celebrated of all British images of Spain; a status it has maintained to this day.

Two years later, J.F. Lewis, himself by then in Spain, vainly tried to create a great 'Spanish' history piece. This was to have been entitled *The Proclamation of Don Carlos* and if it had ever been finished, it would have been the artist's most ambitious work. Despite his failure to paint what might be termed a 'Spanish epic', in Spain itself, Lewis had been assiduous in making watercolour copies of some of the Velázquez's in the Prado [99, 100]. These were intended as aides memoires, but curiously enough, came to have an important impact on art practice in Scotland. In 1853 the copies were acquired for their educational value by the Royal Scottish Academy, for the considerable sum of £500, payable by instalments. In November of that year they were put on public show in rooms at Abercromby Place where they received positive press coverage through two articles in *The Scotsman*. The excitement induced, provoked Lewis himself, by then back in London, to remark:
I am delighted to hear that the Abercrombie Exhtn [sic] *has opened with such éclat. This is very cheering ... I saw E Landseer and*

Mulready last night ... Mulready is quite charmed at the initiative which the Scottish Acad. have taken ...'

The positive reviews, with which the Lewis exhibition was received, were perhaps written by the distinguished Scottish painter Robert Scott Lauder, who argued that these copies were important since they might induce the growth of a real interest in watercolour; a medium it was claimed had hitherto been neglected in Scotland.

Through copies, Lewis took a robustly independent view of what an authentic Velázquez was then taken to be. The Abercromby catalogue described his *Study of a Portion of the Picture of the Adoration of the Shepherds after Velasquez* as an early work which showed the influence of Caravaggio on the young Spanish painter when he had lived in Seville. Now the prototype is considered 'anonymous Italian'. But Lewis had not confined himself to making interpretative 'copies' of famous works only when he was abroad. The first and most important collection of Spanish art in a public institution in Britain was at Dulwich Picture Gallery where *The Flower Girl* [77], the nation's favourite Murillo, had long resided. The Lewis copy of this famous Spanish icon, had also been included in the Edinburgh exhibition. There it had been described as having '... a most pleasing manner and with the truth of nature, all the striking characteristics of the Spanish race, in which a Moorish origin is traceable.'[13]

These Lewis reductions did not provide the expected stimulus for their creator. When Lewis returned home to London from Spain in 1833, he had found himself thinking more of Flemish than of Spanish art. It was as if Lewis had never needed to go to Spain. His reaction was often refracted, or interpreted indirectly through things which either had nothing to do with Spain or were aspects of Spanish material culture, encountered elsewhere.[14] Nevertheless, in a broader perspective, Spain would prove to have been important. It was a prelude for Lewis's

real encounter with the 'other', his life in Egypt, where he lived between 1841 and 1851. Thus Spain had been an apprenticeship for something still more exotic, a means of qualifying Lewis for what he would find interesting in North Africa.

David Roberts, contemporary and rival of Lewis, made a handsome income from the successful exploitation of Spanish subject matter.[15] This he assiduously prepared during an extended field trip from which he returned weighed down with portfolios as a botanist with plant specimens. In the early days Roberts had been a scene painter in Edinburgh playhouses and this may explain the theatrical about him and the quality of 'spectacle' in his work. If Wilkie had painted Spanish subjects in an Italianate manner, sometimes it seemed that Roberts had looked at a Spanish interior with Piranesi at the back of his mind. The contrast between Roberts looking at Spain through an Italian glass, and the reaction of the much younger Aberdonian John 'Spanish' Phillip is marked. Two Phillip watercolours of Toledo and Segovia [38, 39], reveal a much stronger and immediate response than the careful and well mannered finish of Roberts's Spanish works.

Wilkie, Roberts and Lewis were painting

'Spanish' pictures when a more widespread interest in collecting Spanish art was emerging in Britain. By contrast, the French had had a continuous interest in Spanish art since the Peninsular War. Marshal Soult had carried out a ruthless not to say notorious campaign of compulsory purchase and theft. Many of Soult's trophies had remained in France after the defeat of Napoleon. Their presence in Paris helped form a 'public' taste for Spanish pictures years before the British began to take an interest. That burgeoning curiosity reached its climax with the opening of the Galerie Espagnole at the Louvre during the first week of 1838. The gallery was dedicated to the display of over four hundred Spanish pictures which belonged to King Louis-Philippe of France (1830–1848). They were a distinctly mixed bag. There were many absurdly optimistic attributions that reflected both a widespread ignorance of regional Spanish schools and a shaky grasp of individual style. In 1841 the Galerie Espagnole had been augmented with the bequest of a recently deceased British collector, Frank Hall Standish (1799–1840). He was an expatriate Lancashire landowner who had settled in Seville, where he had become morbidly obsessed with the idea of reviving a dormant family baronetcy. But whilst feeding that obsession, Standish had also acquired a notable collection of Spanish Golden Age paintings including Murillo's *Self-portrait*, now in a private collection in America.[16] This was a picture that had inspired the famous German scholar of the Renaissance, Jacob Burckhardt, in August 1843, to ask his readership the rhetorical question 'this whole face, is it not an arsenal of passions?'. Burckhardt's essay in *On Murillo* inspired by what the historian felt had been a first unforgettable encounter with the Standish portrait. With what were evidently some remarkable pictures, Standish had repeatedly tried to bribe the British government to grant him his title. He had offered all his Spanish art to the National Gallery, London, if only the government would oblige him about the baronetcy. After dithering, Lord Melbourne, the prime minister, had declared that, personally, he did not think that buying titles was such a bad thing, but in a democratic age it could not be done. Petulantly, Standish gave the lot to Louis-Philippe.

But although there were some undoubted masterpieces in the Standish collection, these were still very early days both in France and Britain, for a clear understanding of Spanish art. It was only by the 1830s that the 'Spanish School' ceased to be regarded as a sub-category of the Italians, a process of emancipation which owed much to the pioneering scholarship of Sir Edmund Head (1805–1868). Head made an improbable art historian. He had had to abandon an Oxford fellowship on marriage, but pursued his academic interests by becoming a legendary linguist and translator of Icelandic sagas. Head went into public life and rose to become Governor-General of Canada. Before then he had translated German art history books and begun researches on the regional schools of Spanish painting. His studies resulted in 'Noticias de los Quadros', a turning point for the understanding of Spanish art which appeared as an essay in the *Foreign Quarterly Review* of 1834.[17] This represented the first serious scholarly account of the Spanish School in English. It was the most reliable map for scholars traversing that rocky terrain.

A notable success which enlarged awareness on the part of the British of the attractions of the Spanish School, was the acquisition in 1846 or 1847 of a Murillo, by the famously successful picture agent William Buchanan, from the artist's celebrated series of pictures painted in 1667–70 for the church and hospital of La Caridad in Seville. The London National Gallery picture from that series, *Christ at the Pool of Bethesda* [75], along with its companions, had been levered out of the Caridad in 1810 by Marshal Soult. He had acquired works which were to be deposited either in a great museum in Madrid under French auspices, or in the planned Musée Napoléon in Paris. Before the cycle by Murillo had gone anywhere, however, Soult had appropriated them for himself, redirecting the one which was to be acquired by the National Gallery, London, into his own collection in Paris, together with four other works from the Caridad.

The Murillo was taken to be the apogee of well mannered Spanish art. The beauty of the hues, the avoidance of what was considered to be 'Spanish' qualities of tenebrism, mawkishness and hysteria, the clean-limbed figures and the gentle demeanour of pool-side witnesses, demonstrated Murillo's essential good manners and well balanced temperament, which had made him for Captain Davies and his readership, the 'Spanish Van Dyck'. With this well received picture, the British felt it was possible to deny that the painting was a Spanish work at all, though the French viewed the matter in a wholly different light.[18]

By contrast to the ready appreciation of the insinuating charms of Murillo, British understanding of the strengths of either Francisco de Zurbarán or Jusepe Ribera took much longer to develop. Actually there had been one important holding of Zurbarán in Britain since the mid-eighteenth century. In 1756, Richard Trevor, Bishop of Durham, had acquired twelve of the thirteen pictures which made up the full set of Zurbarán's *Jacob and his Twelve Sons* of the 1640s. These Trevor had placed in the episcopal palace at Bishop Auckland which the bishop was transforming into a Gothick mansion. However, their presence there may have had little to do with aesthetics. It is possible that they had been acquired because of what Trevor had done in the House of Lords, to ameliorate the inequalities faced by British Jews.[19]

The association of Zurbarán with the Spanish church made this 'painter of monks', as he was dubbed, a distinct challenge, something which indeed he remains today. Early Victorians may have had an especial difficulty since their prejudices about Spain had been confirmed by reading a famously intrepid work of missionary zeal, George Borrow's hugely successful three volume publication, *The Bible in Spain: Journeys, Adventures and Imprisonments of an Englishman* (1845). It told the story of how Borrow had travelled through the Peninsula trying to interest people in buying Protestant bibles, and the scrapes which befell him. However, Borrow was not the only person who brought the Spanish church into Victorian homes. The poet Robert Browning was drawn to monks, though of a far more acerbic order than Zurbarán's gentle ghosts. Always intrigued by tensions between appearance and reality, corrosive themes are central to Browning's *The Soliloquy of the Spanish Cloister* (1842). In Browning, destructive emotions drip through the stanzas as repression is made to characterise the monastic life. *The Soliloquy* was the most powerful British literary exposure of what was believed to be the hypocrisy of the religious calling in Spain. Browning offered

a merciless insight into the hidden, not to say tortured, thoughts of a monk which the poet set against life outside. Amidst roses, Browning's wretched incumbent curses his fellow monks whilst tormented by awareness of 'Brown Dolores' who dips her blue-black hair in the cold waters of the village fountain.

The dispersal through the London salerooms of the Louis-Philippe collection following the revolution in France of 1848, increased enthusiasm for Spanish painting by artists like Zurbarán, Ribera and Luís de Morales (1520/5–1586). Famous Spanish paintings, and works by little-known masters alike, were then being well publicised in London for the first time. Among them was the most notorious Spanish painting in all nineteenth-century Europe, Zurbarán's *St Francis in Meditation* [82]; a crepuscular vision which had been worshipped in Paris where it had transported the viewer to the darkest chapters of a Gothic novel. Its acquisition by the National Gallery, London, and its public reception, is referred to in a later essay. However, Zurbarán could compose in different keys: by no means was all of his work conceived with the cadence of a funeral march. Something of an allegro was provided by the Immaculate Conception [83] which had appeared in the same sale as the notorious St Francis painting. This was then acquired by the National Gallery of Scotland, Edinburgh, from Lord Elcho in 1859. It reveals something about a growing taste for Spanish painting in Britain that a major work by such a challenging artist as Zurbarán was acquired for the Scottish national collection within ten years of its foundation, whereas the English national collection acquired most of its Spanish pictures only in the 1890s, and nothing for the first thirty years of its existence, saving the acceptable Murillo.[20] But then widespread ignorance about the iconography of sacred imagery in Spain prevailed in Britain long after the separate styles of the major creative figures of Spanish painting had been securely established. It would be over a hundred years before the subject matter of the Edinburgh Zurbarán came to be recognised for what it was: until the mid-twentieth century, what was actually

an Immaculate Conception had been habitually referred to as 'The Virgin in Glory'.

Some felt that the problem in making converts to Spain was that like certain wines, her artists did not travel well. Apologists claimed that the glories of the Spanish School could only be truly appreciated in a monastery or, perhaps, the sacristy of some great cathedral. Shortly after the appearance of Browning's soliloquy, William Stirling published *Annals of the Artists of Spain* (1848). The *Annals* remains the most ambitious synoptic account of Spanish art in English. Here there is an altogether more sympathetic view of the calling of the religious than provided by Browning. Stirling preferred to imagine monks living a life where constraint was the handmaid of serenity. Stirling remains pre-eminent among

English writers on Spanish art in his profound sympathy for the culture and society of the country. By contrast, though Ford was the more gifted writer, his epigrammatic style was achieved in part from the cutting edge of his condescension towards the country.

No one before the appearance of the *Annals* had anything to say in English about the great Spanish sculptors like Juan Martínez Montañés who had been sufficiently highly regarded at the court of Philip IV to have been painted by Velázquez, or for that matter, any Spanish masters of the decorative arts. Stirling does not say enough perhaps, but he certainly meditated deeply on the centrality of the decorative arts to Spanish visual culture: ironwork, chestnut choir stalls, *retablos* and stained glass. The existence in Stirling's papers of working

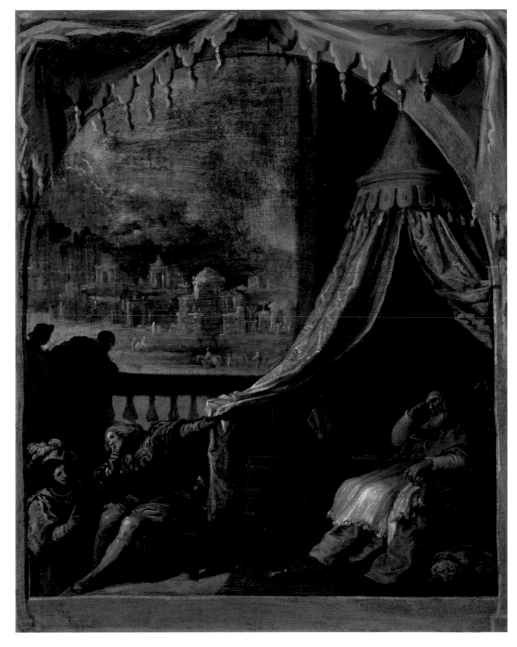

8 Vicente Carducho
Dream of Saint Hugh, Bishop of Grenoble, 1626–32
National Gallery of Scotland, Edinburgh

records in the form of ink scribbles recording in outline, ironwork, weather vanes, or gates, suggest a generous response to the total experience of a Spanish building. Artistically negligible Stirling's hieroglyphics may be, yet they remain testament to the earliest appreciation in Britain of the significance of context for understanding Spanish art. Possibly it was only because Stirling was a very rich man that he was offered the chance to buy Yuste in 1863, the lonely monastery in Estremadura to which the Emperor Charles V had retired after he had abdicated in 1556. Or perhaps Stirling was offered this 'unique property in need of conversion' as an estate agent might today describe that monastery, because it was felt that this client alone was considered a proper custodian of such hallowed ground.

Painting not property, however, remained Stirling's priority. His apologia for the painter Vicente Carducho demonstrated the importance Stirling placed on context as he attempted to help the reader overcome the incongruity of viewing a Spanish altarpiece in a British gallery:

Like many other trophies of Spanish art, these fine works of Carducho have lost much of their significance by removal from the spot for which they were painted. Hung on the crowded walls of an ill-ordered museum, his Carthusian histories can never again speak to the heart and fancy as they once spoke, in the lonely cloister of Paular, where the silence was broken only by the breeze, as it moaned through the overhanging pine forest, by the tinkling bell or the choral chant of the chapel, or by the stealing tread of some mute and white-stoled monk, the brother and heir of the holy men of old, whose good deeds and sufferings and triumphs were there commemorated on canvas .[21]

Stirling was a proselytizer for Ribera, Zurbarán, Goya and El Greco, now familiar enough, but just some of the Spanish painters whose identities only began to be defined from the mid-nineteenth century. The first Goya to enter the National Gallery in London came in 1896, the first El Greco, now only ascribed to the artist, was bought at the Hamilton Palace sale in 1882 [84]. For his part, Ribera had first been noticed in a serious way in Britain in the 1840s. Stirling's undergraduate friend at Cambridge, Francis, 10th Lord Napier of Merchiston, made himself the great champion of 'Lo Spagnoletto'; so-called because though Spanish, Ribera had spent most of his working life in Naples. Napier himself, eventually acting Viceroy of India, had begun what would be an immensely distinguished diplomatic career, with a posting in 1846 as British resident to the kingdom of Naples. He liked to drive out in the residency coach to track down all the Riberas in the kingdom which was made more challenging by having to dodge the bombs of the 1848 revolution. Napier shared his enthusiasm with Stirling, then about to publish his famous volumes on Spanish art. Napier wrote to Stirling from Naples:

Only yesterday I ferreted out an obscure St Diego in the altar of an ancient Spanish family chapel. Those in private hands are too often doubtful. I only know of one of unquestionable authenticity and perfect preservation, with the name of the painter at full length, for sale. I lust after its wrinkled and macerated subject, but possession is still denied, I cannot have my hermit for less than £50. The seductive solitary was drawn by myself from the obscurity of a family chapel at Sorrento.[22]

If national galleries in Britain had problems with Spanish painting, a still greater challenge had long centred upon the question of what was a Velázquez? It is therefore something of an irony that what is now the most celebrated Velázquez in Britain, the *Rokeby Venus* [10], lay for years unremarked in a sequestered house in North Yorkshire. There it had slumbered for nearly half a century before its re-discovery in 1851 by

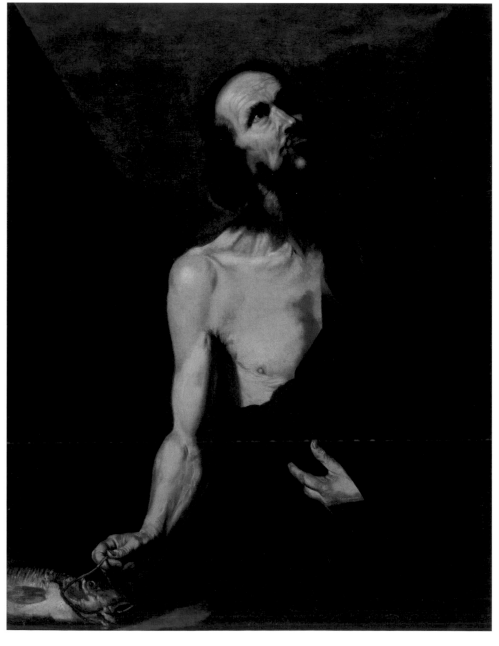

9 Attributed to Jusepe de Ribera
Saint Andrew, c.1632
Perth Museum and Art Gallery

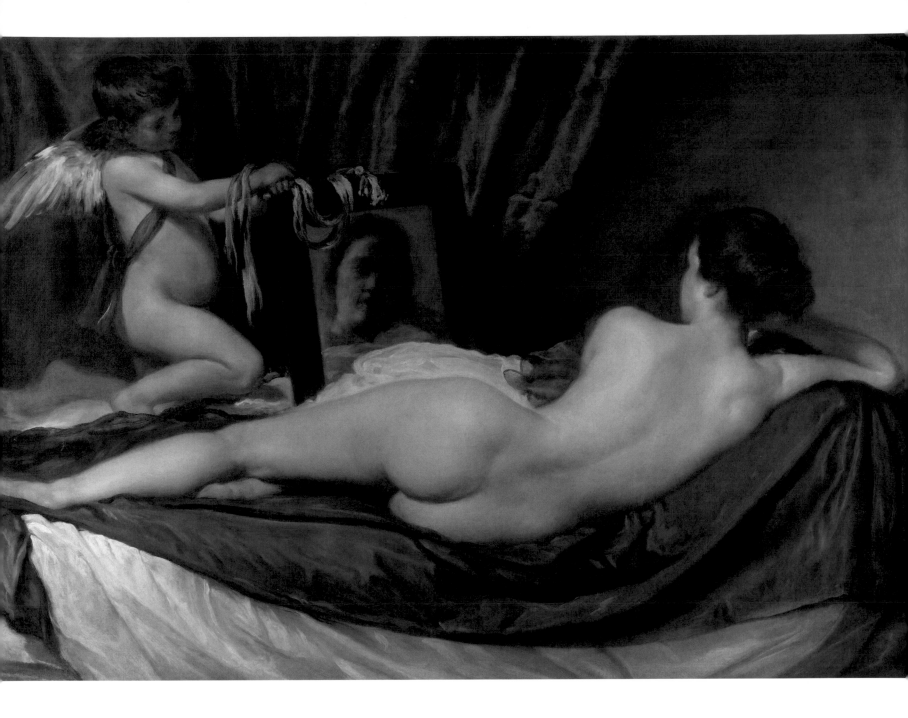

10 Diego Velázquez
The Rokeby Venus, 1647–51
National Gallery, London

Richard Ford. The sight of it so raised his blood pressure that Ford worked off his excitement by scribbling to Stirling to tell him the thrill of it all. The earliest major British artist to 'conquer' the secret of the Spanish master's technique, managed to do so however, without ever visiting the country. This was Sir John Everett Millais, with his *Souvenir of Velasquez* [102] which in 1868 he presented to the Royal Academy, London, as his 'Diploma Piece'.[23] A century before it had been exhibited to such acclaim in Piccadilly, there had been enthusiasts confident in their

mastery of the Velázquez oeuvre.

Of these, the most precocious was the 2nd Baron Grantham to whom reference was made at the start of this essay. He had come to regard himself as an authority on Velázquez through residence in Madrid as British ambassador, between 1771 and 1779.[24] Grantham not only planned a catalogue raisonné, something he never finished, but pressurised guests at the British embassy in Madrid en route for Rome or Vienna, to send back field notes of supposed works by Velázquez, which Grantham had them hunt down. Grantham was enthusiastic about the Spanish School and presented the Escorial with a Spanish picture which he had bought expressly for that purpose. Grantham's

bossiness and his busyness, his range of sympathies and his interests, are all vividly conveyed in breathless instructions with which he pursued his hapless protégé Lord Chichester, who had been perambulated round Andalusia by the leading Spanish art historian of the Enlightenment, Antonio Ponz.[25]

Regency and early Victorian artists grappled with the challenge represented by Velázquez. However, it is not possible to see Velázquez's lasting and profound influence on the British School until late in the nineteenth century. Edouard Manet, writing to his compatriot the French flower painter Fantin-Latour, once famously declared how Velázquez, 'c'est le peintre des peintres'. That

was certainly the feeling among English-speaking artists who, before they discovered Velázquez, had owed so much to the novelty of Manet: John Singer Sargent, Whistler and the celebrated Irish painter, Sir John Lavery. By the 1880s such was the fashion for *hispagnolisme* that some of the most successful portraitists working in London chose to compose in a way which showed a clear debt to Velázquez. Before the craze for Spanish painting, however, John 'Spanish' Phillip had been exceptional among High Victorians for his sensitivity to the facture of Velázquez. Phillip's studies of *Las Meninas* [1] demonstrate a profound engagement with the original; studies which Phillip had undertaken in the 1850s with equal intensity but more effect than Lewis twenty years before.

The popular appeal of Phillip's vitalisation of Spanish art, however, was to be located less in his discipleship to Velázquez than in his rare capacity to produce a hybrid Spanish growth which grafted Murillo onto a stem of Velázquez. The most ambitious of these works was '*La Gloria*'; *A Spanish Wake* (exhibited at the Royal Academy, 1864) [42]. This powerful, confident and energetic masterpiece, with a vitality anticipating Sargent's later visions of Spain, was bought by the National Gallery of Scotland in 1897. It cost the huge sum of £5,250 and remained the most expensive picture the gallery would acquire for many years. It artfully combines a love of the Spanish picturesque, in Spain an urban not a rural phenomenon, with a pastiche of Murillo. Like an anthropologist studying alien cultures, Phillip records a wild sensuality despite its ostensibly mournful theme. His range was broad and also encompassed works such as the *Evil Eye* [40]; an altogether more troubled scene with which the painter could be said to have graduated into the school of Victorian melodramatists. *The Art Journal* of 1864 describing the sensation *La Gloria* had made at the Royal Academy summer exhibition of that year, fell back on the familiar polarities of light and dark which were commonly used to describe the tribal rites of the Spanish:
The forms of the features are finely chiselled; the nostrils are full, as for the free outburst of passion's breath, and the black piercing eyes dart from their shadowed orbs the devil's fire. A girl in the centre of the group, the belle of the ball, with the witchery of Art and

nature, points the fantastic toe, raising with one hand her free and easy dress, and in the other holding in triumph the hat which she has snatched from the head of her companion in the dance.[26]

Phillip was able to articulate what Velázquez meant to him through brushwork. Ironically, however, it took a failed painter who tried but could not reach Phillip's level of understanding, to reveal in print not on canvas, what made Velázquez so special. R.A.M. Stevenson (1847–1900), cousin of Robert Louis, was a well-connected member of the international avant-garde. 'Bob' Stevenson's paintings are dull and meagre, but he succeeded abundantly as a critic when he published his *The Art of Velasquez* in 1895. It remains arguably the finest book in English on the painter.

Stevenson's *Velasquez* was something of a prose poem and utterly different, but no less influential, than another work, which also must be consulted to this day by any student of Velázquez. In 1889 the English translation of Carl Justi's *Diego Velázquez und sein Jahrhundert* (1888) appeared. At once, Justi superseded Stirling whose *Annals*, already referred to, had been the authoritative text on the artist for the previous half century. A work of the advanced German School of art history, Justi's *Velázquez* demonstrated those exacting standards of scholarship, analysis and reliance on documentation, which the relative backwardness of the discipline in Britain could not hope to match. Justi's methodology, as demonstrated in translation, was different from anything else in English on Velázquez, freer as it was from subjective judgement and anecdote.

The quest for Velázquez in these last years of the nineteenth century was also pursued through the practice of painting. Sargent had registered as a copyist at the Prado in 1879, and twice, in 1891 and then again in 1892, when Lavery was working there too. If there was one canvas which might summarise the ambitions and expectations provoked by this intense absorption with Velázquez, it might be Lavery's *R.B. Cunninghame Graham* of 1893 [96]. Perhaps it was because the novelist John Galsworthy and the sculptor Jacob Epstein thought of Cunninghame Graham as 'the modern Don Quixote' that in 1902, William Strang (1859–1921) etched him as the eponymous Spanish hero.

Robert Cunninghame Graham (1852–1936) was the first writer in English to take a sustained interest in Spanish South America since the Lakeland poet Robert Southey. Cunninghame Graham's marked sense of his own patrician credentials,[27] his friendship with Lavery who venerated Velázquez, and their shared sympathy for Spanish culture, all seemed to suggest the portrait by Lavery needed to be in a style which, to those in the know, would locate it in the Spanish Golden Age.

Growing sympathy for an understanding of Spanish art by British painters did little to dispel a long held belief that Spain was a country of lust, violence, and hypocrisy, with a religion that had more to do with hysteria than charity. As for the lighter, more sensual side of that society, the 'Spanish Maid' had tended to be seen either as available and unusually good at sex, or cast as a latter day Andromeda who was urgently in need of rescue from the dragon of religious bigotry. One of the most celebrated expressions of such a volatile mixture was Millais' *The Escape of The Heretic, 1559* [11] where melodrama recalls a bad school play.

Stirling and Ford, both important to the moulding of British attitudes to the Iberian Peninsula, were only two of many celebrated British visitors to the country who had multiple casual sexual liaisons, something for which the country was famous. However, there was too, the altogether more high-minded if patronising attitudes which Wordsworth, especially, had adopted. People of this persuasion believed the Spaniard to be an endangered species and a type to be protected rather than exploited. A century later, such a curious compound of superiority and condescension surfaced once again. It was exemplified in the flight from Britain of Gerald Brenan a novelist and historian of Spain, whose tracking of the violent trajectory of the country, many in Britain found illuminating.[28] He took a perverse pride in locating himself in an austere and implacable terrain, as if this could inoculate him from European civilisation. From his wilderness, Brenan conducted a complicated affair with the Bloomsbury painter, Dora Carrington; a liaison about which Brenan later reminisced to the novelist V.S. Pritchett: 'I was as proud of my affair with her as I was of having been in the line at Passchendaele.

The tears I shed for her were, I thought my true medals.'[29] History does not record whether the encounter was as violent, but we do know that for her part, Carrington also fell in love with what she described as 'the yellow oxhide land' of Granada. In Spain she painted some of her best landscapes [111]. There she was able to escape some of the whimsy of her English views. Her work was clearly indebted to El Greco but to judge by the glandular qualities of her hill tops, and the insistently empty landscapes, she was also influenced by the subversive thoughts of Freud on sex and the dream.

The contested relationship between Spain and Britain had always been a perennial source of inspiration for writers, whether they were Jacobean playwrights or successful popular historians of Victorian Britain. Of the latter, the most dominant had been James Anthony Froude with his best-selling *Spanish Armada*, or his altogether more challenging *History of England from the Fall of Wolsey to the Death of Elizabeth*, the latter appearing in twelve volumes between 1856 and 1870. In no sense can Froude's monument be described as either a history of England, or for that matter, an objective account of the Tudor age. But what it certainly represented was the most influential British version of the *leyenda negra*, or the 'black legend'. In brief, this was the settled belief, subscribed to in Britain and beyond, that Spain had been destroyed by the power of the Catholic church, and its implacable agents such as Philip II. Froude's book is as much an anti-Catholic polemic as it is a dramatic narrative. According to Froude, Britain had risen to the pre-eminence she was enjoying when Froude was writing his contentious history, because she had resisted the destructive genius of Spain as she had championed the Protestant religion.

Froude did not make easy reading for Cardinal Nicholas Wiseman. Wiseman was a Spaniard through and through. As an infant, offered to the priesthood by a pious mother on the high altar of Seville Cathedral, fluent in Spanish, Wiseman came to be charged with reintroducing the Catholic hierarchy into England in 1850. Wiseman's chief relaxation was the writing of art criticism;

Murillo was his favourite painter.[30] He wrote a long review of Stirling's *Annals*, but it was Wiseman's occupancy of the newly created Catholic archbishopric of Westminster rather than his skills as an art critic, which had lasting effects in creating an awareness of Spanish design. The debate to which he contributed was on-going within the Catholic hierarchy and indeed, in the Protestant Ecclesiological Movement, as to the appropriate style for churches. All this helped stimulate an interest in buildings other than Italian. Concurrently, the argument arose as to what was to be put inside new churches, whether Catholic or Anglo-Catholic. Out of this developed the first scholarly

contribution to a British understanding of Spanish architecture. George Edmund Street, architect of the Law Courts on the Strand in London, and pupil master of William Morris, published in 1865 his survey of Spanish architecture, *Some Account of Gothic Architecture in Spain*. It was an important contribution to a burgeoning interest in Spanish architecture within Britain and it was dedicated to the prime minister, W. E. Gladstone.

A new found interest in bricks and mortar, stained glass and iron work, was sustained thereafter by the most extraordinary of all British ambassadors to Madrid. When still in his twenties and at Mosul in modern day Iraq, Sir Austen Henry Layard (1817–1894)

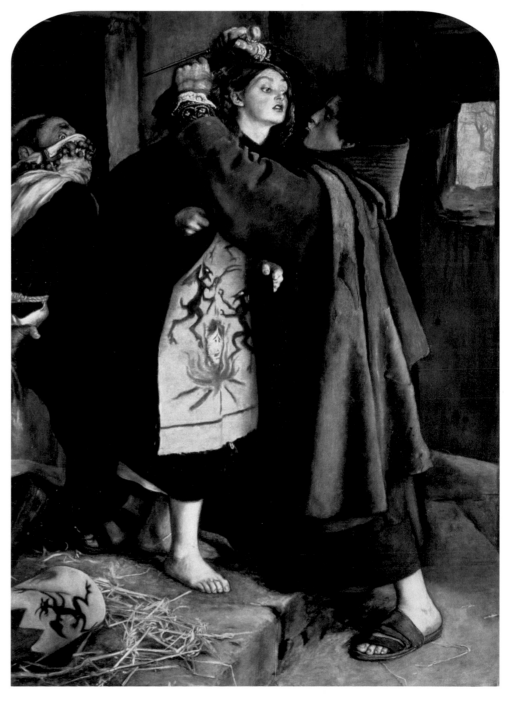

11 Sir John Everett Millais
The Escape of the Heretic, 1559, 1857
Museo de Arte de Ponce, Puerto Rico

had unearthed Nineveh or ancient Babylonia – an astonishing archaeological revelation. In 1871 Layard had become ambassador to Spain. He took a leading Spanish painter, Mariano Fortuny under his wing; he persuaded Sir Henry Cole, the first and greatest director of the Victoria and Albert Museum, to order casts of the best of Spanish ironwork; he summoned the great Italian connoisseur Giovanni Morelli to sort out the early Netherlandish paintings, then neglected and unhung in the Prado; he wrote an important article on Velázquez, and less happily, suggested the dome of St Paul's be lined with Spanish *ajuzelos*.[31]

The British of the next generation had a less earnest view of the country. For them it was not the revelation of the icons of Spanish art which attracted, but with painters, at least, the light which had an especial appeal; the sierra was an altogether more challenging environment than the allotments of the Seine, so beloved by the Impressionists. Arthur Melville and William Nicholson were the first artists to define extremes of Spanish heat and light in a country rather than urban context as in Melville's *Contrabandista*. Whereas Roberts and Lewis never seem to have strayed far from a mosque, for artists of this generation, the comforts of the city were exchanged for the desolation of the plains.

The English artist Edward Burra was profoundly influenced by Spain. The country set Burra's art on a new course. He first visited in 1932 with the novelist Malcolm Lowry. Burra was predisposed to the carnivalesque and the brutish, and so it was entirely predictable that he should have become deeply interested in the Spanish Civil War of which he witnessed only the overture. It was to be 'interest' not commitment. Burra left before the fighting started, and although he never became engaged like Orwell, it provoked a strong emotional reaction. Burra shared the age-old belief that Spain was somehow different: as if no one south of the Pyrenees had heard of Freud, and no one dared think God might not exist. The events of 1936–39, confirmed for Burra that Spain was a country tyrannised by authority. Insistent outrages committed by Falangist and Communist alike, fuelled Burra's long held interest in the effects of war, not only on civilisation, but also civilised behaviour. The more surreal excesses of a Spanish 'Holy

Week' inclined Burra to express religiosity in terms of El Greco, whilst the theatre of war itself, drew Burra subliminally to Goya. Goya had begun life painting picnics but moved on to disembowelled soldiers, while Burra started with Josephine Baker dancing in twenties Paris, only to graduate to depicting a nation waiting for disintegration. Such altogether more sombre imagery would be shown at an important exhibition of his work held at the Redfern Gallery in London in 1942.

The Spanish Civil War divided the English-speaking world, though the intelligentsia were for the most part on the side of the Left and for the most part indeed, wholly ineffective. It was a point made retrospectively by Arthur Koestler (1905–1983). Koestler unlike most foreign intellectuals, had actually faced imminent death, which in his case was by firing squad. This justified him in remarking that in the Spanish Civil War, Bloomsbury and Greenwich Village had gone 'on a revolutionary junket'.

The painter Wyndham Lewis whose sympathies, like his friend the poet Roy Campbell, were pro-Fascist, saw the war through the fractured prism of Futurism. Lewis's most famous response, his *Surrender of Barcelona* [128], has a panoramic medievalism about it which recalls Ambrogio Lorenzetti's celebrated fourteenth-century picture *Good and Bad Government*. It is remarked in a later essay that for Lewis, the Spanish Civil War evoked a chivalric world: in his painted responses soldiers appear dressed in suits of armour. Curiously enough, John Maynard Keynes, most famous as an economist but celebrated too as a critic of the arts, saw the conflict in terms of chivalry; something which outsiders commonly believed to have been beaten into the Spanish character on the anvil of the *Reconquista*. For others, most notably Orwell, the fighting was the very reverse. It was a slow moving conflict which had more to do with the trenches of Flanders than any latter day crusade.

Inhumanity and a sense of despair about what could be achieved was why W.H. Auden abandoned prematurely the Republican cause after only three months in Spain. Auden had left London for the Aragon front in January 1937, a departure greeted by the *Daily Worker* with the announcement: 'Famous Poet to Drive Ambulance in Spain'. But as Auden was waved off at Victoria Station by the painter

William Coldstream, he did not offer a prayer for his own survival but rather, that he might be spared an unwelcome encounter: 'O I do hope there are not too many Surrealists there.'

In Spain, Auden appears to have had the greatest difficulty finding his ambulance. Roy Campbell, the celebrated South African poet of the inter-war years, who witnessed fierce fighting in Toledo, and afterwards pretended he had actually taken part in it, sneeringly remarked of Auden that 'the most violent action he ever saw was when he was playing table-tennis at Tossa del Mar on behalf of the Spanish Republicans'.[32] But then Campbell was the most markedly Fascist of the significant English speaking 'volunteers' who became involved in the fighting. His embarrassing eulogy of Franco, *Flowering Rifle*, caused him major difficulty for years after the Civil War. But notwithstanding games and a ferociously drunken evening with Koestler, Michael Kolzov the Spanish correspondent of *Pravda*, and a Romanian pilot with a gammy leg, the experience of the Spanish Civil War had unexpected consequences for Auden. He had imagined finding left-wing sympathies reinforced but instead, paralysis set in, to undermine belief in direct action. As he later confessed, 'I did not wish to talk about Spain when I returned … I was shocked and disillusioned. But any disillusion of mine could only be of advantage to Franco. And however I felt, I certainly didn't want Franco to win.'[33] Auden's awareness of the murder of ten bishops and thousands of priests by the Republicans, actually set in train what would later be a reversion to Christianity.[34] It was a point which he made tangentially in his most famous poetic reaction to his months in Barcelona between January and March 1937. In *Spain 1937* there is a significant allusion to the redemptive possibilities of the Divine:

And the nations combine each cry, invoking
* the life*
That shapes the individual belly and orders
The private nocturnal terror:
'Did you not found the city state of the sponge,

'Raise the vast military empires of the shark
And the tiger, establish the robin's
* plucky canton?*
Intervene. O descend as a dove or
A furious papa or a mild engineer, but
* descend.'*

And the life, if it answers at all, replies from
 the heart
'O no, I am not the mover,
Not to-day; not to you ...'

Keynes drew attention to *Spain 1937* in *The New Statesman* and focused on its most notorious couplet: 'To-day the deliberate increase in the chances of death; / The conscious acceptance of guilt in necessary murder'. Here Keynes declared that Auden was 'speaking for many chivalrous hearts'.[35] It was not a view shared by Orwell, the dominant English speaking literary figure to emerge from the Spanish cataclysm, and a British writer for whom the Spanish Civil War actually enhanced a literary reputation. Orwell writing in the *Adelphi* in December 1938, when it was clear the Republican cause was doomed, misquoted the lines cited by Keynes, and then went on to suggest that 'the acceptance of guilt *for* the necessary murder' exemplified the lethal combination of the 'gangster and the pansy'. By this Orwell perhaps meant the dabbling by ineffectual intellectuals with manic ideologues, keener on murdering each other than the enemy.

The prolific novelist Norman Lewis was a quite different observer of the gathering storm. The unlikely owner of a successful camera business at 202 High Holborn in London, Lewis came to work as a spy for MI5, and later with the encouragement of Ian Fleming, for the CIA. In 1935, Lewis's *Spanish Adventure* was published. The book reflected his experience of seeing Spain disintegrate in the months before the Civil War. It has been suggested that it was Lewis's refusal to take either the violence or the politics seriously, together with a capacity to coolly appraise what was happening when in considerable personal danger, which qualified him to become an agent.[36]

So much for the differing responses by British authors to the Spanish trauma, but what was the effect on British collectors of the turmoil represented by Picasso's work? There was more interest in Britain in collecting Picassos than has been appreciated hitherto.[37] The influential critic Douglas Cooper famously created an orthodoxy about the critical reception of Picasso by once declaring that in England, 'where Augustus John was still more highly valued than Matisse and Picasso, no collectors of true cubist painting existed either before or

after the War'. This sweeping generalisation, which helped to create the belief that Picasso was 'absent' in Britain, has recently come to be challenged. There were around 130 of Picasso's works in British collections by 1940. Some were as good as anything then to be found in America, where Picasso's impact on collectors was far more profound.

Nevertheless, it is true that the discovery of Picasso in Britain had been slow. It had begun predictably enough, with Bloomsbury as pathfinders, and especially with its taste maker, Roger Fry. Fry mounted the celebrated *Second Post-Impressionism Exhibition* in London in October 1912. There, eleven Picassos had been for sale. Although Fry's gallery window had helped certainly to introduce Picasso to a British clientele, it was only in the 1930s that a sustained interest really got underway: of the 130 works estimated to have been in British collections before the Second World War, 110 were acquired in that decade. Then and only then, did British collectors become positive about Picasso's cubist period. But even though there was a real appetite in Britain for acquiring Picasso's work during the years of the Spanish Civil War – and the fact that Picasso was a Spaniard publicly committed to the *Socialist International*, did him no harm among left-wing intellectuals – his work was seen, not directly, but in a borrowed light. What lead to an enthusiasm for cubist Picasso was the consensus that he had been a spiritual father to Surrealism, and Surrealism long before Picasso, was something that many in Britain had felt an affinity with. But although the route to Picasso was indirect, it has been remarked of the holdings of Picasso belonging to Cooper (over 100 works), and the great apologist for Picasso in Britain, Roland Penrose (sixty works), that 'had they remained intact, Britain would have been able to boast some of the greatest and largest collections of Picasso's art in the world'.[38]

In contrast to the insouciance of Lewis, the triumphalism of Campbell, the dithering of Auden, and the voyeurism of Burra, George Orwell was wounded for Spain. Shot through the neck by a Fascist sniper while at the front outside Huesca, miraculously he survived to write *Homage to Catalonia*, which was published in England in April 1938. It was a book which established in the British literary imagination an association between

its author and Spain no less powerful than that which had then existed for over a century between Lord Byron and the cause of Greek independence. There was a profound difference, however. The story of Greece was one of romance for British writers, but that of Spain, one of corruption, disillusionment and squalor. Orwell believed the reason why the fighting had such a fascination for the British was that it was like the Great War: 'a positional war of trenches, artillery, raids, snipers, mud, barbed wire, lice and stagnation'.[39]

Orwell's book, the most famous British response to the Spanish Civil War, was a record of the trauma of his experience. However, one of the dilemmas raised by *Homage to Catalonia* is to decide which is more powerfully scrutinised, the death of the Spanish Left or the writer's ideals. Whatever the truth, and truth was for Orwell a casualty of the Spanish Civil War, the title page carries an extract from the twenty-sixth chapter of the Book of Proverbs:
Answer not a fool according to his folly, lest thou be like unto him.
Answer a fool according to his folly, lest he be wise in his own conceit

Orwell was famously acerbic, and it is hard to know if this inscription refers to the sufferings the Spanish imposed upon themselves, the wholesale misconception the British had about the Spanish Civil War, or the timeless folly of mankind that Goya, for example, had expressed so powerfully. In *Homage to Catalonia*, Orwell was intent on exposing folly, rather than imagining the grief which Picasso expressed vividly in his *Weeping Woman* [127]. No one was more aware than Orwell that British attitudes to Spain often contained their own confusions. Many who loved the country carried with them a settled conceit about the place. About Spain, the British might be said to have been wise in their own conceits, but as this essay has attempted to suggest, no less various in their discoveries.

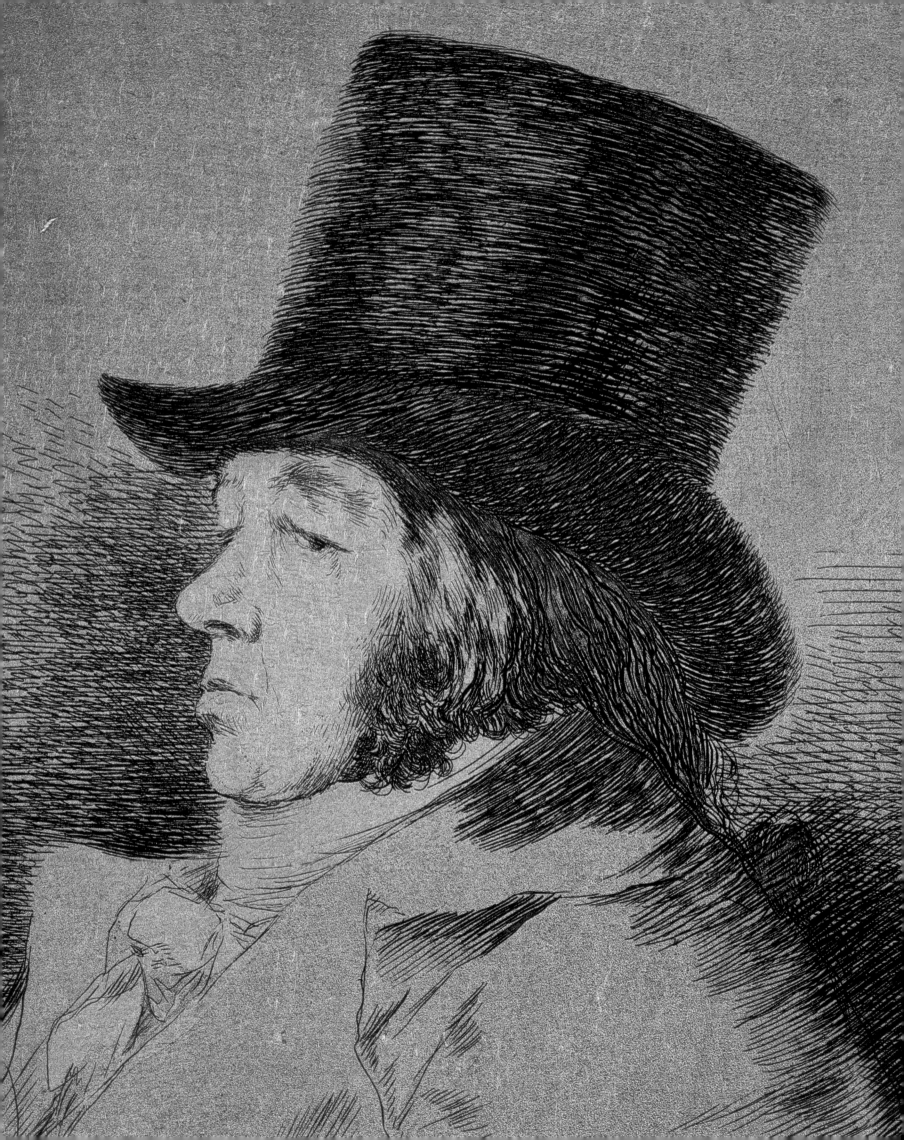

1

THE AGE OF GOYA
NICHOLAS TROMANS

In Spanish history, the phrase 'The Age of Goya' conjures an image of disaster under the guise of victory. Francisco de Goya, although a court painter at Madrid, was closely associated with the French-influenced progressive Spanish intellectuals known (after the notion of Enlightenment) as *los ilustrados* [12]. A maker of sometimes flattering aristocratic portraits and of designs for palace tapestries, Goya was also the author of a collection of etchings titled *Los Caprichos*. These satirised the surviving superstitions of the Spanish people and the interdependence between such ignorance and the maintenance of power by the royal family and the church. The prints were removed from sale within days of their publication in 1799, censorship symptomatic of the new cultural atmosphere that prevailed in Spain following the French Revolution and the ensuing Terror at Paris, and wars between the new French Republic and its neighbours – wars which were to be prolonged under Napoleon Bonaparte's empire until the Battle of Waterloo in 1815.

Goya himself continued to create ever more imaginative and original, sometimes fantastic and terrifying images, but largely withdrew from public life. His appallingly honest etchings of the War of Independence fought in 1808–14 between the Spanish people (*pueblo*) and the occupying French army [22–5] remained unpublished until well after the artist's death. The related large paintings of the rising of the people of Madrid against the French in May 1808, painted in 1814 for the newly restored absolutist King Ferdinand VII (Prado, Madrid) failed to please. In the 1820s, as the political climate in Spain entered new extremes of reaction in response to a Liberal coup, Goya went into voluntary exile in France. Spain had won its War of Independence against the French

usurper: but at what cost? The cost was, at least to Goya, of having to watch the virtual extinction of *los ilustrados* and their legacy in Spain. His friend, the poet Juan Antonio Meléndez Valdés [29], who had accepted office under the French occupation along with other *ilustrados*, in wistful affection for the French tradition of Enlightenment, had narrowly escaped being lynched as a traitor. And as for ordinary Spaniards beyond Goya's well educated and articulate circle, the artist depicted them, in his *Disasters of War*, in their worse-than-bestial encounter with the soldiers of that same France which had promised to bring its reforming spirit to the rest of the world.

Goya returned briefly to Spain from France in 1827, and left his native country for the last time in the autumn of that year, passing through the French town of Bayonne near the border in late September. Although neither knew, simultaneously heading in the opposite direction was the Scottish painter Sir David Wilkie; the two passed through Bayonne within days of one another. Some forty years Goya's junior, Wilkie was embarking on the last phase of a three-year residence on the Continent. An internationally famous painter of genre pictures, Wilkie had scored the greatest triumph of his career in 1822, with an intricate scene of military pensioners in London receiving news of the Duke of Wellington's defeat of Bonaparte at Waterloo (Apsley House, London). Painted for the duke himself for a huge fee, the *Chelsea Pensioners*, with its suburban setting far removed from the action itself, contrasts almost grotesquely with Goya's images of the sadistic butchery of the struggle against the French in Spain. We might then be tempted to see something symbolic in the exchange of painters near the French–Spanish border

12 Francisco de Goya
Self-portrait (detail), 1797
National Gallery of Scotland, Edinburgh

in 1827. Spain lost a fearlessly honest witness to its own degradation, and gained in his place a foreign artist who would allow a more picturesque version of Romanticism to colour his vision of Spain.

Wilkie remained for several months in Madrid, visiting Andalusia in April 1828. Although surely he must have encountered Goya's work in Spain, he never mentions it in his known letters and journals. There are, however, several points of indirect contact between the two artists. The London merchant Samuel Dobree was one of Wilkie's early patrons, the owner of the *Letter of Introduction*, 1813 (National Gallery of Scotland, Edinburgh), Wilkie's image of an Enlightenment scholar finding himself ill at ease in the nineteenth century. But Dobree was also an exceptionally early British admirer of Goya, even composing his own commentary on the *Caprichos*, in the form of captions to each plate.[1] Dobree may well have shared his enthusiasm with Wilkie: but we do not know. Wilkie and Goya certainly shared a patron in the Duke of Wellington, who had led British forces against the French in Portugal and Spain in 1808–14. Goya and Wilkie each completed three oil portraits of the duke: Wilkie's executed in the 1830s, but Goya's dating from 1812 when Wellington was temporarily in control of Madrid. The picture now in the National Gallery in London [18] is a remarkably intimate image given the great drama of its political context – as if Goya were hoping to find some trace of humanity in the soldier who was perhaps in a position to help end Spain's agony. Wellington's decorations, some of them apparently added later by Goya, partially deflect our attention from the man wearing them, but Goya's initial preparatory red chalk drawing (from which the artist possibly also intended to derive an etching) gives the sitter a sensitive, even melancholy air [17].[2]

In London in 1812, Wilkie had been caught up in the patriotic excitement around the British army's successes against the French in Spain (victories on land, in comparison with those at sea, had been slow in coming). To an amateur artist friend he suggested that 'if any of our landscape painters were to go out to Spain and bring home … a picture of the country round Salamanca or even rub in the air and smoke of a successful engagement on the spot, he would make his fortune.'[3]

Although it was to be fifteen years before Wilkie himself entered Spain as something of a pioneer among professional British artists, in 1827 his mind was still concentrated upon the history of what the British called the Peninsular War of 1808–14.[4] Very soon after his arrival at Madrid, Wilkie was planning what eventually became a quartet of paintings recording the guerilla uprising against the French: a picturesque celebration both of 'Spanishness' and, indirectly, of a victorious campaign for the British army in which the guerillas were seen as, in effect, irregular reinforcements. In all four pictures the *pueblo* are seen as being inspired by Catholic clergy to repulse the French invaders. In the *Spanish Posada* [13] stock Spanish regional types gather at an inn to form a guerilla council of war chaired by a monk. In the *Guerilla's Departure* [19] it is a priest who lights the peasant fighter's cigar, the symbolic fuse of the revolt, while a barely clothed child in the foreground has been remembered by Wilkie from pictures by the Spanish painter Murillo. And in the *Defence of Saragossa* [21], representing one of the mythic moments of heroic resistance of the war, a friar directs the cannon with his crucifix.

The Defence of Saragossa, a picture which seemed to mark so drastic a change in Wilkie's style to London audiences when exhibited in 1829, forms another intriguing link between Goya and Wilkie. The city of Saragossa, near which Goya had been born, was besieged and largely destroyed by the French army in 1808. Goya travelled back to the city in that year to make studies of its heroic defence at the invitation of its commander, the local aristocrat, General José de Palafox. But the subsequent drawings were apparently destroyed by French soldiers, and from 1809 Goya began working instead on the far less ennobling imagery of the *Disasters of War* etchings. The most – perhaps the only – optimistic print among the *Disasters*, however, refers directly back to the siege of Saragossa. *Qué valor! (What courage!)* [22] represents a young woman firing a cannon, alluding to the legendary moment when Agustina Saragossa y Domènech, the 'Spanish maid' as the poet Lord Byron called her, stepped up to light a gun after its crew had been killed.[5] This is the same subject taken up by Wilkie in his *Defence of Saragossa*, although he would have

had Byron's not Goya's image in his mind. Wilkie also includes a portrait of Palafox, dressed not in uniform but as a civilian volunteer, painted from life after the artist was introduced to the celebrated old hero by a friend at the Russian embassy. Would Palafox have told Wilkie how glad he was to see Goya's plans for pictures celebrating the Spanish resistance finally being carried out? What for that matter would Goya himself, who died at Bordeaux in April 1828, have made of Wilkie's war pictures had he been able to see them?

The military category of the 'guerilla' was coined during the War of Independence to describe the surprise attacks by irregular fighters upon the French army (literally it means 'little war' and in Spanish the fighters were *guerrilleros*). What they represented – the spontaneous uprising of the poor against the foreign invader – meant that their political image was dramatically ambivalent. In Britain, their appearance was greeted by Liberals such as Lord Brougham as heralding the legitimate return of 'the people' to the world stage, and as such, heralding the imminent arrival of democracy elsewhere in Europe, including Britain.[6] However, Tories such as Sir Walter Scott were scandalised at this interpretation. Scott himself offered an alternative characterisation of the guerilla as akin to the Scottish Highlander – an individualistic warrior, ferocious in the defence of the political establishment. In Spain itself, the guerillas' role in the war was welcomed by anti-French nationalists of different political hues, but what was to be their fate after the ejection of the French and the restoration of King Ferdinand? The Ultras who now surrounded Ferdinand feared that a poor man who had taken up arms might, after all, get used to the idea of having a role in history. One of the most famous of all the guerillas of the 1808–14 war, Juan Martín Díez ('el Empecinado' – the stubborn one), had his portrait painted by Goya soon after the end of the war (private collection) and was celebrated in a painting of 1822 by the British military artist Denis Dighton.[7] But Martín went on to take part in the 1820 Liberal coup and was subsequently executed following Ferdinand being restored to his throne for a second time in 1823.

Against this background, we can see how well Wilkie's pictures of the War of

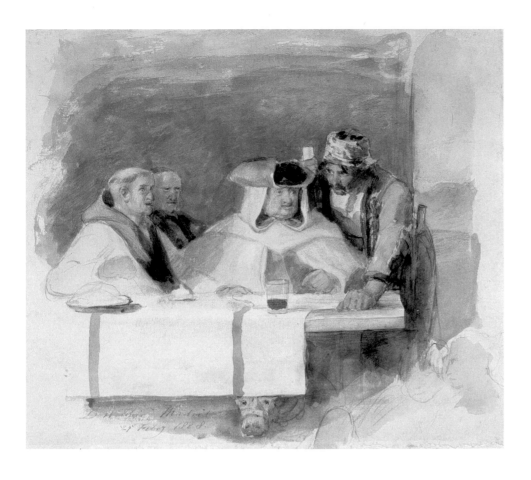

13 Sir David Wilkie *Study for 'The Spanish Posada: A Guerilla Council of War'*, 1828

National Gallery of Scotland, Edinburgh

14 Sir David Wilkie *Study, perhaps for 'The Spanish Mother'*, 1828

Ashmolean Museum, University of Oxford

Independence fitted the conservative vision of the guerilla as an ordinary working person led to war by patriotism and the clergy, rather than by any grievance based upon politics or social class. As Wilkie's pair of subjects of a guerilla's departure and return [19, 20] seems to suggest, if the clergy can light the fuse of revolt, they will also be there to lead the fighter safely back to his place in a well ordered social hierarchy once the fighting is over. In London in 1829, although the art critics were cool, George IV showed his support for Wilkie's version of European history by buying all three of the completed Spanish subjects and commissioning the fourth, the *Guerilla's Return*. Such patronage suggests how important this latter theme of the return to the *status quo ante* was to a monarch's scheme of things. Already, while still in Spain in 1828, Wilkie's war subjects had gone down very well with the grandees of Ferdinand's court at Madrid. The regime that had brought back the Inquisition and persecuted the Liberal heirs of the *ilustrados* could enjoy in them an account of Spain's recent history in which church and *pueblo* had united, as if through the sheer force of nature, to oust the foreigner.

The war pictures were not Wilkie's only Spanish subjects. At Madrid he had fallen in with the American author Washington Irving who was gathering material for his *Life and Voyages of Christopher Columbus* (1828) and *A Chronicle of the Conquest of Granada* (1829). A large painting of a scene from Irving's biography of the explorer, sharing the basic compositional idea of the *Spanish Posada*, was eventually shown by Wilkie in London in 1835 (North Carolina Museum of Art). In 1834–5 Wilkie also exhibited a couple of female Spanish subjects, *The Spanish Mother* [27], based on a drawing made in Seville [14] and *Sancho Panza in the Days of his Youth* of 1835. Ironically, both pictures were inspired, not by any Spanish painting, but by figures in an altarpiece at Parma by Wilkie's beloved Italian Renaissance master Correggio, his *Madonna della Scodella*. Parallel and perhaps equal to Wilkie's attention to the political history of Spain had always been his determination to seek out the Italian paintings collected by the Spanish court in the sixteenth and seventeenth centuries. These he studied in the newly established Prado at Madrid and

at the Escorial outside the capital. Intrigued also by Spain's own painters, Wilkie was on the look out for pictures for sale: particularly portraits by Velázquez which the future Tory prime minister, Sir Robert Peel, wanted to add to his collection. After Wilkie's return to London in the summer of 1828, the first of his friends to be inspired by Wilkie to make his own journey to Spain was not another artist but a picture-dealer, William Woodburn. Woodburn managed to acquire at least one of the pictures attributed to Velázquez which Wilkie had been offered but had left behind (*Prince Baltasar Carlos in the Riding School*, Wallace Collection, London).

British professional artists only began to arrive regularly in Spain in the 1830s. Washington Irving's *Tales of the Alhambra*, a collection of stories of different inhabitants of the Moorish palace at Granada over the centuries, published in 1832 and dedicated to Wilkie in fond memory of their time together in Madrid and Seville, prompted several publishers and painters to turn their attention to Andalusia in particular. The region became a lucrative source of novel pictorial material to feed the home markets for pictures, prints and illustrated books. David Roberts and John Frederick Lewis both set off on separate tours in 1832, producing images which now risk seeming bland, so thoroughly did their iconography establish itself as part of the staple of nineteenth-century European *espagnolisme*. But beyond the *majas*, Moorish architecture, bullfights and clerical costumes, Lewis, at least, also sought to return to the historical themes developed by Wilkie. In 1836–8, Lewis worked on a series of ambitious exhibition pictures, executed largely in opaque watercolour or gouache, which described events of the Carlist War.[8] This conflict was sparked by the death of King Ferdinand in 1833, which precipitated a struggle for the succession between supporters of the king's daughter, Isabella (known as Cristinos after her regent mother María Cristina), and those of Ferdinand's brother Don Carlos. The Carlists, who refused to acknowledge a female succession, were perceived to come primarily from the more conservative parts of Spanish society – especially the regular clergy (that is, monks and friars) and the populations of the Basque region and Navarre in the north of the country.

To much of Europe the Carlists seemed to

fit the mould of the guerillas of the previous generation: priest-led peasants fighting an apparently hopeless battle against the forces of the nominally Liberal state. But now their enemies were not the French but fellow Spaniards. The different sides in this Spanish civil war each had foreign supporters as passionate as those who were to volunteer to fight in Spain in the Civil War of the twentieth century. The charismatic leader of the Carlists in the north, Tomás Zumalacárregui, in particular became the focus of something of a personality cult, and appeared in Lewis's untraced picture of *A Spy of the Cristino Army brought before the Carlist General-in-Chief*. The war was notorious for its cruelty, with scant quarter being granted by either side, and this again appeared to echo the wretched barbarity of the War of Independence. As Richard Ford, the leading British hispanophile and former patron of Lewis in Spain in the early 1830s, put it in the title of the pamphlet he published against British intervention in the conflict, there was an 'unchangeable character' to a war in Spain.[9]

In his *Pillage of a Convent in Spain*, 1837, Lewis picked up another theme in which Wilkie had been interested: the arrogance of the modern Liberal state in appropriating, for new museums, works of art from their traditional custodians. The picture shows Cristino soldiers forcibly removing works of art from a monastery. We presume the monks are supporters of the Carlists and that the paintings are destined for one of the new state galleries established in the 1830s. (Napoleon's army had set the pattern for this process by pillaging hundreds of pictures and other artworks during their occupation of Spain.) Lewis focuses on the fate of a version of one of Murillo's favourite subjects, the Immaculate Conception, and in a related contemporary work, he depicted Murillo in a convent, painting a Sevillian girl of the *pueblo* as the Virgin (Minneapolis) – an idea later reprised by John Phillip in his *The Early Career of Murillo*. The implication is that Murillo's art grew naturally from its roots among the *pueblo* and their clergy, and that its removal from them by the modern state represented its deracination. The culmination of Lewis's Carlist war subjects was to have been a highly complex image, which was later referred to as *The Proclamation of Don Carlos* [15, 16]. It would have showed the announcement of the pretender's claims to a celebrating audience of working people (or perhaps the beginning of his march on Madrid in May 1837), but was never completed. As if to return the old masters to the people, Lewis seems to have planned to base his composition on a painting by Rubens recently acquired by the National Gallery in London, *St Bavo Receiving the Monastic Habit*.

15 John Frederick Lewis
Study for 'The Proclamation of Don Carlos', c.1836/8
Ashmolean Museum, University of Oxford

16 John Frederick Lewis
Study for 'The Proclamation of Don Carlos', c.1836/8
Ashmolean Museum, University of Oxford

17　Francisco de Goya
Arthur Wellesley, 1st Duke of Wellington (1769–1852), 1812
The British Museum, London

18　Francisco de Goya
The Duke of Wellington, 1812–14
National Gallery, London

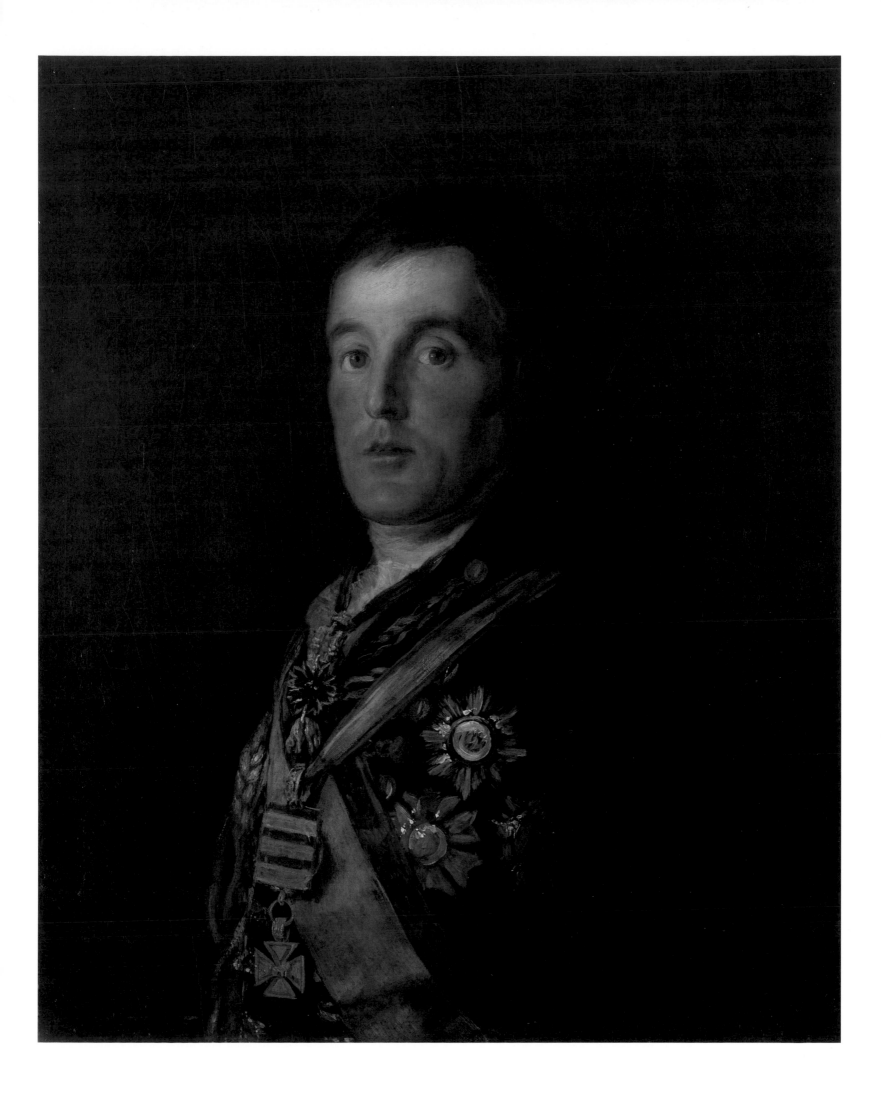

19 Sir David Wilkie
The Guerilla's Departure, 1829
The Royal Collection

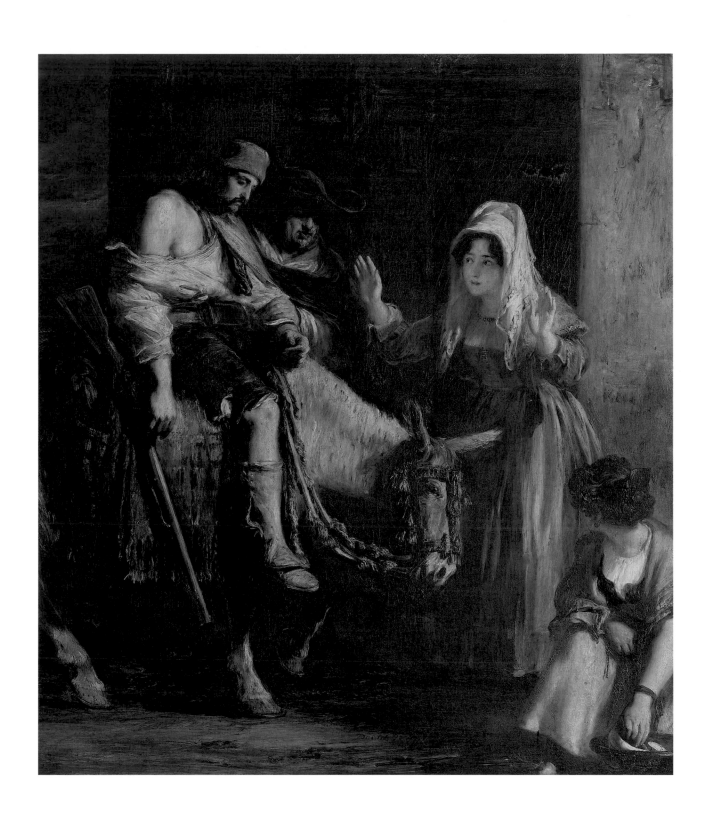

20 Sir David Wilkie
The Guerilla's Return, 1830
The Royal Collection

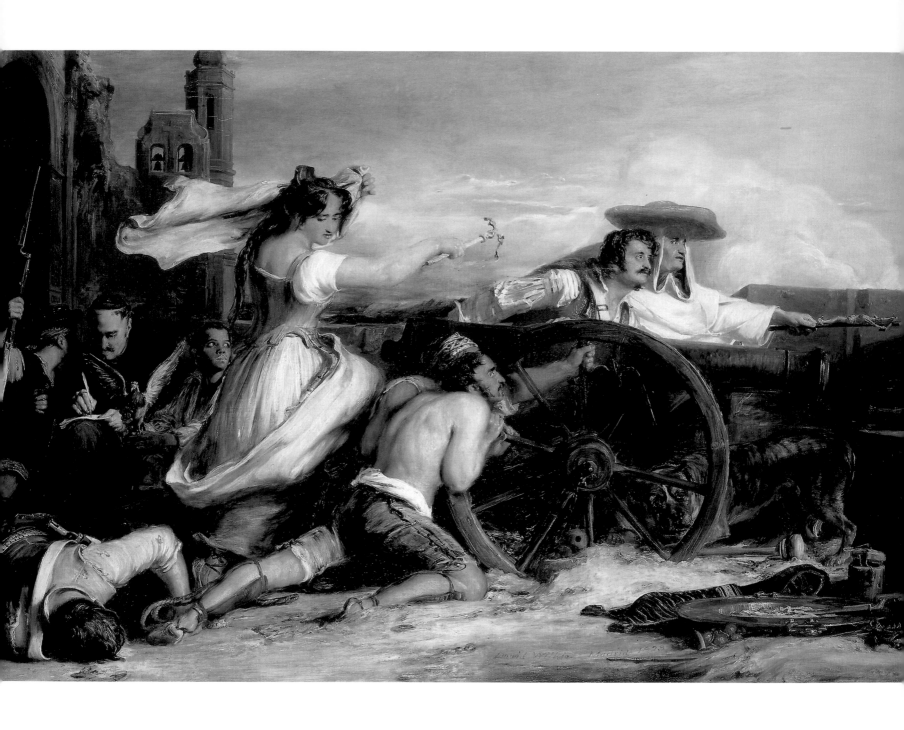

21 Sir David Wilkie
The Defence of Saragossa, 1829
The Royal Collection

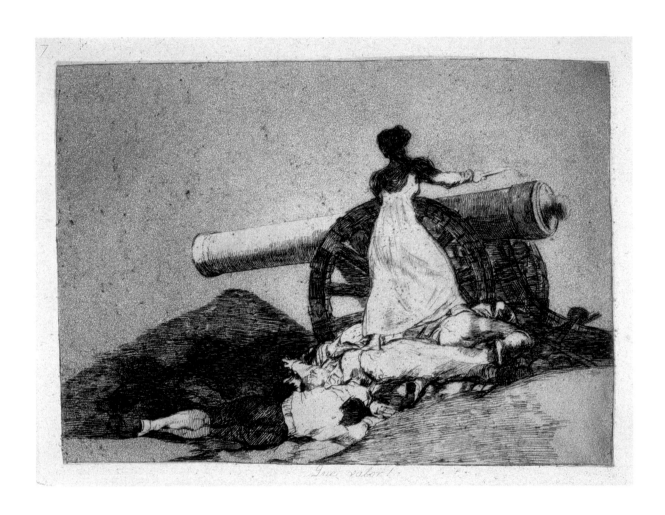

22 Francisco de Goya
Qué valor! (What courage!), plate 7 of *Los Desastres de la Guerra (The Disasters of War)*, 1809–14
National Gallery of Scotland, Edinburgh

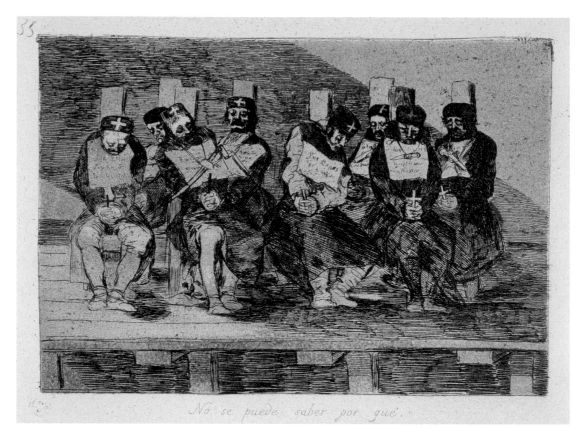

23 Francisco de Goya
No se puede saber por qué (One can't tell why), plate 35 of *Los Desastres de la Guerra* (The Disasters of War), 1809–14
National Gallery of Scotland, Edinburgh

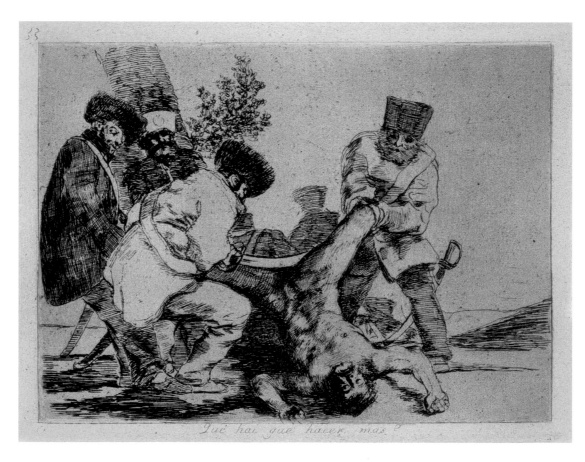

24 Francisco de Goya
Qué hay que hacer más? (*What more can be done?*), plate 33 of *Los Desastres de la Guerra* (*The Disasters of War*), 1809–14
National Gallery of Scotland, Edinburgh

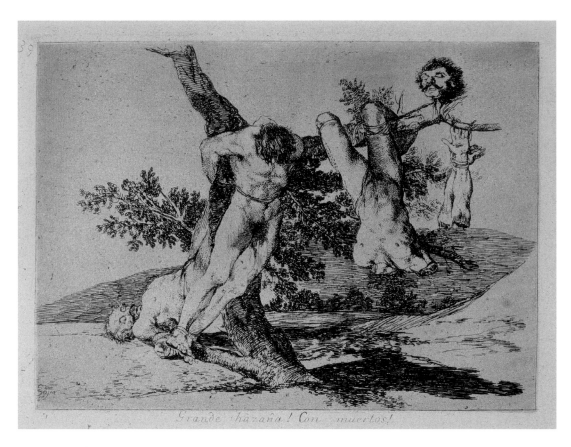

25 Francisco de Goya
Grande hazaña! Con muertos! (A heroic feat! With dead men!), plate 39 of *Los Desastres de la Guerra (The Disasters of War)*, 1809–14
National Gallery of Scotland, Edinburgh

26 Francisco de Goya
Contra el bien general (Against the common good), plate 71 of *Los Desastres de la Guerra (The Disasters of War)*, 1809–14
National Gallery of Scotland, Edinburgh

27 Sir David Wilkie
The Spanish Mother, 1833–4
Private collection

28 Sir Thomas Lawrence
John, Lord Mountstuart
(1767–1794), 1794
Private collection (Mount Stuart)

29 Francisco de Goya

Don Juan Antonio Meléndez Valdés, 1797

The Bowes Museum, Barnard Castle, County Durham

2

THE SPANISH PICTURESQUE
CLAUDIA HEIDE

The dashing full-length portrait by
Sir Thomas Lawrence of John, Lord
Mountstuart is a rare example of a British
sitter posing in a specific Spanish environ-
ment.[1] [28] When it was exhibited at the
Royal Academy, London, in 1795, few would
have been able to identify the setting as the
Guadarrama mountains with the Escorial at
the foot. Travel to Spain was unthinkable for
most. Voltaire, the writer and philosopher,
had stated famously in 1760: 'Spain is a
country we know no better than the wildest
parts of Africa ... [which] does not merit
being better known.'[2] Travel was limited to
merchants, soldiers and a small number of
aristocrats.[3] However, a British army arrived
in 1808 under the command of Arthur
Wellesley, later Duke of Wellington, to join
the Spanish against the Napoleonic army of
occupation. While their joint victory over the
French helped to generate British interest
in Spain, it was the advent of Romanticism,
and a thirst for new, alien experiences which
led to a growing enthusiasm for what was to
be, nevertheless, a carefully manicured view
of the country. A commitment was inspired
by aesthetic notions which largely rejected
the classical tradition and, instead, valued
the unknown, the exotic and irrational; all
of which, so it was believed, could be found
south of the Pyrenees. Spain, unspoiled by
industrialisation, offered Romantics the
chance to discover an unexplored culture.
Travelling was uncomfortable and dangerous,
but to the Romantic on his quest for the
'unknown', Spain was the perfect destination.
The American writer Washington Irving,
there between 1826 and 1828, revelled in it:
*... what a country is it for a traveller, where
the most miserable inn is as full of adventure
as an enchanted castle, and every meal is in
itself an achievement! Let others repine at the*

*lack of turn-pike roads and sumptuous hotels,
and all the elaborate comforts of a country
cultivated and civilised into tameness and
commonplace; but give me the rude mountain
scramble, the roving, haphazard, wayfaring;
the half wild, yet frank and hospitable
manners, which impart such a true game-
flavour to dear old romantic Spain!*[4]

Some who roughed it as part of a 'Spanish
adventure', published travel accounts: rugged
mountains, Hispano-Islamic palaces, for-
tresses, monasteries, cathedrals and people,
dancing gypsies, lean monks and banditti
'armed to the teeth', all offered material to
delight writer and painter alike. The most
notable publication was by Richard Ford, a
brilliant essayist, who made his reputation
out of his three-year stay in Spain between
1830 and 1833.[5] Residing chiefly in Seville
and Granada, Ford immersed himself in
Spanish culture, adopting Spanish dress [46]
and becoming fluent in the language.[6] He
travelled widely: covering over 2,000 miles
between Seville and Santiago on horseback,
sketching and taking notes of places and
people. Ford considered travel in Spain a
means of self-improvement. It would make
a man knowledgeable about the country
and its people: 'impart a new life'; teach
the 'golden rules of patience, perseverance,
good temper and good fellowship', and
'shake off dull sloth'.[7] Ford's learning was
poured into *A Hand-Book for Travellers in
Spain and Readers at Home* (1845), the first
comprehensive guidebook in English. This
offered advice on the best routes and inns,
but also provided extensive information on
history, architecture, painting and sculpture.
Considered a 'great literary achievement' that
had never 'been performed under so humble
a title', Ford's *Hand-Book* became a best-
seller.[8] Its encouraging reception prompted

30 John Phillip *Spanish Boys Playing
at Bullfighting*, 1860–1 (detail)
National Gallery of Scotland, Edinburgh

Ford to transform his shrewd observations of Spain into essays on Spanish customs, society and life, published in 1846 as *Gatherings from Spain*. Ford's special combination of vast knowledge with stylish prose, wit, humour and trenchant expressions of personal prejudice, distinguished his new book from earlier, dry matter-of-fact accounts,[9] and made the idea of travelling to what its author described as 'Europe's most racy country', all the more alluring.

Meanwhile artists had begun to visualise Spain. How did they respond to the physical reality of the Iberian Peninsula? Foremost amongst them was Sir David Wilkie, the distinguished nineteenth-century British painter who visited Spain in 1827. He was the first to sense the novelty value of the country. Wilkie largely focused on history and genre pictures.[10] It was another Scot, David Roberts, a popular topographer, who visualised the terrain. Inspired by Wilkie's earlier trip and driven by what Roberts perceived to

be economic necessity, he had left London in 1832.[11] His nine-month venture was marked by intense work that involved a heavily edited vision in pen, ink, watercolour or oil, of selected Spanish landmarks.

For the most part, such carefully manipulated interpretations of landscapes and monuments were meant to inspire awe in the viewer. Following convention, and drawing on his previous experience as a painter of stage scenery, panoramas and dioramas, Roberts commonly sacrificed topographical accuracy for visually stimulating effect. The manipulation of light, proportions and angles, to achieve dramatic impact or evoke a certain mood appropriate to the subject, is a standard ingredient in Roberts's work. In the *Entrance to the North Transept, Cathedral of Burgos* of 1835 [44], a painting worked up from a watercolour done on the spot in 1832, the artist deliberately selected a low viewpoint. This allowed him to exaggerate the height to achieve effects of insistent verticality with the so-called 'Golden Staircase', a magnificent Renaissance ensemble of stonework and gilded iron. The two sculpted winged creatures seated on the balustrades appear much larger than in reality. Strongly lit from above, they seem nearly as alive as the figures gathering at the bottom of the staircase. The atmosphere is that of grandeur, drama and mystery. From

Burgos, Roberts went on to Madrid arriving there in early December 1832. He visited the Prado and made sketches of street scenes, fountains and buildings, such as the elegant Royal Palace built by the Bourbons [31]. Since Ford was to describe Madrid as a 'city built on several mangy hills that hang over the Manzanares', with dry and icy winds in the winter that pierce 'through flesh and bone to the marrow'[12] it is no surprise that Roberts was not entirely happy,[13] and that in early January 1833, he travelled south to pursue a picturesque vision in the warmer climes of Andalusia and Morocco: Cordoba, Granada, Malaga, Ronda, Tangier, Tetuan, Gibraltar, Cadiz, Jerez and Seville were all on the itinerary. His travels resulted in a large portfolio of sketches, which alternate between microscopic views of buildings and broader panoramas of towns set in beguiling landscapes. Viewpoints were carefully chosen. The dramatic location of Ronda, a medieval town hanging high above the River Tajo, was best rendered from a far distance, so Roberts decided [33]. The bridge, which links the two parts of the town, is seen in another sketch from below to emphasise the height of the canyon. Individual monuments however, such as Seville Cathedral, demanded closer inspection and much more time. Roberts's ambitious interior of Seville Cathedral [32] was painted in situ during the

31 David Roberts
The Royal Palace, Madrid, 1833/5
University of Liverpool Art Gallery & Collections

32 David Roberts
Interior of Seville Cathedral during the Ceremony of Corpus Christi, 1833
The Abbot of Downside

But before Roberts left Seville, a grandee approached him to purchase the Corpus Christi picture, but he refused. He craved for success back home, and so left with all his sketches and canvases. Roberts's *Interior of Seville Cathedral*, first exhibited at the British Institute in 1834, and then at Liverpool, was rated by many as his best canvas. He eventually sold it to his friend Robert Hay for the impressive sum of £300. Roberts's sketches too, proved extremely lucrative. Transformed into engravings, they were published in *The Landscape Annual* in four volumes over several years, together with a text by the travel writer Thomas Roscoe, who had himself toured Spain in 1835.[16] Roberts's lithographs were available separately in coloured sets for the more affluent, and uncoloured for the less. Some 12,000 copies of the 1837 *Annual* alone sold within two months.

festival of Corpus Christi in 1833, at a time when the interior, strongly lit and filled with people, was in all its splendour.[14] Roberts decided to include the 'Dance of the Seises', an ancient ritual consisting of a group of boys performing a minuet in front of the high altar. As a painter, Roberts was delighted, and as a Scottish Presbyterian, bewildered by so much colour, music and dancing in a church. He wrote to a friend that such a ceremony would probably not be allowed 'anywhere else under the name of religious worship. What would my worthy mother think if she saw so many friskin and loupin, "like so many antics in the Kirk." '[15] Roberts had no inclination to understand Spanish culture on its own terms. He frequently made scathing remarks about the Spanish; the clergy in particular whom he viewed with a mixture of bemusement and suspicion. His travels came to an abrupt end when cholera ravaged Seville in September 1833.

But Roberts did not enjoy the field uncontested. He had to compete with *Sketches of Spain and Spanish Character* (1836), a volume of twenty-six lithographs by John Frederick Lewis. These were worked up from watercolours which had been created in Spain during much the same time as Roberts had been in the country. Roberts and Lewis never met in Spain, but had they done so, they would have discovered different priorities. Lewis, as a genre painter, was above all interested in the Spanish people, their customs and manners, an interest that he shared with Ford, whom he had met in Seville in 1832. Like Ford's essays on Spanish character, Lewis's watercolours offer a colourful portrayal of Spaniards as a lively, passionate and sensual people always ready to enjoy themselves. For example, Ford was to observe that music was 'a serious affair' in Spain, especially among the lower classes: 'In a venta and courtyard, in spite of a long day's work and scanty fare, at the sound of the guitar and click of the castanet, a new life is breathed into their veins.'[17] Correspondingly, in *A Fiesta Scene in the South of Spain* [34], Lewis captures the light atmosphere of an

33 David Roberts
Ronda, Spain, 1834
Tate, London

34 John Frederick Lewis
*A Fiesta Scene in the South of Spain,
Peasants Dancing the Bolero*, 1836
Bristol's City Museum & Art Gallery

outdoor gathering with a couple performing a bolero, a dance much admired by foreigners who thought of it as a kind of 'pantomime of love'.[18] Similar figure types recur again in Lewis's *Spanish Fiesta* [41] where a bullfight is the cause of the festive atmosphere. John Ruskin, the Victorian arbiter of taste, thought that Lewis had 'been eminently successful in his seizing of Spanish character' and purchased the painting.[19] Both Lewis and Roberts established their reputation through their complementary but distinct images of an exotic and picturesque country.

The proliferation of Spanish views and travel literature not only made the British aware of Spain, but also had a cumulatively prescriptive effect: travellers now knew what to expect, which sites to visit and in what order. For their part Spaniards began to accommodate themselves to the traveller. By 1850 Spain had become an increasingly popular destination for Britons, some of whom were now equipped with a camera to record views of Spain in the new calotype technique patented by W.H. Fox Talbot in 1841.[20]

The most ambitious photographic survey was undertaken by Charles Clifford, active in Spain from 1850 to 1863. Little is known about Clifford's early years in the Iberian Peninsula: records suggest a hazardous early venture as an aeronaut for an air balloon show in Madrid in 1850. By 1853 Clifford had begun to take views of monumental sites and by 1854, sent work to the Photographic Society in London: by 1857, to the Société Française de la Photographie in Paris. Clifford's photographic career in Spain had educational and moral aims, unlike earlier sets of prints which had been created by British painters working in the country. Clifford's ambitions can be gauged from his preface to his undated *Photographic Scramble through Spain*, a list of 171 photographs

35 Charles Clifford
Puerta del Sol, Panoramic View, c.1857
Museo de Historia, Madrid

36 Charles Clifford
Puerta del Sol, 1862
Victoria and Albert Museum, London

37 Charles Clifford
Canal de Isabel II (Presa del Ponton de la Oliva), 1855
Biblioteca Nacional, Madrid

of sites, intended for the British public. He stated that he wished to record Spain's monuments and preserve and immortalise its impressive past. Many of Clifford's sites were familiar through Roberts, but he also experimented with his own viewpoints, angles and textures to evoke a quite new vision or atmosphere, or to obtain visually stimulating effects.

Clifford's range is much more varied than Roberts. He travelled more widely and photographed little-known places, such as the small town of Orihuela near Murcia, off the beaten tourist track. Commissioned by Queen Isabella II, Clifford went on to compile no less than three albums relating to her official trips to the regions of Spain between 1858 and 1862.[21] Clifford was also interested in modern Spain, which on the whole, British painters of the nineteenth century were not: especially the urban changes that Madrid was undergoing. The hub of Madrid life, the Puerta del Sol, for instance was entirely taken down and rebuilt in 1857–8. Following the example of the French photographer Marville, who had documented the urban development of Paris under Haussmann, Clifford photographed it before and after transformation. His impressive panoramic view of 1857 captures the square with run down buildings and small businesses [35]. Several photographs dated 1862 present the site after its reinvention: a vast square, now lined with monumental buildings, including the 'Grand Hotel de Paris' which confirmed a new Spanish taste for French fashion [36]. Commissioned by the Spanish crown, Clifford also documented ambitious engineering projects, such as the construction (1851–6) of the Canal de Isabel II, which for the first time brought an adequate water supply to Madrid [37]. Clifford's scenes of labour and industry offered a new vision of a country in the process of modernisation. Yet, within the British iconography of Spain, such views remained an exception.

Greater diversity was brought to representations of topography by a younger generation of painters in the 1860s. They arrived with a new approach to landscape, which favoured fresh observation over the artifice of Roberts. Frederic Leighton, a well-travelled artist came first to Spain in 1866. He mainly sketched *en plein air*, capturing the Andalusian landscape in the intense southern light.[22] The Pre-Raphaelite John William Inchbold, adopted a more minute style, to depict two hauntingly realistic views of the flat agricultural land, including farm buildings and peasants near the Valencian coast [49].[23] While both Leighton and Inchbold offered new ways of looking at Spain, neither engaged very profoundly with the country.

By contrast the Aberdonian John Phillip immersed himself in Spanish culture. Phillip visited three times, specifically in 1851–2, 1856–7 and 1860–1; a commitment which earned him the sobriquet, 'Phillip of Spain' on account of his ambitious paintings of customs and manners. Phillip is exceptional since no other artist became so dependent on the country for his success and fame in Britain until David Bomberg. As with Lewis, so too, Phillip's figures are lively, playful and flirtatious. In the tavern scene *La Bomba*, 1863 [47] an attractive woman flirts with a handsome bullfighter, while ignoring an elderly man, who leans over the table, lusting after her. The play of gazes and expressions is as much the subject of the painting as the carefully rendered clothes, especially the glamorous jacket worn by the bullfighter.[24] Phillip's most flamboyant painting in size, costumes and expressions is 'La Gloria', 1864 [42]. It represents a Spanish wake which is being held for a dead child. The mourning mother is comforted by two figures in the shadowy foreground, while a colourful group dances in the bright sunshine to celebrate the ascent of the child's soul directly to heaven. To Phillip or his compatriots, this kind of practice certainly seemed bizarre. Many other pictures by Phillip offered a view of Spaniards as a people entertaining certain beliefs, either religious or plainly superstitious, which would have encouraged the British viewer to adopt a contemptuous attitude. In the *Evil Eye* [40], which records an ambivalent encounter, Phillip depicts himself in Victorian attire, attempting to sketch a Spanish woman, who recoils because she believes she is being given the 'evil eye': the malevolent gaze that would bring bad luck. Whether this depiction is based on a real event or on imagination, it is impossible to say. Some time before Philip painted this, Ford had stated his view that in Spain, a belief in the evil eye was no longer alive among the 'better classes'.[25]

What aspects of Spain did British painters ignore? What was largely absent was the life of the aristocracy and bourgeoisie, scenes of industry, work and progress; except arguably, and only to some degree, in the photographic work of Clifford. Spain certainly gave Ford a platform, and the Peninsula also accounts for significant and successful phases in the careers of Wilkie, Roberts, Lewis and Phillip. However, their distinct approaches to Spain were vitiated and indeed to some degree, at least, compromised by the demands of commerce, the impediments of ignorance and preconception, the prejudices of the British public, and the demands of the print and illustrated book market.

38 John Phillip *A Street Scene in Toledo*, 1856–7
National Gallery of Scotland, Edinburgh

39 John Phillip *An Old Doorway and House at Segovia*, 1856–7
National Gallery of Scotland, Edinburgh

40 John Phillip *The Evil Eye*, 1859
Hospitalfield, Arbroath

41 John Frederick Lewis
Spanish Fiesta, 1836
The Whitworth Art Gallery, The University of Manchester

42 John Phillip
'La Gloria': A Spanish Wake, 1864
National Gallery of Scotland, Edinburgh

45　John Phillip
Spanish Boys Playing at Bullfighting, 1860–1
National Gallery of Scotland, Edinburgh

46 José Bécquer *Richard Ford as a Majo*, 1832
Private collection

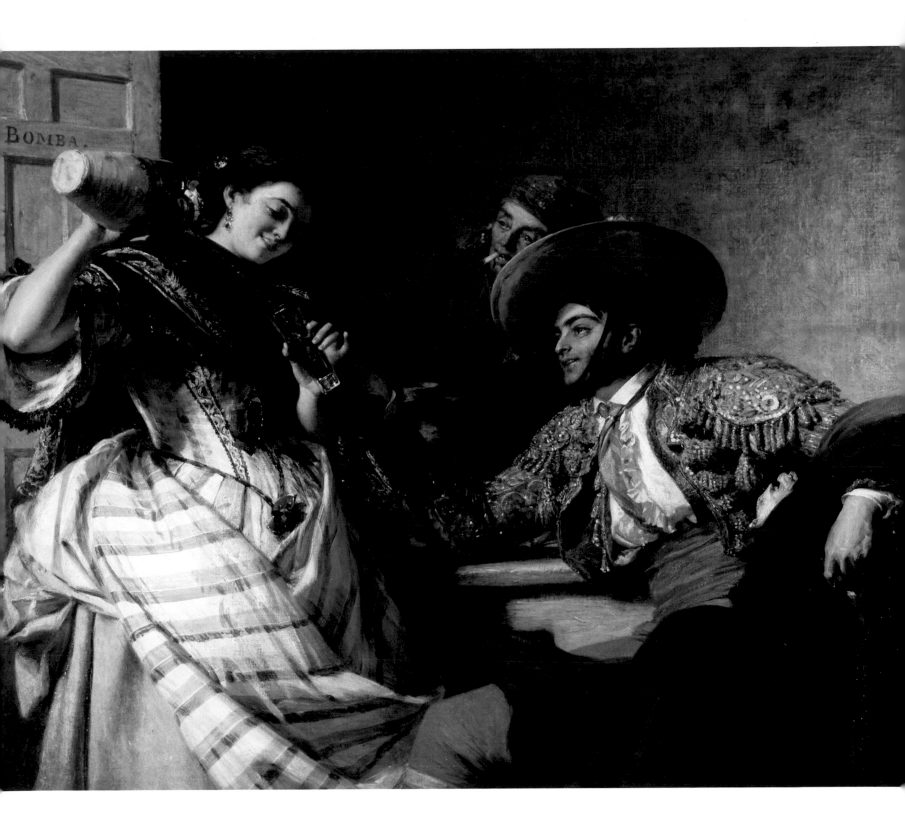

47 John Phillip *La Bomba*, 1863
Aberdeen Art Gallery & Museums Collections

48 David Roberts
Chapel of the Nunnery of the Virgin at Carmona, 1833
National Gallery of Scotland, Edinburgh

49 John William Inchbold
Springtime in Spain: Near Gordella, 1866
Birmingham Museums and Art Gallery

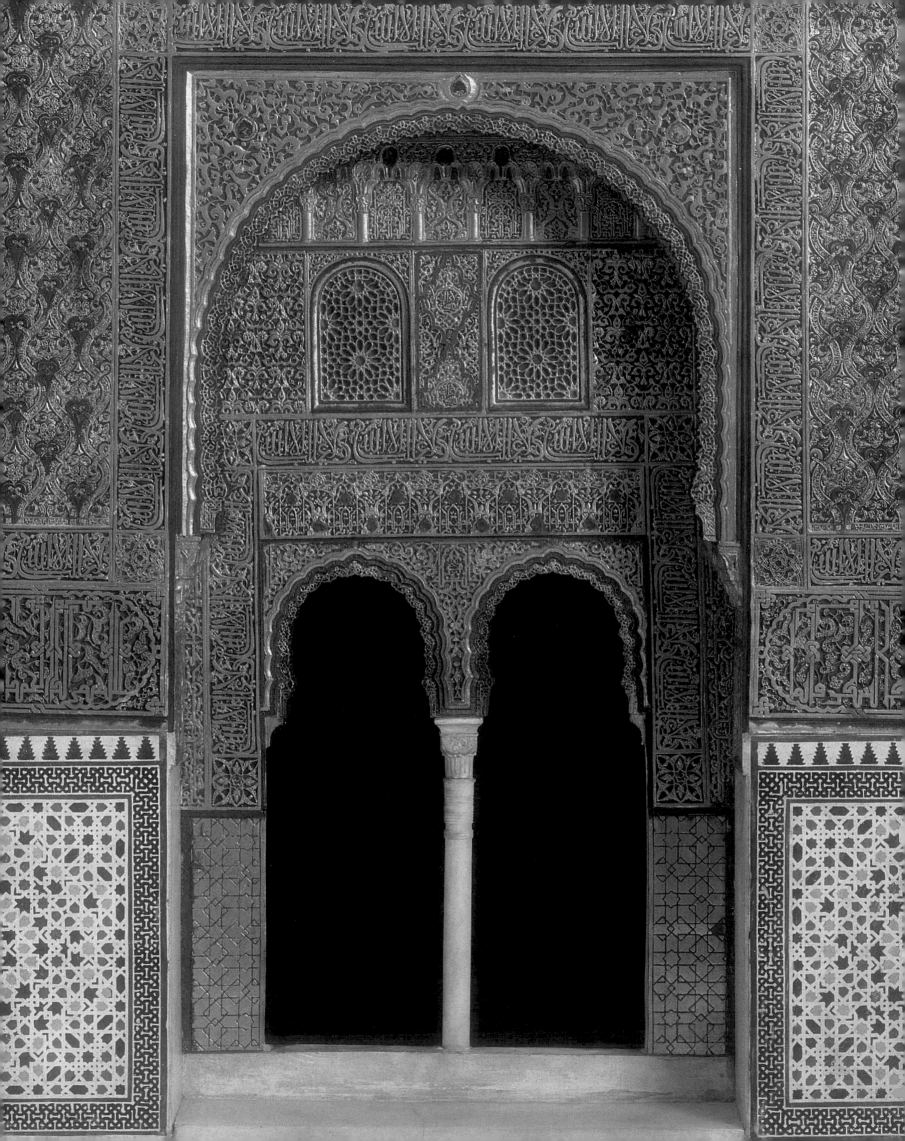

3

A DREAM OF THE SOUTH: ISLAMIC SPAIN
CLAUDIA HEIDE

A great part of the British fascination with Spain focused on the country's Islamic past.[1] This could be best seen in the southern province of Andalusia, where Muslim rule had persisted from 711 to 1492, when the last Nasrid sultan, Boabdil, handed Granada to King Ferdinand and Queen Isabella who where known as the Catholic Kings. Islamic Spain or 'Al-Andalus', had not only represented the Western border of the Islamic world, but also Europe's most fertile ground for the progress of science, philosophy, agriculture and the arts.[2]

In the nineteenth century, Andalusia, a crossroads between the European and the Oriental, came to play an important part in the burgeoning fascination with the Orient: the Maghreb (Morocco, Algeria and Tunisia) and the Near and Middle East. What has come to be designated, the 'Oriental Obsession', was bound up with the romantic yearning to search for the exotic 'other'. It often involved a tour to the Near and Middle East, via Greece, or Andalusia and Morocco. Andalusia, where the Islamic past was clearly imprinted in its monuments, represented the nearest and most accessible place to gain a flavour of the Orient, without having to endure overly demanding travel beyond Europe.

Nineteenth-century writers perceived the region as 'Oriental' or 'Moorish'.[3] For instance, Victor Hugo, in the preface to his seminal *Les Orientales* (1829), declared Spain 'Oriental';[4] this is echoed by Richard Ford, the most eloquent Victorian writer on Spain, who continuously referred to the modern Spaniard as 'Oriental'; a type which had more in common with a 'Turk' than a 'European'. Washington Irving too, wrote that 'the habits, the very looks of the people have something of the Arabian character'.[5] Similarly,

Andalusia reminded one traveller 'constantly' of Syria: 'There are the same mountains ... negligent cultivation has only scratched the soil here and there in both ... The towns and villages perched on peaks or nested in secluded places are much the same – and little wanting but a few tents and turbaned figures and camels to make the South of Spain another Syria.'[6]

A curious mixture of admiration and condescension marked attitudes in western Europe towards Al-Andalus.[7] In the eighteenth century, the eminent historian William Robertson drew attention to the significant role that Islamic Spain played in the development of European culture.[8] For Robertson, the end of Al-Andalus and the eventual expulsion of the Moriscos (Muslims converted to Christianity), which happened in 1609, led to the economic decline of Spain. To the nineteenth century which typically favoured Spain's Islamic past over her Catholic culture, Andalusia's Islamic monuments provided a stimulus to an idealised vision of medieval history suggesting a polyglot Spain marked by religious tolerance and an exquisitely sophisticated culture under Muslim rule. Attention was focused on the iconic monuments in Seville, Cordoba and Granada. In Ford's view, modern Seville was a purely Muslim city, as the 'Moslems, during a possession of five centuries entirely rebuilt the town. ... the best houses are still those built by the Moors or on their models'. The painter David Roberts, arriving in Seville in 1833, was in awe of its mixture of Islamic and Gothic architecture, stating that 'here alone is work for any Artist for a year or two'.[9] Seville Cathedral, built on the location of the former Alhmohad mosque, offered both Gothic and Islamic elements, which Roberts meticulously depicted in his painting entitled

50 Rafael Contreras
Lateral Arch in the Hall of the Comares, Alhambra, c.1865 (detail)
Victoria and Albert Museum, London

The Moorish Tower at Seville [56]. It shows the cathedral's belfry, the so-called Giralda, which originally served as the minaret of the mosque that once occupied the site. In Cordoba, the artist-traveller focused on the Old Great Mosque which symbolised the cultural peak that the city had reached as the capital of the Umayyad Caliphate (929–1031). What was more, the building, converted into a Christian place of worship in the early thirteenth century, was an exciting hybrid. Intriguingly, a drawing by John Frederick Lewis depicts Christian mass in a small chapel with multi-lobed arches, which recall the Villaviciosa chapel and the adjacent royal chapel. Lewis added elements from Seville: the religious painting above the altar, by Murillo, hung in reality in Seville Cathedral, while the figure on the left of the chapel itself, resembles one of the pages of the 'Dance of the Seises', a ritual only performed in Seville Cathedral.[10] The couple seated on the right may be Richard and Harriet Ford, whom Lewis had first met in Seville in 1832. Such a medley is far from unusual in the British iconography of Andalusia.

The monument, which above all captivated the British imagination, was the Alhambra in Granada, the vast palace-fortress built by the Nasrid sultans between 1238 and the end of the dynasty in 1492. A very early print, included in one of the rare eighteenth-century travel accounts of Spain,[11] gave only a vague impression of a castellated exterior and the dramatic location of the fortress on a hill overlooking the city. An earlier more frivolous and three-dimensional image of the palace could be seen in Kew Gardens, where an Alhambra-pavilion (destroyed) had been built in the 1750s following the fanciful design by William Chambers, who bizarrely managed to combine in his confection, Graeco-Roman, Gothic and Islamic elements.[12] The marriage of the Gothic and Islamic style here, was no coincidence. Sir Christopher Wren in his *Parentalia* (published posthumously in 1750) had already pioneered the idea that the Gothic style derived from the Islamic.[13] In other words, Gothic cathedrals were 'an awkward imitation' of Islamic buildings in Spain.[14] The theory has long been dismissed, but nineteenth-century travellers often saw the Alhambra through the prism of the Gothic style, which prevented them from understanding the building on its own terms. This can be seen in the *Arabian Antiquities of Spain*, the first volume of plans, elevations and details of ornament from the Alhambra published in 1815 by James Murphy, an Irish architect and antiquarian who from 1802 had travelled extensively in Spain and lived in Cadiz for many years.[15] While it was the first survey of the Alhambra palace to appear in Britain, it represented a highly distorted vision, which turned the compact interiors into lofty cathedral-like spaces, as if to illustrate the Gothic-Islamic theory. Murphy's towering visions were also affected by the 'Sublime', a concept theorised by Edmund Burke in 1756, which denoted intense emotions and feelings of awe as a result of viewing something of incomprehensible beauty, horror or grandeur.[16] For the traveller, the 'Sublime' abounded in the labyrinth-like character of the Alhambra, in its dazzling wall ornamentation and in the startling stalactite vaults (*muqarnas*) that seemed to escape rational explanation. Overall, Murphy's pioneering study was superficial, antiquarian and ultimately failed to enthuse a wide public. Nevertheless, for all its shortcomings, Murphy's publication was a landmark on the long road to a scholarly grasp of the iconic monument of Islam in Europe.

But it was literature not architectural folios or guidebooks which raised the profile of the Alhambra by transforming it into a romantic sanctuary for foreign writers, artists and tourists. 'Magic', 'dreamlike' and 'enchanting' are adjectives repeatedly used by Romantic writers to describe the palace. Washington Irving felt so spellbound that he took up residence in 1828 despite its utter state of neglect. Irving felt that the 'peculiar charm of this old dreamy palace is its power of calling up vague reveries and picturings of the past, and thus clothing naked realities with the illusions of the memory and the imagination.'[17] His *Tales of the Alhambra* (1832) became a best-seller, which greatly encouraged visitors. A privileged few, including Richard Ford, eagerly followed Irving. According to one, the Spanish authorities willingly gave rooms to certain travellers, 'especially English, who would come and reside in the palace, bringing their own beds and cooking utensils'.[18] A stay in the Alhambra, as uncomfortable as it may have been, was perceived as a means to

51 David Roberts
Fortress of the Alhambra, 1838
Caja General de Ahorros de Granada

52 Owen Jones *Grammar of Ornament, Illustrated by Examples from Various Styles of Ornament*, 2nd edition, 1868, plate XLII* and plate XL (left top and bottom)
National Gallery of Scotland, Edinburgh

53 Owen Jones *Plans, Elevations, Sections and Details of the Alhambra*, 1842–5, vol.I, plate X and vol.II, plate XIII (right top and bottom)
Private collection

fulfil Thomas Roscoe's appeal in the preamble to *The Landscape Annual* of 1835 of how 'we can live in the Past as though it were our natural home, and regard its legends as things of our own experience.'[19]

The painters John Frederick Lewis and David Roberts consolidated the romantic image of the Alhambra. Lewis [55] as a genre painter filled his views with picturesque figures,[20] while Roberts offered more awe-inspiring visions [51]. Comparison with Clifford's photograph of the *View of Granada, from the Albaicín* [60] exposes Roberts as an adroit manipulator of an aesthetic which at one and the same time

allowed the British viewer to make sense of both the Gothic and the 'Sublime'. Roberts's largest known oil painting, the *Fortress of the Alhambra* [51] epitomises his Romantic adulation. The Alhambra, depicted from an elevated viewpoint on the Albaicín hill and set against the snowy peaks of the Sierra Nevada, is bathed in a vaporous golden light that produces a suitably nostalgic atmosphere. The dancing foreground figures wearing nineteenth-century dress accentuate the idea that what we contemplate in the distance is a paradise lost. The entire picture, with its invented architectural structures and its tall palm tree (uncommon in Granada) in the foreground, is a fantasy that perfectly matched British notions of Spain as an Oriental 'other'.[21] Roberts certainly understood his British clientele much better than the architectural fabric of the Alhambra.

The first rigorous investigation of the

palace was undertaken by the Welsh architect and designer Owen Jones. He arrived in 1834, after a tour of Greece and Turkey. Following a study trip to Egypt, in 1837, he then returned a second time to continue his archaeological study. For this Jones produced a celebrated corpus of hundreds of measured drawings and paper tracings, rendering in detail the plans and elevations of the palace. He was also the first to take scrapings of residual pigment on the walls. All this went towards the appearance of what rapidly established itself as one of the great architectural publications of nineteenth-century Europe: *Plans, Elevations, Sections and Details of the Alhambra*. In addition to measured plans, elevations and details of ornament, it also featured the methods of construction, and the role of epigraphy in the ornament, all representing a significant effort to understand the building rationally. Jones's analysis for instance revealed that the decoration, including the *muqarnas*, hitherto described as dazzling or magic, was actually based on sound geometrical and mathematical principles and

could be understood logically [53].

In contrast to Roberts and Lewis, who had revelled in the picturesque decay of the edifice, Jones offered a restored, polychrome Alhambra based on his study of what he believed had been an intensely chromatic monument. He thought that vivid primary colours of blue, red and yellow, had been dominant in the upper parts of the interiors whilst these had been balanced by the less colourful secondaries (purple, green, orange) found in dados.[22] To represent the colours accurately, Jones used chromolithography, a new, expensive and complicated printing technique, hitherto never successfully applied in Britain. As a triumph of art, technology and observation, Jones's publication included the most exquisite illustrations of the Alhambra [53]. The scholarly nature of his work was underpinned by his collaboration with the Arabist Pascual de Gayangos (1809–1897),[23] the foremost authority on Al-Andalus. Drawing on primary sources (both Arabic and Castilian) Gayangos translated Arabic inscriptions included in wall

54 Charles Clifford
The Lion Fountain: The Court of the Lions, c.1858
Victoria and Albert Museum, London

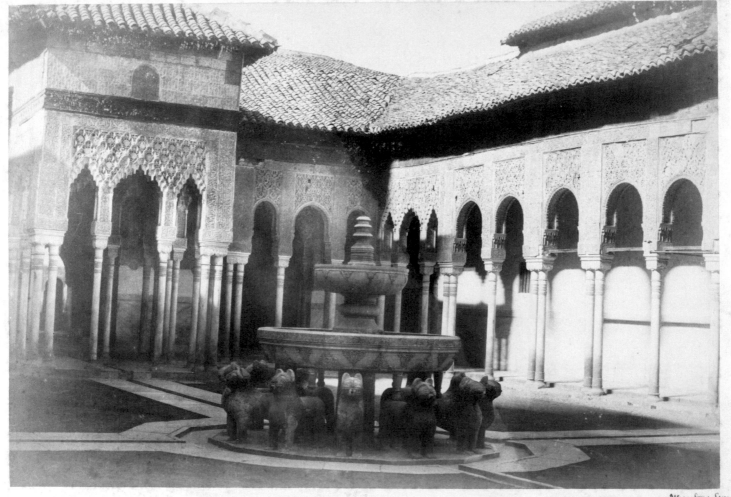

ornament, and wrote an essay on the history of the Alhambra, which offered an utterly different approach to the monument to that in Irving's dreamlike *Tales of the Alhambra*. At last, almost a century after the British had taken notice of this exceptional site, the combined efforts of a scholar and an architect succeeded in producing the breakthrough in the diffusion of a more accurate knowledge of Europe's most splendid Islamic building.

Jones's sumptuous plates of the Alhambra contrast with black and white photographs taken by Clifford during three visits between 1851 and 1862.[24] Many of the photographs are similar to Jones's plates in their close focus on tracings and patterns. However, Clifford did not undertake a scientific survey but chose rather, to sustain a retardatory Romantic approach, which relied on careful selection of viewpoints and manipulation of light. His atmospheric photograph of the famous Court of the Lions offers a seductive vision of the courtyard as a magic place of oriental elegance and splendour, or as Irving had once put it, the most favourable place to induce a 'phantasmagoria of the mind' [54].[25] Over half a century later, the Scottish painter Sir Muirhead Bone replaced magic with a down-to-earth view of the courtyard then undergoing restoration: scaffolding obstructs a full view of the dilapidated space [63].

As visitors to the Alhambra rapidly increased, there soon arose a desire to own a piece of the palace, however small. As has been remarked,[26] the absence of a strict policy to protect the site made possible the traffic of objects – tiles, fragments or entire pieces of architecture – which often ended up on the international art market. One travel writer exclaimed dramatically 'Oh the sweet miseries of the ventas [country inns] When these are gone – gone alas! will be the splendours of Granada: its Alhambra will be torn to pieces by travellers.'[27] A spectacular purchase was made by the landscape painter Walter Donne, who acquired and integrated four slender marble columns of the Nasrid period (Victoria and Albert Museum, London) in his studio in London.[28] The Spaniards themselves astutely responded to the growing hunger for souvenirs by producing copies of architectural fragments at affordable prices and in variable sizes. Rafael Contreras, appointed restorer of the Alhambra in 1847, specialised in the

production of three-dimensional miniature models, like that of the *Lateral Arch in the Hall of the Comares, the Alhambra* [57]. Miniature Alhambras were usually acquired by visitors as souvenirs for the home, but they also found their way into the School of Design in London (later South Kensington Museum).

Jones had included decorative details from the Alhambra in his *Grammar of Ornament* (1856), a collection of specimens from around the world that soon established itself as the major source book for students of design [52]. Here Jones stated that the Alhambra was at the 'very summit of perfection of Muslim art, as the Parthenon of Greek art ... Every principle which we can derive from the study of the ornamental art of any other people is not only ever present here, but was by the Moors more universally and truly obeyed.'[29] That Jones's enthusiasm for Hispano-Islamic design was contagious can be seen in the proliferation of Alhambra-inspired fabric, wallpaper and ceramics in middle-class homes in late Victorian Britain.

The South Kensington School of Design purchased Alhambra models, original pieces of decoration, and plaster casts of architectural fragments.[30] In addition, mid-nineteenth century French neo-Nasrid ceramics, such as the spectacular Alhambra vase by Joseph Theodore Deck, were acquired.[31] All these purchases were to encourage students to adopt the principles of Hispano-Islamic style. As for Jones himself, he put archaeological knowledge into practice, with his designs for residential buildings, such as Kensington Palace Gardens (1844).[32] Others followed as can be seen in George Aitchison's designs for the Arab Hall in Lord Frederic Leighton's house in Holland Park, London.

What ultimately made the Alhambra tangible to the British was the new Crystal Palace, a modern iron and glass structure, built in 1854 at Sydenham. Unlike its temporary precedent that had housed the Great Exhibition of 1851 in Hyde Park, the Sydenham version included an 'Alhambra court' created by Owen Jones, which offered the experience of an Alhambra interior in three dimensions.[33] It was one in a series of 'Fine Arts Courts', but significantly the only one to focus on a single building. Although Jones aimed for accuracy, constraints of space, budget and time led to many alterations and distortions:

the central fountain in the Court of the Lions played a more dominant role in south London than in Granada, for the pavilions were omitted and the number of columns reduced. Nevertheless, Jones succeeded in replicating certain features, such as the *muqarnas*. However, he later admitted that 'we have been driven to bungles or imperfect finishings which no Moorish eye could have endured'.[34] As in his Alhambra volumes of 1842, Jones had envisioned a polychrome Alhambra where colours would have balanced each other. Jones's belief in chromatic harmony even led him to suggest that the columns of the Alhambra had been originally gilded, a hypothesis that would be dismissed in the early twentieth century.[35] The enforced pastiche of the Alhambra which was the outcome of the Crystal Palace project, partly motivated by Jones's wish to promote architectural polychromy among his peers, was largely well received.[36] Most visitors responded in predictably romantic terms through an 'oriental' lens, associating the space with the idea of the 'Orient' or the legendary harem. Whether such visitors were able to appreciate the history and architecture of the Alhambra on their own terms is doubtful. For all the sustained research and scholarship by Jones, the Romantic sentiment towards the Alhambra was hard to eliminate. Jones's Alhambra Court, easily accessible to the British public until the destruction of the Crystal Palace in 1936, certainly contributed to the mythic image of the original Alhambra in Granada and helped to raise its profile: declared Spain's first national monument in 1874, it continues to inspire thousands of visitors today.

55 John Frederick Lewis
Courtyard of the Alhambra, 1832–3
Fitzwilliam Museum, Cambridge

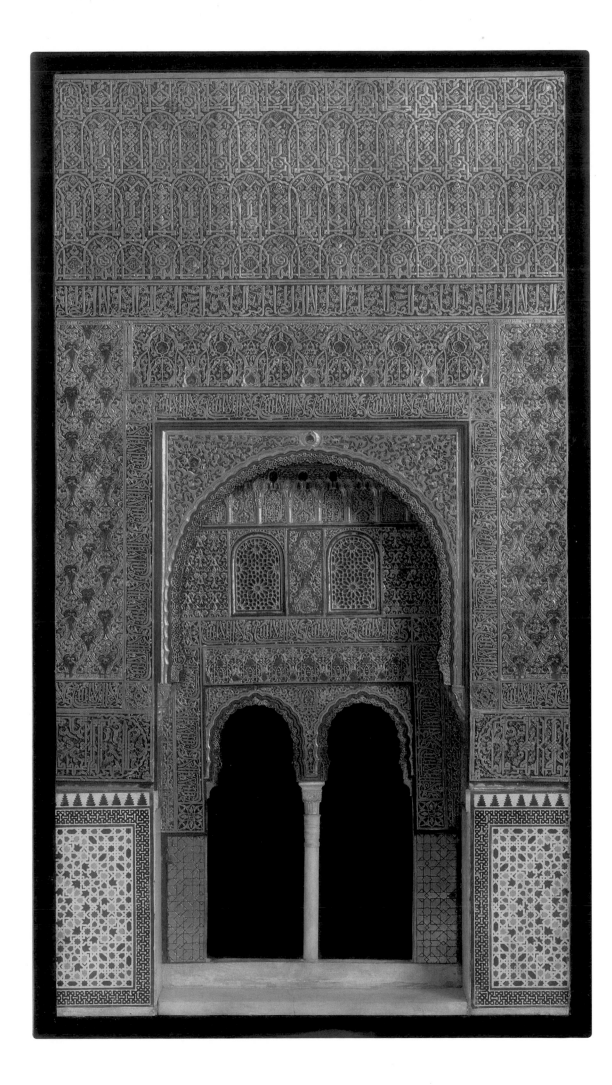

56 David Roberts
*The Moorish Tower at Seville
called the Giralda*, 1833
The Abbot of Downside

57 Rafael Contreras
*Lateral Arch in the Hall of the Comares,
the Alhambra*, c.1865
Victoria and Albert Museum, London

58 Charles Clifford
Torre del Vino, Granada, 1860s
Victoria and Albert Museum, London

59 Charles Clifford
Corridor Leading to the Hall of Justice, the Alhambra, 1860s
Victoria and Albert Museum, London

60 Charles Clifford
View of Granada, from the Albaicín, 1860s
Victoria and Albert Museum, London

61　John Frederick Lewis
The Alhambra, Granada, 1832
The British Museum, London

62 Harriet Ford
The Patio del Mexuar, the Alhambra, 1831
Private collection

63 Sir Muirhead Bone
*The Court of the Lions, the Alhambra, c.*1930–6
Kelvingrove Art Gallery and Museum, Glasgow

THE BRITISH 'DISCOVERY' OF SPANISH GOLDEN AGE ART

HILARY MACARTNEY

'Of art in Spain ... we are almost totally ignorant.' So claimed the diplomat and writer on art, Sir Edmund Head in 1834, pointing out that Murillo and Velázquez were the only Spanish artists who were well known in Britain, and that the names of others had hardly crossed the Pyrenees.[1] Yet according to William Stirling in his *Annals of the Artists of Spain* of 1848, private collections in Britain 'could probably furnish forth a gallery of Spanish pictures second only to that of the Queen of Spain'.[2] Both assessments were largely true, for the awakening of interest in Spanish art in Britain was a fitful and contradictory affair, rather than a linear progression from ignorance and misunderstanding to recognition and revelation. Many of the names of the Spanish artists of the sixteenth and seventeenth centuries, and their potted biographies, had in fact been published in English in 1739, in an abridged version of the biographical section of Antonio Palomino's treatise on art. In it, the editor hoped that lovers of art would be 'agreeably surprized to find a new World of Artists [in Spain], and an invaluable Treasure of Art', where even 'Men of Figure did not so much as suspect that there had been the least Taste or Notion of it'.[3] Whether many readers would have been able to connect artists' names with examples of their work seems unlikely, for many Spanish paintings which made their way into British collections in increasing numbers from the eighteenth century on, remained little known and even less seen. The extraordinary series of *Jacob and his Twelve Sons* [78–81], by Zurbarán and his studio, provides a case in point. These outlandish figures depicting the progenitors of the lost tribes of Israel arrived in England around 1726, and, interestingly, were owned by a Jewish merchant in London, before they were taken north by Richard Trevor, Bishop of Durham, to his palace at Bishop Auckland in 1756. Remarkably, they were not published in the modern literature on art until the 1930s and 1940s.[4]

By contrast, two paintings by Murillo which also came to Britain at an early date became extremely well known – and even notorious – in the nineteenth century. The *Three Boys* [65] and *Two Peasant Boys* [74] were probably the Murillos which were seized and sold in London in 1693, as part of the art collection of the Jacobite John Drummond, 1st Duke of Melfort, after the deposition of the Stuart King James VII and II.[5] They formed part of the founding collection of Dulwich Picture Gallery, London, one of the first public art galleries in 1811, but the enormous popularity of Murillo, and of these street urchin paintings in particular, was controversially challenged by the most influential Victorian art critic, John Ruskin. In 1853, he objected to Murillo's depiction of these 'repulsive and wicked children' as 'mere delight in foulness'.[6]

It was the Peninsular War (1808–14), however, which did most to focus British attention on Spain and its art. The intimate relationship between art and war was dramatically highlighted by the Spanish paintings which entered the Duke of Wellington's collection at Apsley House, London. Captured by Wellington's troops in the baggage train of Napoleon's brother, Joseph Bonaparte, as he fled the Battle of Vitoria in 1813, these had been stolen from the royal collections in Madrid, where Joseph had been installed as king during the war. After the rolled-up canvases were discovered amongst the booty in London, Wellington attempted to return them to King Ferdinand VII, who had been restored to the Spanish throne, but

64 Diego Velázquez
A Spanish Gentleman, probably José Nieto, Chamberlain to Queen Mariana of Austria, Wife of Philip IV (detail)
Wellington Collection, Apsley House, London

the king confirmed them as a worthy prize to the duke.[7] They included Velázquez's *The Waterseller of Seville* [66], which had been highly valued by the painter himself.[8] Its fame had been emphasised by Palomino and in the *Anecdotes of Eminent Painters in Spain* (1782) by Richard Cumberland, an English writer who claimed to have been on a secret mission in Madrid, though their exaggerated descriptions of the waterseller's ragged clothes, and scabrous flesh exposed beneath, suggest that neither had actually seen it.[9]

Around the middle of the nineteenth century, private and public collections in Britain were nurtured by important sales in London and Paris. The most significant was the sale in 1853 of the Spanish pictures

65 Bartolomé Esteban Murillo
Three Boys, c.1670
Dulwich Picture Gallery, London

66 Diego Velázquez
The Waterseller of Seville, c.1618–22
Wellington Collection, Apsley House, London

belonging to the former King of France, Louis-Philippe. These had hung in the legendary Galerie Espagnole at the Louvre in Paris from 1838 to 1848, where they were seen by countless artists and writers from both sides of the English Channel. Their auction in London, along with the Standish collection, which had been bequeathed by the Englishman Frank Hall Standish to Louis-Philippe, attracted much attention. Writing in the *Athenaeum*, Richard Ford hailed these sales as 'an epoch in Spanish art annals and education in England', for they had prompted an informal '*matinée artistique*' to be held every day of the sales, at which 'this strange and hitherto little understood school was studied and weighed at its own worth'.[10]

The Early Career of Murillo, by the Aberdeen-born painter John 'Spanish' Phillip, tapped into public interest in Spanish art at this time by alluding to two of the best-known works in the Louis-Philippe sale. The likeness of Murillo in Phillip's painting is based on the Spanish painter's youthful

Self-portrait, whose fame spread as it moved from Seville to Paris and then London. Before it was bought for the Louis-Philippe collection, the Murillo was in one of the most important private collections of Spanish art ever formed – that of Julian Williams, British consul at Seville, where the Scottish painter Sir David Wilkie reportedly made an 'excellent' but now lost copy of it.[11] Phillip's cowled figure of a monk, his face hidden in shadow, recalls Zurbarán's *St Francis in Meditation* [82], which had become a cult image of romantic asceticism when it hung in the Galerie Espagnole in Paris. The National Gallery, London, attracted controversy when it purchased the Zurbarán to add to its tiny Spanish collection, which until then was represented only by Murillo and Velázquez.[12] The acquisition was attacked by William Coningham, a noted art collector, in a letter to *The Times*, as a 'small, black, repulsive picture', but stoutly defended by Richard Ford and William Stirling for its 'intensity of devotional feeling' and 'truthful power of

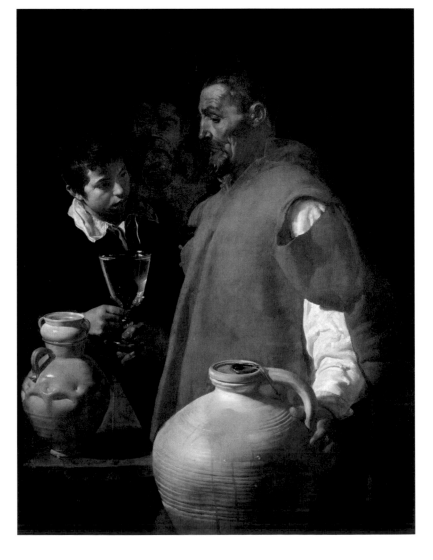

67 *Queen Mariana of Austria*, by Velazquez, albumen print in Caldesi & Montecchi, *Photographs of the Gems of the Art Treasures Exhibition*, Manchester, 1857, Ancient Series, no.75, Manchester and London, 1858

Brotherton Collection, Leeds University Library

68 Pedro Núñez del Valle
Jael and Sisera, c.1630
National Gallery of Ireland, Dublin

technical execution'.[13] The subject of Phillip's *Early Career of Murillo* was suggested by a picturesque passage in Stirling's account of the Spanish painter in his *Annals*, which was quoted when the painting was shown at the Royal Academy, London, in 1865.[14] The shovel hats of the two religious figures in the picture are reminders of Wilkie's Peninsular War paintings, and introduce another filter through which Phillip saw, and invited the British public to see, Spain and Spanish art.

Much of Stirling's extensive collection, which hung at his family seat at Keir, Perthshire, and at his London house, was purchased at the Louis-Philippe and Standish sales, and at those of the collections of John Meade, formerly British Consul General in Madrid, and the French General Soult, the latter looted during the Peninsular War.[15] Many of the still little-known 'big names' of Spanish art were represented in Stirling's collection, including El Greco and

Zurbarán. In the following decades, John Bowes, a wealthy businessman, and his French wife Joséphine acquired Spanish pictures, notably El Greco's *Tears of St Peter* [88], for the magnificent, purpose-built Bowes Museum at Barnard Castle which, when opened in 1892, became the largest public collection of Spanish art in Britain.

Access to Spanish art had been increasing throughout the nineteenth century. In the 1840s, Anna Jameson's guidebooks to public and private galleries in and around London initiated new gallery-goers in how to look at and indeed, behave in front of works of art, expressing her disapproval of 'the loiterers and loungers, the vulgar starers, the gaping idlers' on visits to the Duke of Westminster's collection at the Grosvenor Gallery, and that of the Duke of Sutherland at Bridgewater House, which contained some of the finest examples of Spanish art in Britain.[16] The great exhibitions which were held in cities throughout Britain from the mid-nineteenth century onwards did even more to change perceptions of public access to 'high' art. The Manchester Art Treasures exhibition of 1857 was hailed as the beginning of the democratisation of art. It brought together for the first time a vast number of important works of art, including many Spanish pictures, from private collections throughout Britain. Most of the Spanish paintings were hung

together, and offered the British public their first real opportunity to assess the school as a whole. Velázquez made a significant impact on artists such as John Everett Millais, and especially James McNeill Whistler. Amongst the works attributed to Velázquez were three portraits of the family of Philip IV of Spain, probably all high-quality workshop copies, which were then in the collection of Colonel Hugh Baillie of Jedburgh. These were included in *Photographs of the Gems of the Art Treasures Exhibition*, a pioneering publication which used photographic illustrations to record some of the exhibits [67].[17]

By the end of the nineteenth and beginning of the twentieth centuries, a shared notion, however vague, of the 'Spanishness' of Spanish art had become current. An exhibition held at the New Gallery in London in 1895–6 was the first of several to focus exclusively on the arts of Spain, and the presence of many of the most prominent British artists, collectors, and curators on its organising and lending committee was an indicator of how fashionable Spanish art had become. Throughout the nineteenth century, efforts had been made to define the Spanish school for the British public. Wilkie, who had portrayed himself as discovering 'the very Timbuctoo of art' on his visit to Spain in 1827–8, had an astonishingly pervasive impact on this process.[18] His thoughts on the subject

in his letters home and his journal were cited by almost every writer on Spanish art for the rest of the nineteenth century. Among them were Richard Ford, whose *Hand-Book for Travellers in Spain and Readers at Home* (1845) was unprecedented in the amount of information it provided and the outspoken views it expressed on matters relating to art; and Sir Edmund Head, whose succinct account in the *Hand-Book of the History of the Spanish and French Schools of Painting* (1848) was followed by Stirling's remarkable, three-volume *Annals*, which examined art in the wider context of the history of Spain.

There was general agreement that the Catholic church in Spain had had the most powerful influence on Spanish art. The idea that much of the art of Spain was commissioned by the Roman Catholic church was undoubtedly the greatest obstacle to British appreciation of Spanish art. Anti-Catholic feeling was strong in Britain, and the Spanish church was popularly considered by Protestants to embody the worst excesses of the unreformed Roman church. Practical help in making Catholic art accessible to mainly Protestant British viewers was offered by Mrs Jameson's series of books on *Sacred and Legendary Art*, which explained the iconography of the Virgin Mary, the saints, and the monastic orders. Another related problem concerned the negative associations of dark-toned Spanish works, as the public controversy over the Zurbarán *St Francis*, and even the Dulwich Murillos demonstrated. The descriptions of the *St Francis in Meditation*, the Murillo urchins, and Velázquez's *Waterseller* also show that Spanish art was associated in British minds with an extreme form of naturalism. The refusal of Spanish artists to idealise, coupled with the menace of darkness in Victorian minds, led critics such as Ruskin to claim the moral inferiority of the Spanish school, especially compared with lighter-toned, pre-Catholic Reformation paintings by Italian artists. Even Mrs Jameson warned her readers of the possible ill effects of viewing Spanish art, confiding that she herself found that 'many Spanish pictures together oppress the spirits' and their 'gloomy monotony' was 'painful and fatiguing'.[19]

Stirling's *Velazquez and his Works* (1855), the first monograph on the painter, offered some relief from the discomforts of Spanish religious art, by emphasising the notable achievements of Spanish portraiture, and claiming an innate British empathy with its truthfulness and lack of idealisation. The way was then clear for the cult of Velázquez, which neatly side-stepped the thorny problem of anti-Catholicism, and positively ennobled the aesthetic of tonal painting. The notion that artists served their patrons, whether royal or ecclesiastical, by projecting their image and ideas was no longer in keeping with the aspirations of modern art and artists. Focusing instead on the creative process of painting, especially issues of facture and technique, the enormously influential monograph on Velázquez (1895) by the art critic and one-time painter, R.A.M. Stevenson, deflected attention from this central role of Golden Age artists in Spain, presenting the principal court painter of King Philip IV of Spain instead as a universal model for painters.

69 El Greco

The Burial of Count Orgaz, from a Legend of 1323, 1586–8
Parish Church of Santo Tomé, Toledo

The cult of Spanish artists, and particularly Velázquez, also focused attention on the nebulous area of attributions, and the need to clarify what constituted authentic works. The difficulties experienced, even by prominent connoisseurs, in distinguishing Velázquez's works are highlighted by the painting of *Jael and Sisera* [68]. The idea that this could have been mistaken for a Velázquez seems incredible to modern eyes. The current attribution to Pedro Núñez del Valle (early 1590s-c.1665), however, is the result of relatively recent scholarship which has at last begun to recover the names and oeuvre of many more Golden Age artists.[20] Despite the stiffness of his figures, Núñez was an accomplished painter, though of course no match for Velázquez. He was praised by early writers including Palomino but was subsequently all but forgotten. The painting depicts a little-known Old Testament story which was probably intended as a political allegory of Golden Age Spain. Its provenance prior to the 1890s is unknown, but it was thought to have entered Britain during the Peninsular War, and to have 'found a resting place, disregarded and unvalued in some country house', till it was auctioned in London in 1891.[21] It was bought by J.C. Robinson, formerly curator at the South Kensington Museum (now Victoria and Albert Museum, London) and one of the leading authorities on Spanish art, who had also owned Velázquez's *An Old Woman Cooking Eggs* [70]. *Jael and Sisera* was shown for the first time at the New Gallery exhibition, at the height of the cult of Velázquez, when the attribution was much challenged, but vigorously defended by Robinson.[22] Such opportunities for public exhibition and debate were crucial to scholarship, and Aureliano Beruete, in his monograph on Velázquez (1897), which appeared in English in 1906, declared confidently that 'light is ... gradually dawning' on 'the disorder and confusion which reign in these attributions'.[23]

Amongst other loans to the New Gallery exhibition was the portrait of *Queen Mariana of Austria*, now apparently lost. After the Manchester Art Treasures exhibition, it was bought by Hercules Brabazon Brabazon (1821–1906), whose devotion to Velázquez is likewise recorded in the 'souvenirs', or sketches he made after the Spanish master's compositions.[24] Another artist-lender to the New Gallery was John Singer Sargent, one of the most famous of Velázquez's devotees. His involvement in the exhibition revealed his wider taste for the arts of Spain and in particular, for El Greco, whose elongated figures and theatrical effects found an unexpected echo in the flashy and daring productions of Sargent's brush. Loans by Sargent included two richly embroidered ecclesiastical vestments, with panels depicting Biblical scenes and saints, as in the spectacular examples painted by El Greco in his most famous masterpiece, *The Burial of Count Orgaz* [69], as well as a version (no longer considered autograph) of another well-known El Greco, *St Martin and the Beggar*.[25] The *St Martin* was clearly one of Sargent's most prized possessions and was prominently hung in his London studio where it would have been seen by fellow artists and other visitors.

Nineteenth-century writers had struggled to understand El Greco's extreme late style, except as the product of wilfulness or madness.[26] Now at last it was about to be celebrated. In 1913, the leading art critic, Roger Fry, was inspired by four paintings at the Spanish Art Gallery of Lionel Harris in London to publish a brief notice on El Greco in the *Burlington Magazine*. This fostered the enduring image of El Greco, both as the archetypal outsider in art and as precursor of 'the most recent developments in modern art'.[27] When the National Gallery, London purchased *The Agony in the Garden of Gethsemane* [85] in 1920, Fry described its effect on the British public as 'an electric shock', comparing the 'violent attack' of the forms, the 'ecstatic gestures', and the 'sweeping diagonals' to the 'melodramatic apparatus' of film, the newest form of popular entertainment, and claiming that 'not even the cinema star can push expression further than this'.[28] The picture of El Greco's oeuvre was still distorted, and few of the cult works then are now accepted as wholly autograph: *The Agony in the Garden of Gethsemane* is attributed to El Greco's studio, the paintings Fry saw in 1913 no longer appear in El Greco catalogues, and Sargent's *St Martin and the Beggar* is attributed to El Greco's son Jorge Manuel (1578–1631). But the power which artists and writers recognised in El Greco's art fired new scholarship and helped defuse religious objections.

As in the case of the growing interest in the art of Goya, on whom the artist Sir William Rothenstein (1872–1945) published the first monograph in English in 1900, the cult of Velázquez and El Greco emphasised personal artistic vision and relevance for modern art. Rather than the 'discovery' of a school, the history of taste for Spanish art in Britain should perhaps be seen more as a series of 'epiphanies' in which the genius of a handful of individual artists was each revealed in turn.

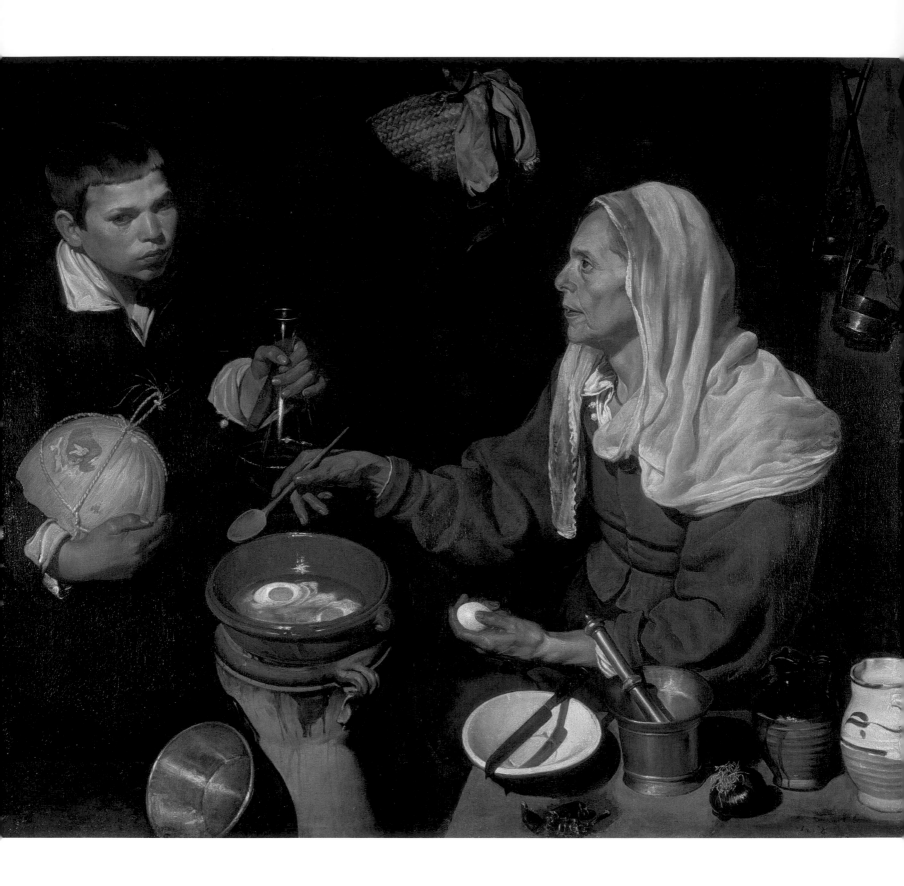

70 Diego Velázquez
An Old Woman Cooking Eggs, 1618
National Gallery of Scotland, Edinburgh

71 Diego Velázquez

A Spanish Gentleman, probably José Nieto, Chamberlain to Queen Mariana of Austria, Wife of Philip IV, 1635–45

Wellington Collection, Apsley House, London

72 Attributed to Juan Bautista
Mártínez del Mazo
Don Adrián Pulido Pareja, after 1647
National Gallery, London

73 After Diego Velázquez
King Philip IV of Spain (1605–1665)
National Gallery of Scotland, Edinburgh

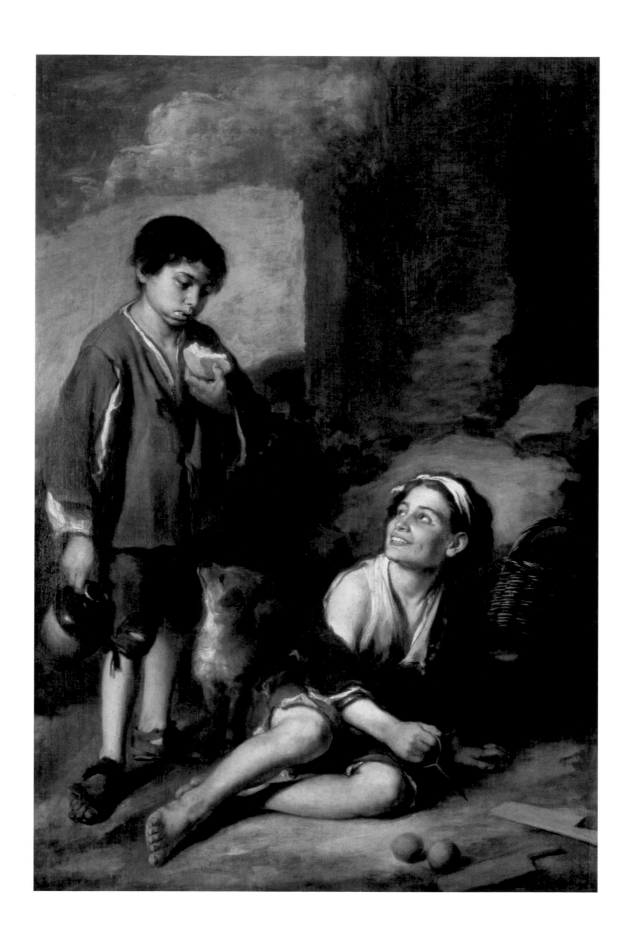

74 Bartolomé Esteban Murillo
Two Peasant Boys, c.1670
Dulwich Picture Gallery, London

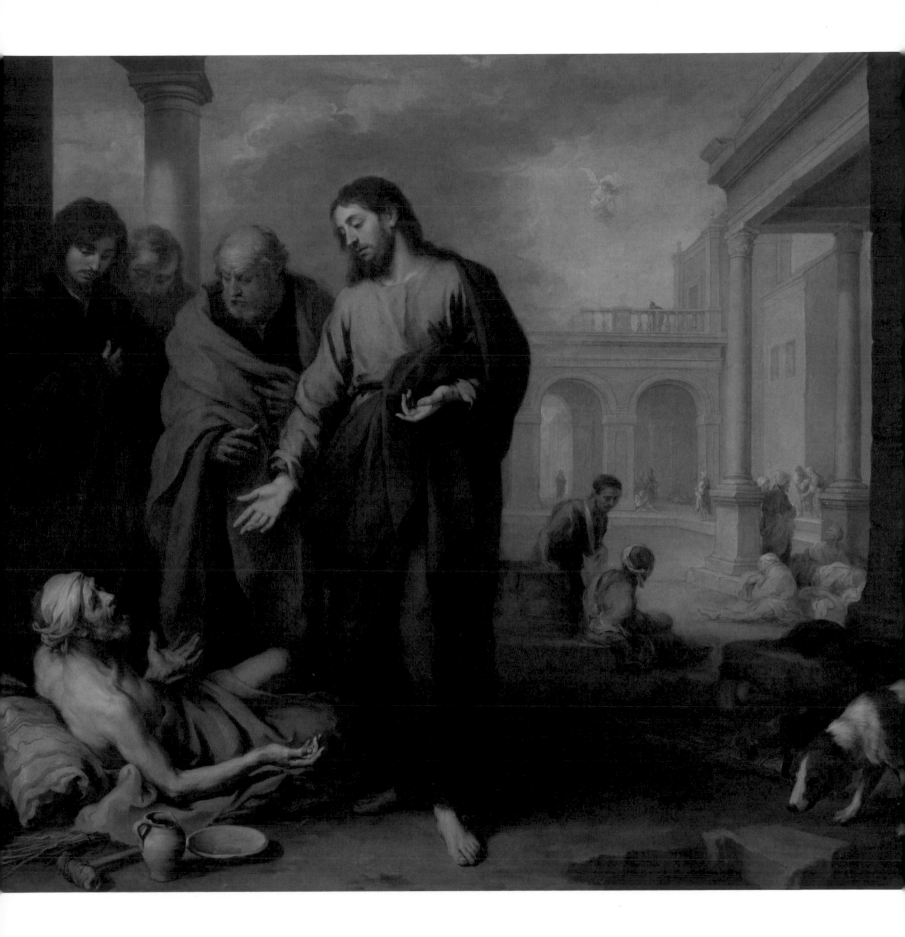

75 Bartolomé Esteban Murillo
Christ at the Pool of Bethesda, 1667–70
National Gallery, London

76 Bartolomé Esteban Murillo

A Young Man with a Basket of Fruit (Personification of 'Summer'), c.1665–70

National Gallery of Scotland, Edinburgh

77 Bartolomé Esteban Murillo
The Flower Girl, c.1665–70
Dulwich Picture Gallery, London

78 Francisco de Zurbarán

Zebulun, 1640s

The Lord Bishop of Durham, Auckland Castle, County Durham

79 Francisco de Zurbarán

Joseph, 1640s

The Lord Bishop of Durham, Auckland Castle, County Durham

80 Francisco de Zurbarán

Asher, 1640s

The Lord Bishop of Durham, Auckland Castle, County Durham

81 Francisco de Zurbarán

Levi, 1640s

The Lord Bishop of Durham, Auckland Castle, County Durham

82 Francisco de Zurbarán

St Francis in Meditation, 1635–9

National Gallery, London

83 Francisco de Zurbarán

The Immaculate Conception with Saint Joachim and Saint Anne, early 1640s

National Gallery of Scotland, Edinburgh

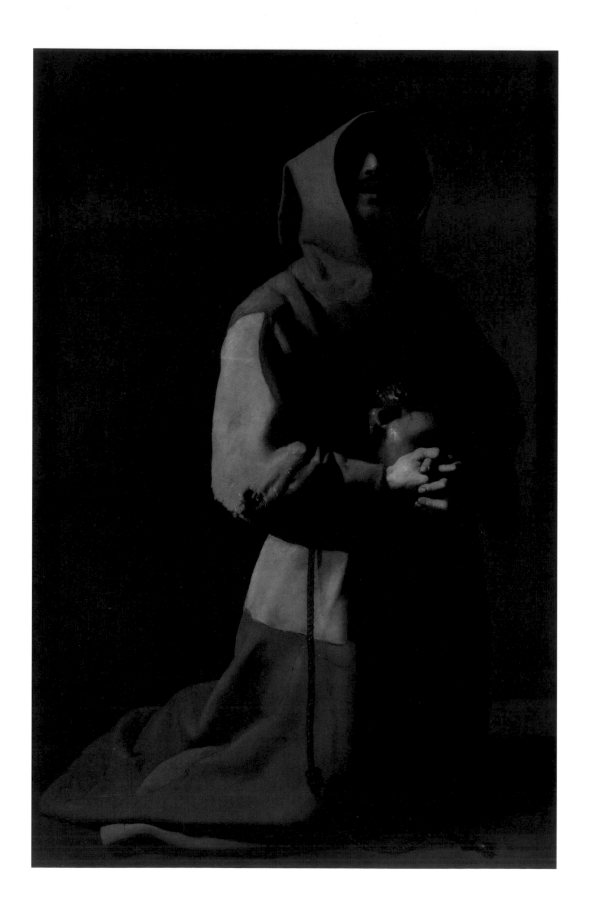

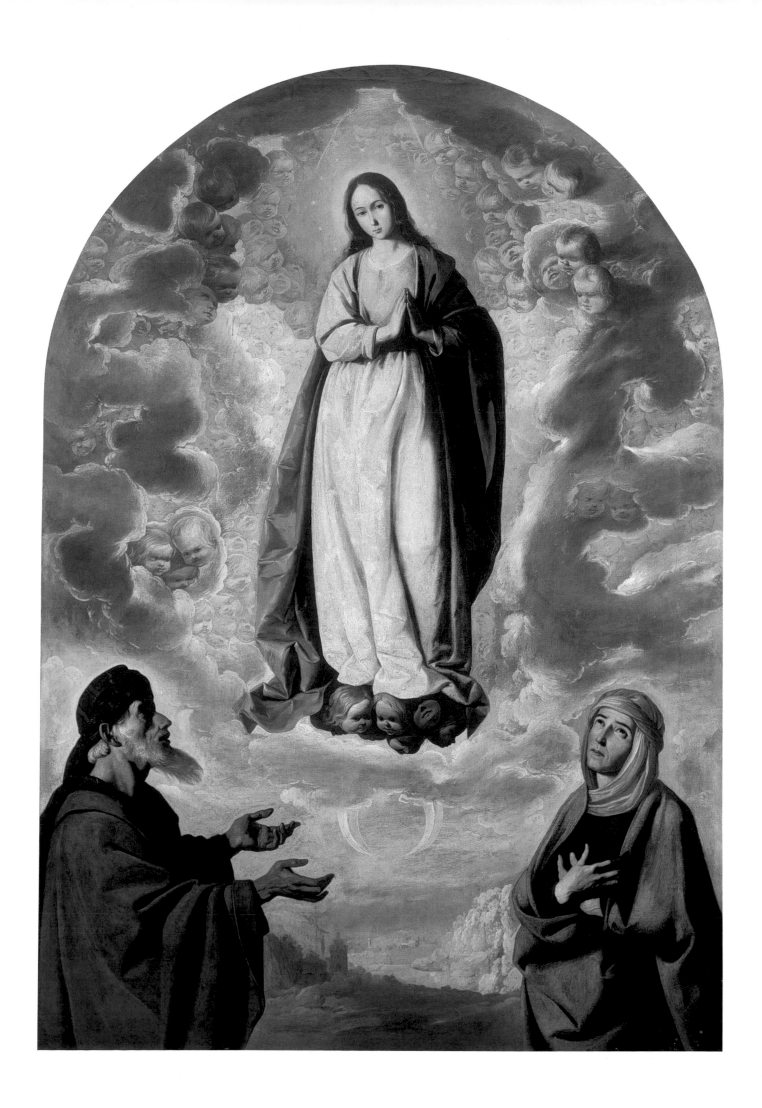

84 Attributed to El Greco
Saint Jerome as Cardinal, 1590–1600
National Gallery, London

85 Studio of El Greco
Agony in the Garden of Gethsemane, 1590s
National Gallery, London

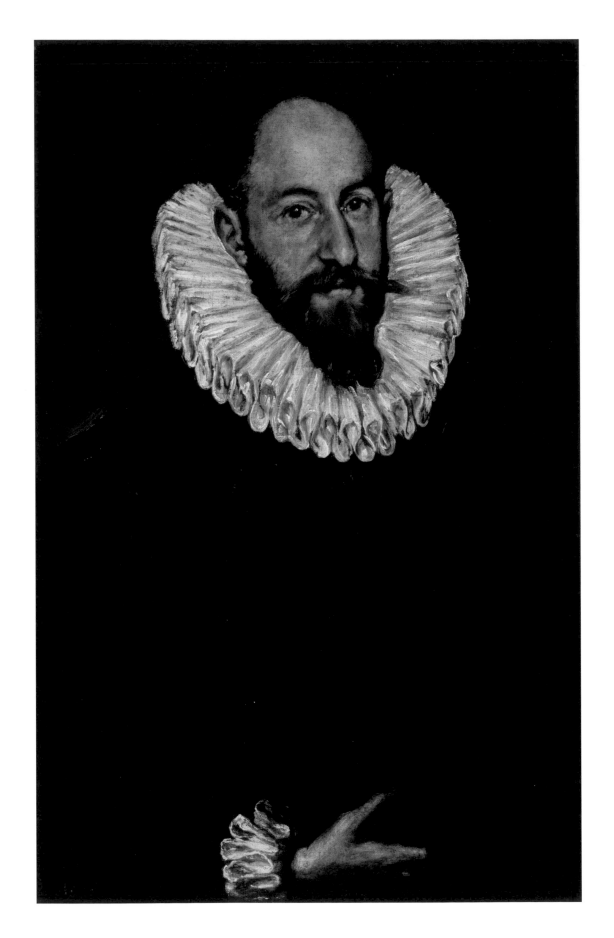

86 El Greco

Portrait of a Man, c.1590s

Stirling Maxwell Collection, Pollok House, Glasgow

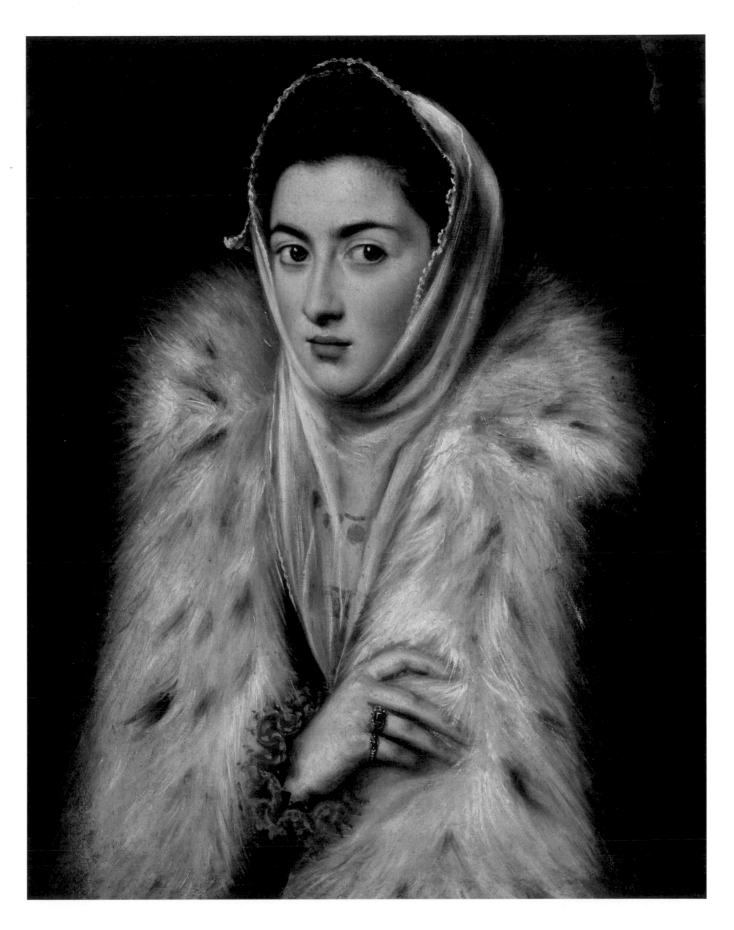

87 El Greco
Lady in a Fur Wrap, c.1577–80
Stirling Maxwell Collection, Pollok House, Glasgow

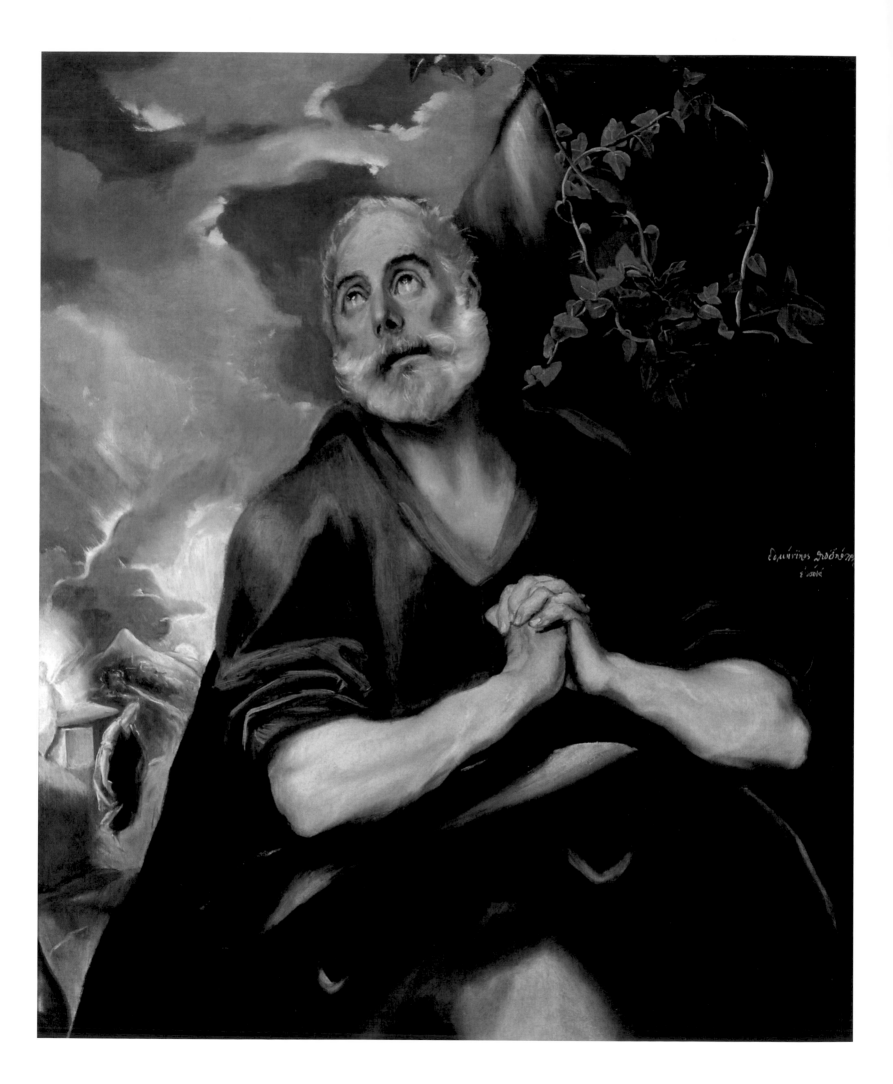

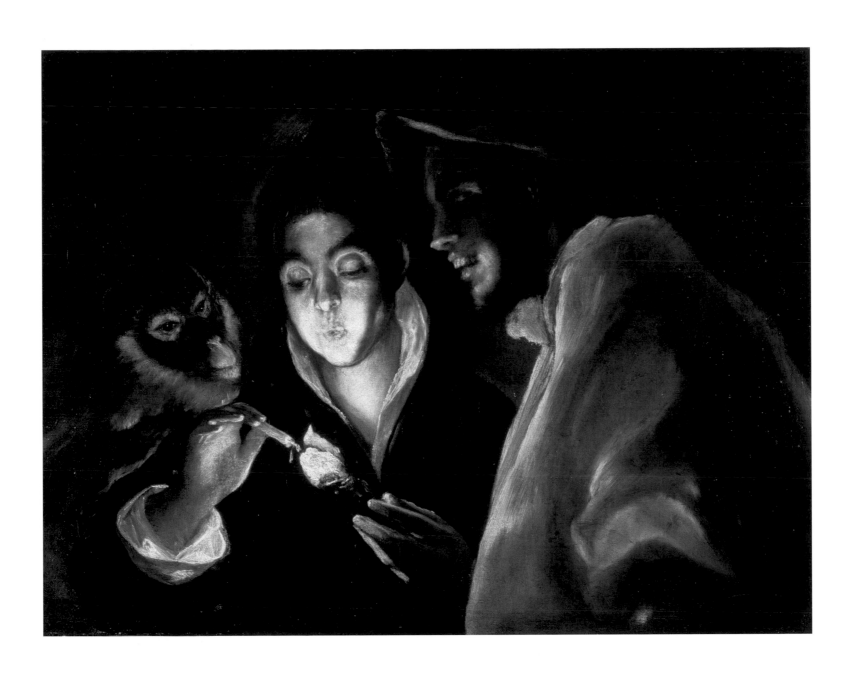

88 El Greco
Tears of St Peter, 1580s
The Bowes Museum, Barnard Castle, County Durham

89 El Greco
An Allegory (Fábula), c.1585–95
National Gallery of Scotland, Edinburgh

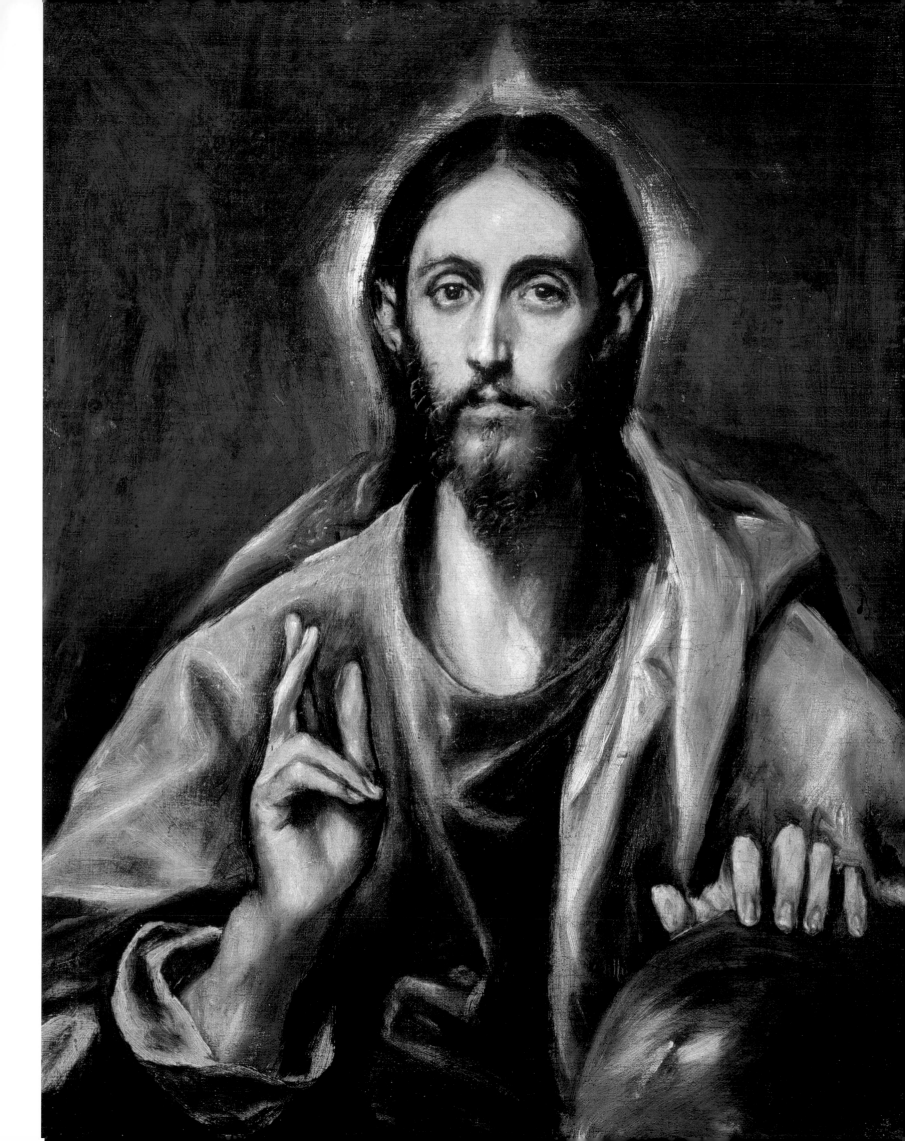

5

THE CULT OF VELÁZQUEZ

PAUL STIRTON

In October 1862 the Anglo-American painter James McNeill Whistler wrote to friends: 'You must be waiting impatiently for my journey to Spain, because you are right, I shall be the first to look at the Velazquez for you – I shall describe them, I shall tell you everything about them! – what great happiness.'[1] By then, Whistler and his generation in Paris had been steeped in the *espagnolisme* that had gripped the French Romantics over the previous three decades. They had read the Spanish tales of Alfred de Musset and Prosper Mérimée, seen plays like *Ruy Blas* (1838) by Victor Hugo, attended 'Spanish-themed' salons and watched the spectacle of Spanish dancers such as Lola de Valence. Most significantly, they frequented cafes and studios where Gustave Courbet and Edouard Manet recounted their experience of Spanish art. By this time, the Galerie Espagnole of Louis-Philippe had been dispersed, but this merely fuelled the longing for direct experience of Spanish art.

Whistler never did reach Madrid but as a consolation he acquired a series of photographs of paintings by Velázquez which informed his art for the rest of his career. Certainly he saw original (or attributed) works by 'the master from Madrid' in exhibitions, but it was photographs which exerted the strongest influence: providing motifs, gestures and technical devices that he deployed in the impressive series of portraits of the 1870s and 1880s. *Arrangement in Grey and Black No.2: Portrait of Thomas Carlyle* [92] is perhaps the first attempt at the sort of fluid brushwork and variegated 'blacks' that were associated with Velázquez's greatest works. Likewise, *Harmony in Grey and Green: Portrait of Cicely Alexander* (Tate, London) marks a new breakthrough in an understanding of Velázquez's allusive technique amongst

painters working in Britain. The most explicit homage, however, is found in male portraits such as *Arrangement in Black No. 3: Sir Henry Irving as Philip II of Spain*, 1876 [93] or *Arrangement in Flesh Colour and Pink: Portrait of Théodore Duret*, 1884, both of which rely on Velázquez's Pablo de Valladolid [94] in the bold stance, the importuning gesture and the loosely brushed ground plane. These features would reappear, sometimes in the most explicit manner or submerged within a web of interacting lines and gestures. Even at the end of his career, Whistler returned to the pose of Pablo de Valladolid for the moving self-portrait entitled *Brown and Gold* [104]. What is perhaps surprising is how Whistler could divine the principles of Velázquez's art from a rather dark sepia photograph. On the other hand, it may have been the very restricted nature of that reduced tonal image that liberated Whistler's imagination and allowed him to take up the ideal of a new art based on Velázquez. Many other painters were rendered inadequate, not to say incapable, when confronted by the sheer technical subtlety of Velázquez.

Whistler was not the first British artist to notice Velázquez. As has been remarked in an earlier essay, Wilkie had taken an interest; both commenting on and copying pictures. J. F. Lewis and John Phillip too had produced their own copies. These were much admired and used for teaching in both the Royal Academy, London, and the Royal Scottish Academy, Edinburgh [99, 100]. Nevertheless, Murillo was held in higher esteem and exerted a greater influence on the artists of the earlier nineteenth century. Victorian travellers and writers had also been drawn to Velázquez and had attempted interpretations on both the quality and significance of the court pictures. William Stirling had even

91 Sir John Everett Millais
Souvenir of Velasquez, 1868 (detail)
Royal Academy of Arts, London

devoted a separate volume, following his ground-breaking *Annals of the Artists of Spain* (1848), to Velázquez alone (1855). So the Spaniard was hardly unknown to the British. None the less, their view was heavily anecdotal and documentary; less rooted in the qualities of paint and naturalism that was to inspire Whistler.

The next major artist to seek inspiration from 'Don Diego' was another American expatriate trained in Paris. John Singer Sargent moved to London in 1884 following the controversy surrounding his *Portrait of Madame Pierre Gautreau* ('*Madame X*') at the Salon of that year. Almost immediately he began a lucrative practice portraying the British upper classes in the manner of the great portraitists of the seventeenth century. What marked Sargent out from his contemporaries was an unrivalled facility in the handling of paint, and his marked sense of the theatrical; stagey but never less than spectacular. Historic techniques and visual acuity combined, allowed Sargent to work directly from the model while exploiting the deep tones and painterly handling of the grand manner. The source for this was his training under Carolus-Duran who reputedly hectored his students with the rising trivium of 'Velasquez, Velasquez, Velasquez, ceaselessly study Velasquez'.[2] Sargent, more than any other, had the technical facility to exploit this lesson. For many artists, Velázquez was an elusive and unattainable model, but it fuelled some of Sargent's greatest pictures. The Graham Robertson portrait [103] is perhaps his masterpiece in the dark, fluidly worked full length. But many of Sargent's group portraits and fancy pictures reveal the extent to which he reinterpreted Velázquez. *The Daughters of Edward Darley Boit* [95] and *An Interior in Venice*, 1899 are very different pictures, but they are each a response to *Las Meninas*, 1657,

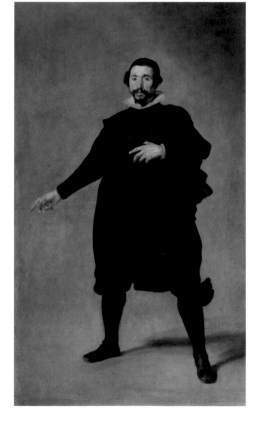

92 James Abbott McNeill Whistler
Arrangement in Grey and Black No.2:
Portrait of Thomas Carlyle, c.1872
Kelvingrove Art Gallery and Museum, Glasgow

93 James Abbott McNeill Whistler
Arrangement in Black No.3:
Sir Henry Irving as Philip II of Spain, 1876
The Metropolitan Museum of Art, New York

94 Diego Velázquez
Portrait of the Jester Pablo de Valladolid, 1632–4
Museo Nacional del Prado, Madrid

a picture that was only just emerging as the great masterpiece which it clearly is to modern eyes. Whistler had tried something similar, although less explicit, in *The Artist's Studio* in the mid-1860s, but had been unable to bring the idea to a satisfactory conclusion.

One of the features that seemed to mark out the (re)discovery of Velázquez was the extent to which it was driven by artists not critics. It was artists who sensed a kinship with Velázquez's work and his whole approach to the craft of painting. Above all, it was the emergence of a new aesthetic in the last quarter of the nineteenth century that laid the groundwork for Velázquez's elevation to the front rank of European old masters. In Britain Velázquez was associated with the gradual discovery of progressive French art in the wake of Manet (perhaps the greatest disciple of the Spanish School). As younger artists turned to France for lessons in paint handling, in 'plein-air' colour values, and in a commitment to observed naturalism, it was Velázquez who seemed to have followed this same road two centuries earlier. Walter Sickert was not alone when he stated in 1889, 'Velázquez was an Impressionist'. [3] This sentiment would be echoed later by virtually all the progressive painters of the New English Art Club, the Glasgow School, and the other groupings. It is perhaps indicative of this split between the followers of Whistler and the figures of the Establishment, that the same year that saw Sickert make his characteristically blunt and unequivocal link between Velázquez and the Impressionists – a group that Sickert knew and understood better than any of his British contemporaries – Frederic Leighton would devote his annual address to the students of the Royal Academy to the character and shortcomings of the Spanish School. To Leighton, Velázquez may have been the finest of the Spaniards but his work was weakened fatally by his role as a fawning courtier. The difference between these two attitudes towards the art of Velázquez – one anecdotal and assessed by moral association, and the other unashamedly aesthetic, seeking to make a bridge between the lessons of the past and modern ideals – indicates the gulf that was opening up between the Establishment and the new 'secessionist' groups in Britain. The disparate responses to Velázquez among the younger artists found their focus in 1895 with

a publication which marked a new standard of art criticism in Britain.

The Art of Velasquez by R.A.M. Stevenson is still one of the most remarkable books written about the art of the past, inspired by the frustrations of a failed painter who could nevertheless use his experience to recognise the genius in Velázquez's art. [4] Cousin of Robert Louis Stevenson, dabbler in law, medicine and journalism, 'Bob' Stevenson is known primarily for his astonishing investigation into the 'process' of great paintings. He does not attend to technical issues alone, although a great deal of the text is devoted to analysing the Spaniard's use of colour, tone, composition, brushwork and space. Even more remarkable is Stevenson's attempts to understand the mysterious alchemy whereby marks on a canvas can form recognisable shapes, assume meaning, and develop conceptual significance. As someone who had tried naturalist painting for several frustrating years, he was aware of the huge gap that exists between mere description, however accurate, and the skill that matches brushwork to a new way of seeing and feeling. [5]

Stevenson had emphasised that the only way to appreciate Velázquez was to visit the Prado in Madrid. This is still true. No other artist of the first rank is represented so thoroughly in one gallery. British artists interested in Velázquez, and by now many were, had to make the pilgrimage to Spain as an essential part of their training. But British collections did have a number of great paintings, which were becoming more accessible. By 1895, the National Gallery in London had acquired a series of major works by Velázquez and other Spanish artists to form a small, but outstanding group of pictures. The landmarks in this process were Velázquez's *La Tela Real* (bought 1846) and Zurbarán's *St Francis in Meditation* (bought 1853), culminating in the acquisition of the *Rokeby Venus* in 1906. But a work which perhaps acted as a touchstone for the emerging British tradition of portrait painting in the Velázquez manner was the great *Philip IV of Spain in Brown*

95 John Singer Sargent
The Daughters of Edward Darley Boit, 1882
Museum of Fine Arts, Boston

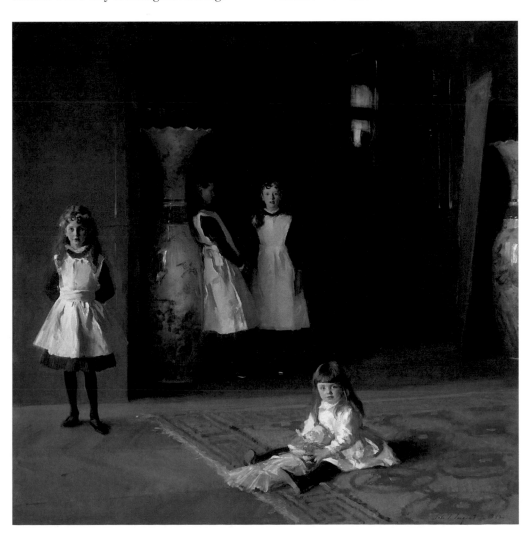

and Silver. The fact that it was given this picturesque title soon after its acquisition in 1882, suggests that Velázquez was becoming interpreted through the eyes of Whistler's aesthetic. Just as the Glasgow Corporation had acquired Whistler's *Portrait of Thomas Carlyle* in 1891, showing the extent to which a portrait could be both modern and a good likeness – both a work of art and an image with gravity and personal presence – artists returned to Velázquez to elaborate the repertoire of the bourgeois full length. This approach was at its most extreme among the artists of the 'International Society' [International Society of Sculptors, Painters and Gravers], the organisation set up by Whistler in 1897 and dominated by his followers and acolytes through the Edwardian period. It is perhaps not surprising that one of the most successful portraitists in this vein should be John Lavery, a leading figure of the Glasgow School and campaigner for the acquisition of the Carlyle portrait. Lavery's *Portrait of R. B. Cunninghame Graham* is not merely a homage to both Whistler and Velázquez in its pose, its handling and colour scheme, but also a perfect vehicle to emphasise the swaggering *hispagnolisme* of its sitter. By 1893, when it was painted, Cunninghame Graham was something of a celebrity, as well known for his exploits in Spain and South America as for his writings. He could even claim descent through his mother's line from the Spanish nobility and had adopted the sobriquet, 'Don Roberto'. Adventurer, novelist, politician and minor aristocrat, he is depicted as the man of action as well as one of poise and breeding. It is no accident that in 1902, the artist-printmaker William Strang employed Cunninghame Graham's features for Don Quixote in a series of etchings illustrating scenes from Cervantes's novel.

Such treatment was not restricted to those with Spanish associations. When William Nicholson painted Max Beerbohm, a fastidious and somewhat effete Englishman, he portrayed him in the subtle tones and loosely sketched manner of Spanish court portraits. Nicholson applied a similar variation on Velázquez's mature style to his own depiction of the aged Walter Greaves [98], Whistler's

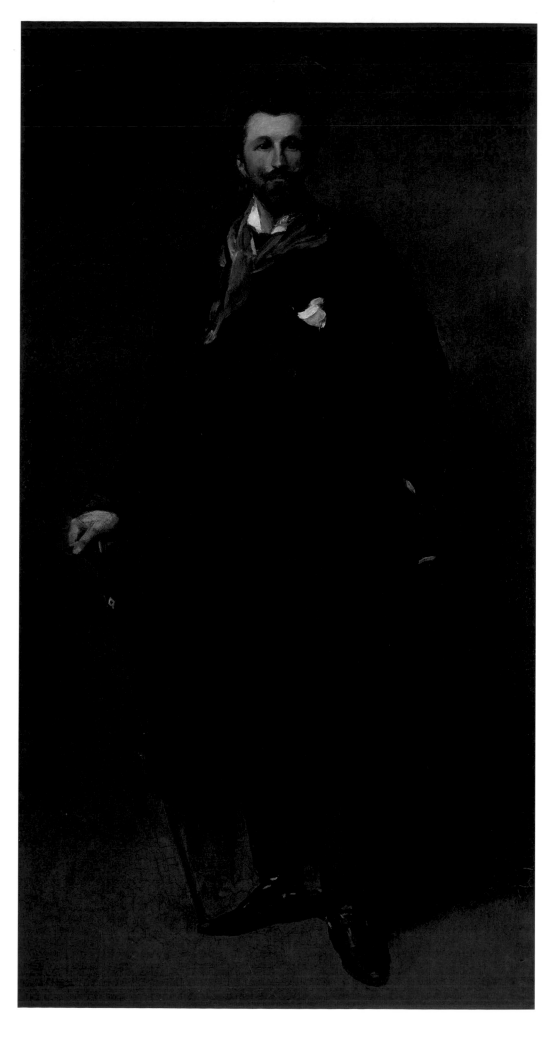

96 Sir John Lavery
R.B. Cunninghame Graham, 1893
Kelvingrove Art Gallery and Museum, Glasgow

boatman and disciple. Clothed in the many shades of black and grey that traditional Victorian formal dress demanded, Greaves rests his hand on the piano for support echoing the gesture of Philip IV in so many of his formal portraits by Velázquez. The same gesture appears in the curious and vivid portrait, *Dolly*, 1896, by the precocious Aberdeen painter Robert Brough. Here, and in the same painter's *Fantasie en Folie* of 1897, the sitters' features appear to be modelled directly on those of the Habsburgs, further elaborating the sense of Velázquez as a living presence in contemporary art.

This identity with Velázquez carried on throughout the Edwardian period. Nowhere more so than in the 'swagger portraits' and lavish family groups set within the generous spaces of contemporary drawing rooms. Sargent continued these until he gave up commissioned portraiture in 1907 to concentrate on more congenial subjects. Others, however, could turn their hand to a pastiche of Velázquez. The Hungarian Philip de Laszlo was one of the most successful, as was William Orpen. Lavery also pursued a combination of lucrative portrait commissions and ever decreasing landscape work.

In 1913 he was working simultaneously on two large portrait groups which took their lead from *Las Meninas*: one of his own family at home and the other of the royal family at Buckingham Palace [97]. That the cult of Velázquez had become a rather staid formula by now is best demonstrated by looking back at *Las Meninas* in the light of these attempts to apply the Spaniard's complex spatial rendering, his endlessly suggestive relationships, and the supreme mastery of 'facture as description' when applied to modern English domestic settings. This is perhaps an unfair comparison – like mentioning Shakespeare in a conversation about minor poets. But it makes the point that Velázquez had become a standard source for the British portraitist, to be adapted with varying degrees of success.

One artist, however, seemed to remain fascinated by something intangible in Velázquez's art, and his own work became marginalised partly as a result. James Pryde, brother-in-law of and collaborator with William Nicholson, developed his own 'take' on Velázquez, inspired, like the rest of his generation, by Whistler. He found in Velázquez both the dark and theatrical as

well as the pure pleasure of manipulating paint in ways that stretch the powers of simple representation. In simplified, gloomy scenes like *The Doctor* [105] we can easily spot the references to *Las Meninas* in the asymmetry of the receding coulisses [wings] which lead us back into the room. But we can also sense an artist at work who is struggling with the relationship between facture [paint work] and description. This was what Stevenson had described in words, and what Whistler had grasped intuitively from looking. This tension between two properties that Velázquez held in perfect balance, lay at the heart of early Modernism. It is no coincidence that the period was marked by the new debates on Post-Impressionism and of the pre-eminence of form in art. For this, however, Roger Fry, the leading apologist for the avant-garde at the time, looked towards El Greco rather than Velázquez.

97 Sir John Lavery
The Royal Family at Buckingham Palace, 1913
National Portrait Gallery, London

98 Sir William Nicholson
Walter Greaves, 1917
Manchester City Galleries

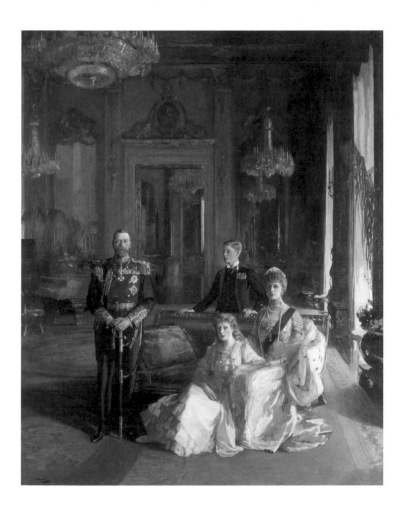

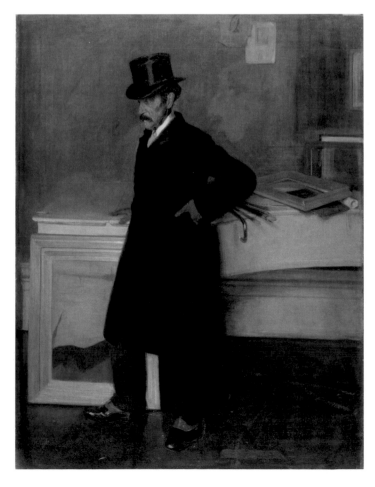

99 John Frederick Lewis after Velázquez

Prince Baltasar Carlos on Horseback, c.1832–3

Royal Scottish Academy Collections, Edinburgh

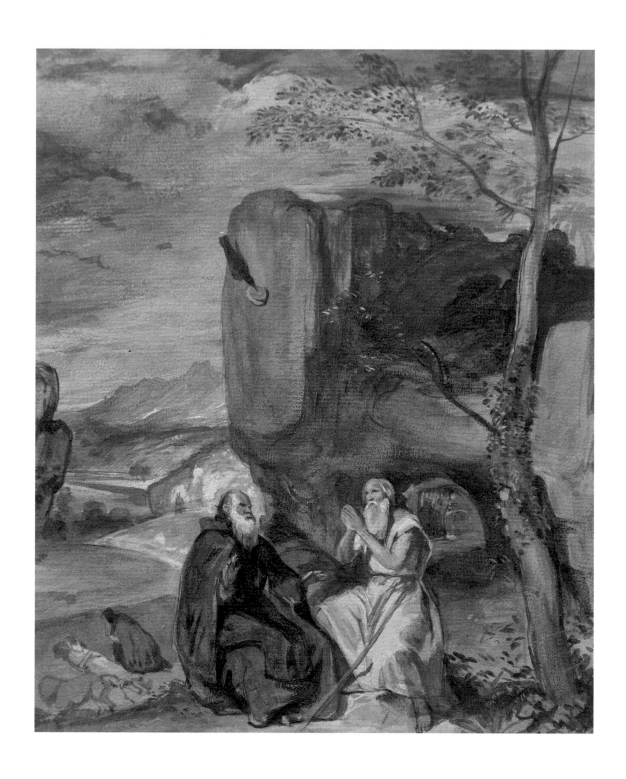

100 John Frederick Lewis after Velázquez

Landscape with St Anthony Abbot and St Paul the Hermit, c.1832–3

Royal Scottish Academy Collections, Edinburgh

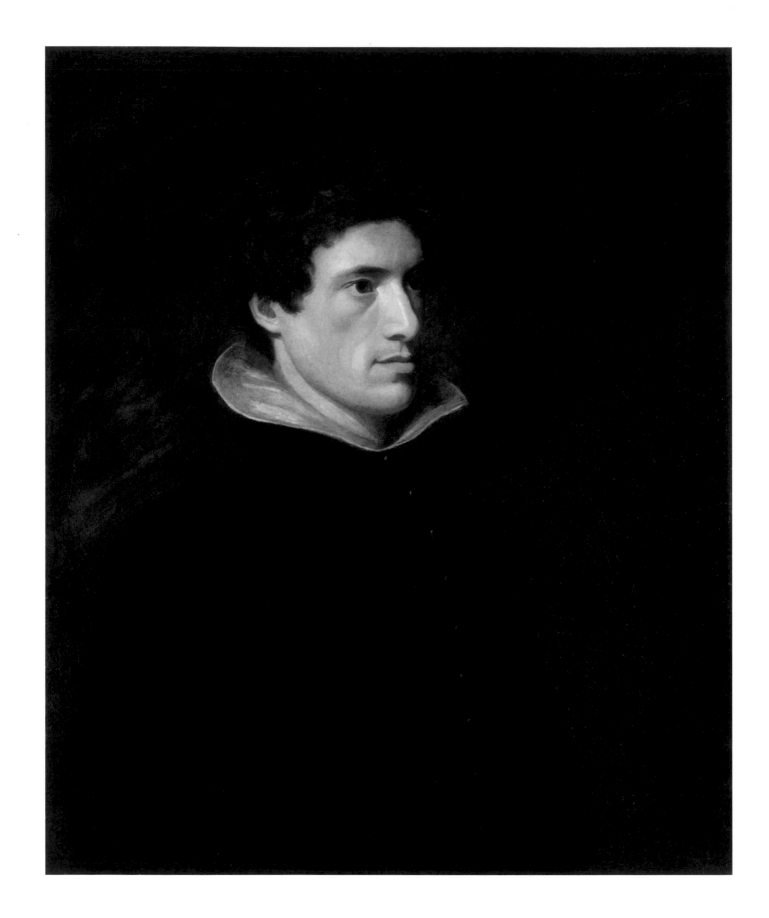

101 William Hazlitt *Charles Lamb*, 1804
National Portrait Gallery, London

102 Sir John Everett Millais *Souvenir of Velasquez*, 1868
Royal Academy of Arts, London

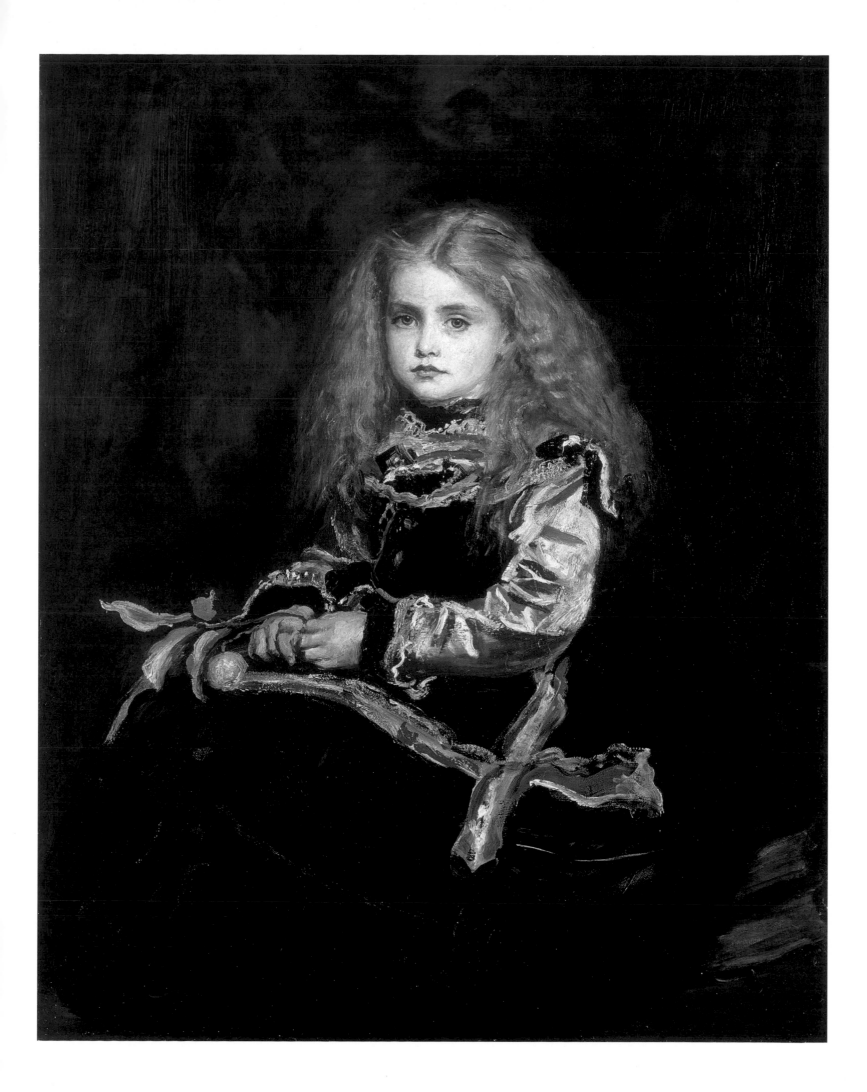

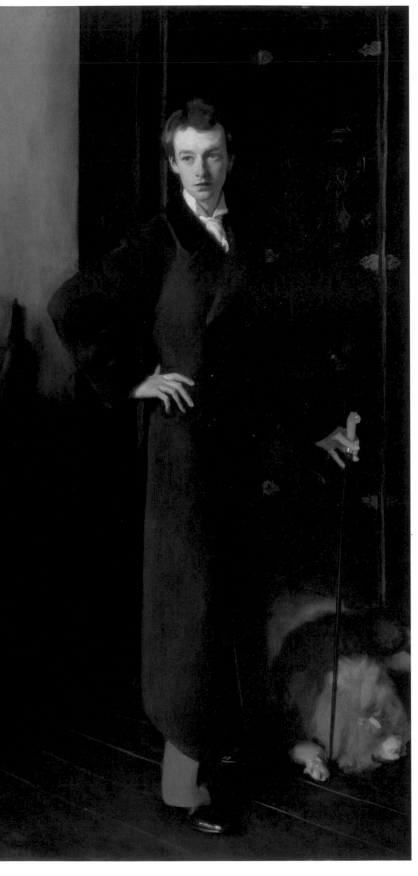

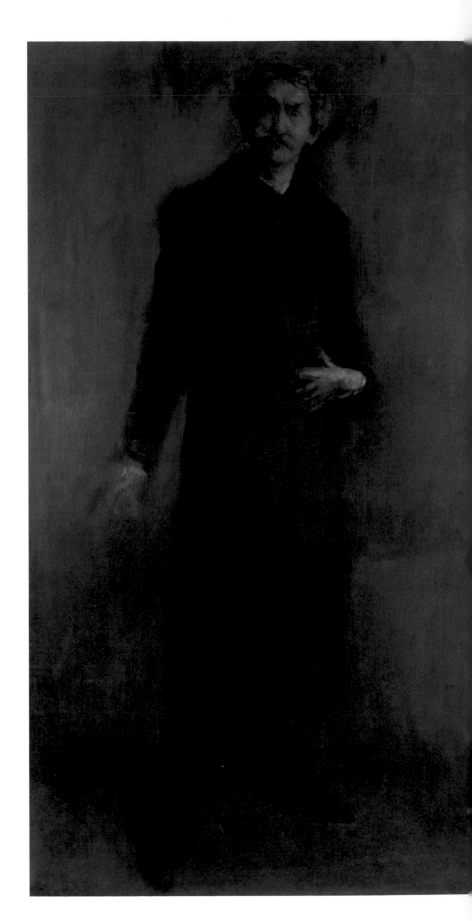

103 John Singer Sargent
Portrait of W. Graham Robertson, 1894
Tate, London

104 James Abbott McNeill Whistler
Brown and Gold (Self-portrait), c.1895–1900
Hunterian Museum & Art Gallery, University of Glasgow

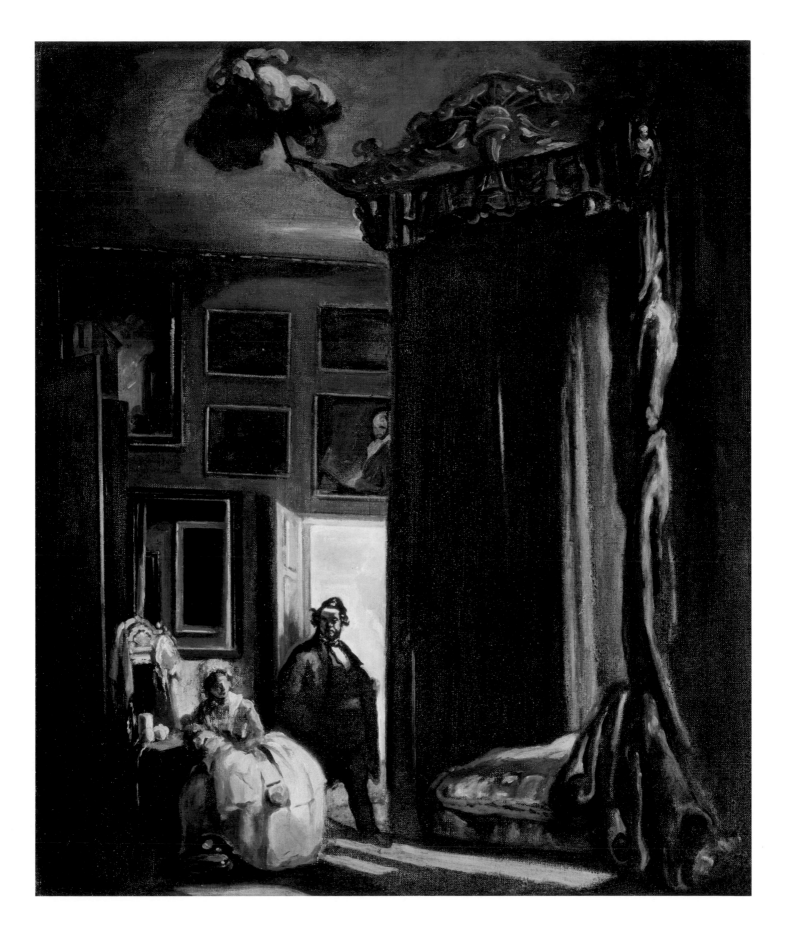

105 James Pryde
The Doctor, 1909
Tate, London

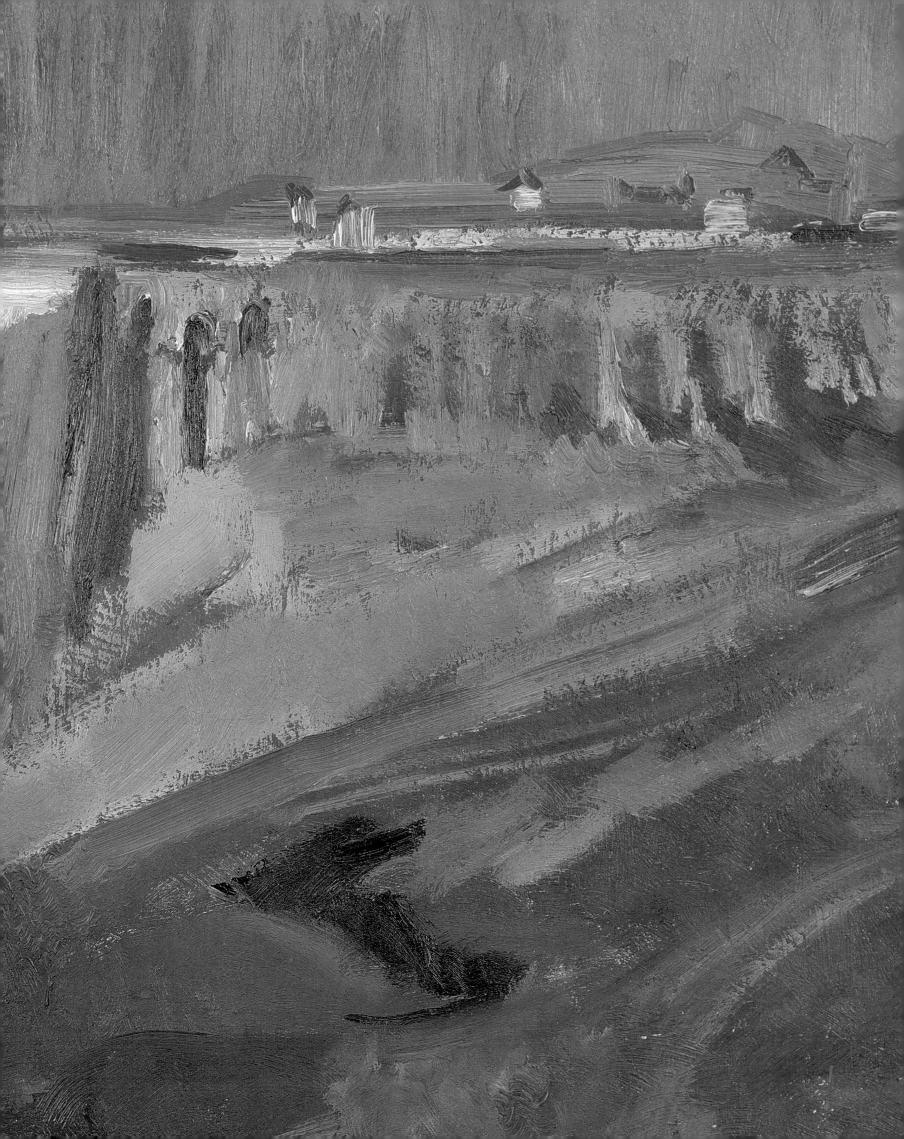

6

COLOUR AND LIGHT: FROM SARGENT TO BOMBERG
MICHAEL JACOBS

Spain continued into the twentieth century to be widely perceived as in the Romantic era – an essentially backward and exotic country dominated by extremes of mysticism, passion and sensuality. Its appeal to travellers remained based to a great extent on barely a handful of artistic geniuses, on the folkloric traditions of the south, and on the Moorish palace-city of the Alhambra, already so popular with tourists that there were queues to get into the Court of the Lions.

If travellers had once greatly exaggerated the dangers and difficulties of a Spanish journey, there was now even less justification for doing so. Road travel and accommodation were much improved; bandit attacks happened far more in fiction than reality; the advent of the railway had put Granada and Seville within easy reach of Madrid, and turned the once notoriously inaccessible hill-town of Ronda into a genteel summer resort complete with a 'Paseo de los Ingleses'.

Though a visit to the Prado in Madrid was a prerequisite to anyone seriously interested in the culture of Spain, the main draw for most tourists was the southern region of Andalusia, which was thought to be a repository of everything that was most typically Spanish. Nearly all the Spanish clichés of Andalusian origin had been brought together in 1845 in Prosper Mérimée's novella *Carmen*, which – thirty years later – was made by Bizet into an opera misleadingly praised for its realism. The craze for Andalusia had now reached new international heights, and was fuelled further by Edmondo de Amicis's hugely successful *Spagna* (1873) – a travel book whose gushing pages were symptomatic of the hyperbole increasingly and wearyingly applied to Spain.

An English copy of de Amicis's book was owned by the American-born painter John

Singer Sargent, who, as has been pointed out, was first attracted to Spain by the art of Velázquez. It was above all with the intention of studying the latter's paintings in the Prado that Sargent travelled to Spain in the autumn of 1879. But after staying in Madrid and Toledo (where he had admired the increasingly fashionable El Greco), he had been tempted to go on to Andalusia and follow the well-established route that included Granada, Seville, Malaga, and the Serranía de Ronda. The painting opportunities, not to mention the overall enjoyment of the trip, were affected by something that Sargent had perhaps not expected of Spain, let alone of the south – continual pouring rain. None the less, this first brief taste of Andalusia would have long-term consequences.

Sargent was most impressed by Granada, and not just by the Alhambra. It was in Granada that he seems first to have fallen under the spell of flamenco dance and song. The roots of this music are probably ancient; but flamenco as a public spectacle evolved in the nineteenth century with the growth of tourism. Granada, as the then tourist capital of Spain, was famous for its flamenco shows or *zambras*, which came to be the speciality of the gypsy cave district of the Sacromonte. Sargent's attendance at one of these shows would give rise, a few years later, to his large canvas *El Jaleo* [107]. This, the most powerful portrayal ever painted of a flamenco performance, also encapsulates what would soon become one of the most hackneyed images of Spain.

Despite having succumbed to Anadalusia's seductive exoticism (which encouraged him to move on immediately afterwards to Tangier – a place regarded since the time of Roberts and Lewis as an Andalusia writ large), Sargent would not go back to Spain

106 David Bomberg
The View of the Bridge and Tajo, Ronda, 1935 (detail)
Private collection

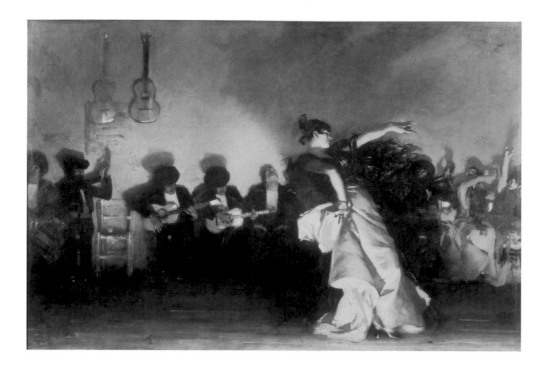

of Spain as flamenco – the bullfight [108]. British travellers to Spain had very mixed feelings towards this aspect of Spanish life, especially as the horses of the picadors went unprotected up to the 1920s, and spectators had frequently to witness the guts of the animals spilling out on to the ring. However, bullfights were also seen as conveying that element of intense morbid excitement which foreigners thought integral to any Spanish journey. Crawhall, as a lover of animals and a specialist in painting them, might not have been the most likely devotee of such fights. But he went to one in Algeciras in the company of the painter Denholm Armour, who wrote that it was 'one of the most stirring spectacles I have ever seen, despite the horrors that the horse part makes one feel... Crawhall afterwards did a very fine picture of a picador and bull ...'[1] At least two British commentators have defended Crawhall's interest in the subject on the grounds that he was primarily concerned with the portrayal of movement.

107 John Singer Sargent *El Jaleo*, 1882
Isabella Stewart Gardner Museum, Boston

108 Joseph Crawhall *The Bullfight*, c.1889–91
The Burrell Collection, Glasgow

until the autumn of 1912, by which time his art, like that of his Spanish contemporary Sorolla, had been affected by the French-inspired fashion for representing the dazzling, Mediterranean sunlight. Fortunately the weather conditions were apparently better than they had been during his last stay. Although he was still drawn by stereotypically picturesque Spanish subjects, such as the *Blind Musicians* [114], he concentrated now on the effects of the sun brilliantly illuminating, say, one of the fountains in the grounds of the Royal Palace at Aranjuez.

The colour and light of Spain, so much more intense than what would generally be found in northern Europe, became a primary obsession of some of the more progressive British artists drawn to Spain from the 1880s onwards. Among these was Joseph Crawhall who paid several visits to Andalusia while staying in Tangier for various periods between 1884 and 1891. During these years, he was associated with the Glasgow Boys, a group who introduced to Britain their own brand of Impressionism, and accordingly distanced themselves from the stuffy Royal Academy. Crawhall, praised by the group for his remarkable economy of line, was also encouraged during this time (probably by fellow Glasgow Boy Arthur Melville) to devote himself mainly to watercolour, a medium well suited to his sketchy concision.

Stylistically daring though he might have been, Crawhall found himself attracted towards a subject that was as much of a cliché

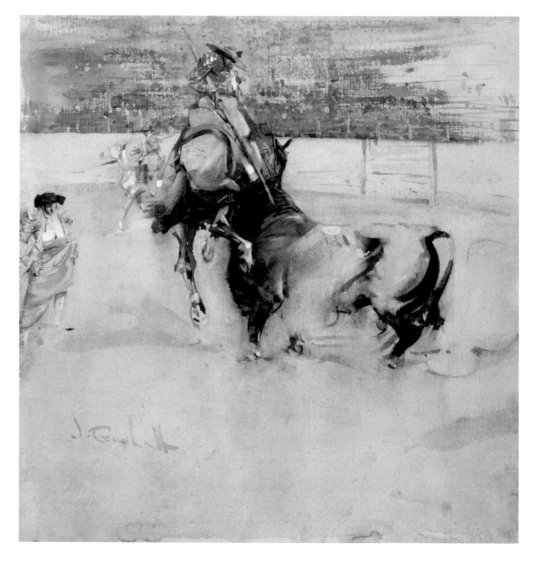

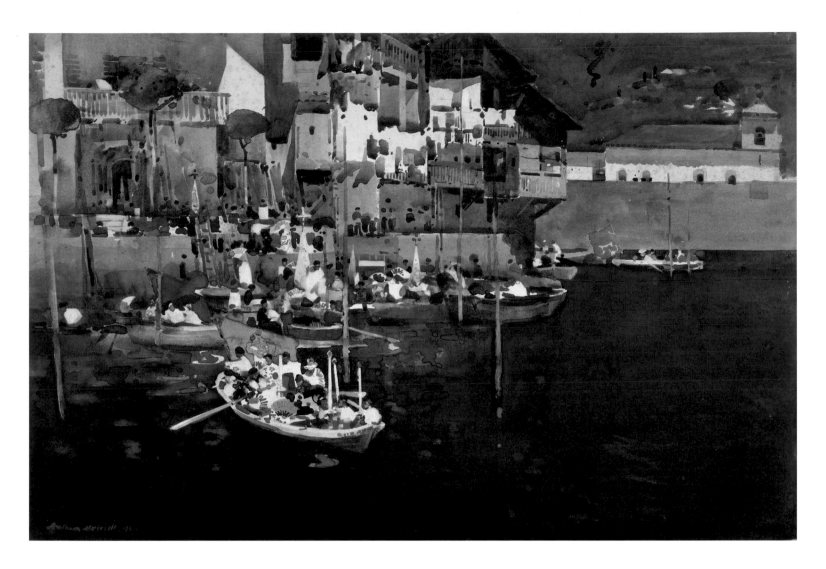

109 Arthur Melville
A Mediterranean Port (Pasajes), 1892
Kelvingrove Art Gallery and Museum, Glasgow

Crawhall's undeniable fascination with bullfighting and with Spain appears to have infected Arthur Melville, who was inspired to go there in the spring of 1890, and developed a literally fatal passion for the place: he would return every year to Spain until 1904, when he contracted typhoid, and died at the age of forty-nine. To an extent, much greater than Crawhall, Melville was able to take such worn Spanish themes as Ronda and the bullfight and concentrate on the decorative and abstract elements of his subjects. Melville's *Bravo Toro* [115] is a culminating example of his peculiar and original brand of impressionism: while evoking the festive atmosphere of a fight, better almost than any other painter has done, it is also a dazzling mosaic of colours that could easily illustrate the equation between art and musical harmony as proposed by Melville's avant-garde contemporary Wassily Kandinsky.

Melville was also one of the few British artists of his day to travel in Spain far from the beaten tourist track. He did so in 1891 in the company of another great colourist, Frank Brangwyn, whose work, though often under-appreciated in Britain (as indeed has been Melville's), would actually be singled out by Kandinsky as a pioneering example of early modernism in its contrasting use of blues and reds.

Brangwyn and Melville made their way in 1891 straight to the Aragonese town of Saragossa, from where they set off at first to explore a region known hitherto to artists mainly as the birthplace of Goya. In a letter Brangwyn later wrote to the *Studio*, he described how the two of them discovered the appeal of obscure, neglected places such as Catanillo ('a dead city, peopled with strange earth-coloured phantoms'), and of the often monotonous landscape of the Spanish interior, which for them had 'a subtle pathetic charm in its monotony' and 'a rich yet subdued colouring'.[2] But perhaps the main artistic revelation of the tour came after they

had left Aragon and moved on to the small Basque fishing village of Pasajes, then as little visited as it had been when the orientally-deluded Victor Hugo had unexpectedly come across it nearly fifty years earlier, and had the sensation of 'being in Tetuan'. Brangwyn and Melville – who thought of the village instead as 'a tiny Venice, with essentially Spanish features' – found perfect material for their art in the sight of a patchwork of coloured, balconied houses reflected in a narrow bay [109].[3]

Another British colourist of considerable originality was the short-lived Welsh painter J.D. Innes, who painted in 1912 some tiny Fauve-like canvases in the countryside around Ronda [110]. Yet it was not until well after the First World War that Spain would once again be a major source of inspiration to British artists. An important new phase in the British appreciation of Spain began with the arrival in 1923 of the Bloomsbury associate and future hispanist Gerald Brenan. As with several of the intellectual British travellers who would come to Spain in his wake,

Brenan was rebelling against a strict English middle-class background, and hoping to find in this country the antithesis of the world in which he had been raised. Preferring not to settle in a major tourist centre such as Granada, he perversely chose to live for a few years in a remote, primitive, and (by his own reckoning) ugly Andalusian mountain village that would have been anathema to earlier British visitors to Spain. Soon afterwards he was visited by his Bloomsbury friends including Virginia Woolf who, significantly, carried with her a book about Paul Cézanne.

Brenan's adopted district of the Alpujarra, with its flat-roofed, cube-like architecture, could easily be imagined in terms of the paintings of Cézanne and his cubist followers. But the enormous importance of Cézanne to European artists of the 1920s was not just a stylistic one: his works encouraged people to do what Brenan had done and move to unspoilt rural districts of Europe in search of their own Mediterranean arcadia. The latter's obsession with the enclosed land of the Alpujarra seems to have been briefly transmitted to Dora Carrington (with whom he was passionately if platonically in love), who painted outside his village one of her most powerful canvases depicting the Yegen landscape – a work which captures the compelling other-worldliness of this part of Andalusia. The sophisticated English and French scenes normally favoured by

Carrington and her Bloomsbury colleagues must have seemed afterwards unadventurous by comparison [111].

The appeal of Spain started now significantly to broaden, with foreigners going there in the hope of finding the pungent vestiges of an unchanged and archaic Europe. In those heady years leading up to the Spanish Civil War of 1936–39, the British engagement with the country became more intense than ever, with a number of British writers, such as V.S. Pritchett, Walter Starkie, Norman Lewis, and Laurie Lee, making their names through their extensive solitary wanderings around the country, often on foot, and sometimes with a guitar or fiddle. Lee's published account of his Spanish travels, *As I Walked Out One Midsummer's Morning* (1969), encapsulated the ideals of this generation, and fixed in the minds of the British the idea of Spain as a place for romantic escape.

There were artists of this period who were similarly overwhelmed by their Spanish experiences, for instance the great eccentric Edward Burra, who fell in love with Spain even before getting there. Enamoured with the Spanish paintings he saw in the Louvre, he began teaching himself the language with the aid of Hugo's *Spanish Simplified*. In 1932 he travelled to Granada, where he joined up with the novelist Malcolm Lowry (whose *Under the Volcano* owes almost as much to Andalusia as it does to Mexico), and stayed

in the same pension where Sargent had twenty years earlier. A lover of low life, the grotesque, and the works of Goya, Burra had been side-tracked on the way to Granada by the town of Almería, whose glorious seediness and desert-like surroundings made him call the place 'a spot so beautiful I wouldn't have missed it for the world'.[4] His taste for the strange and seamy later drew him – on his return to Spain in the spring of 1935 – to explore the nocturnal life of Madrid and the notorious Barrio Chino of Barcelona. Burra found the outbreak of the Civil War particularly calamitous because of such close contact with Spain, and consequent sympathy he acquired for the Spanish people. The start of the hostilities caught him on another visit to Granada, shortly before the notorious assassination there of the poet García Lorca. He thought of the war in terms of a country in the sudden grips of a demonic possession.

So many other British artists and writers were forced, like Burra, to flee Spain in 1936. One such painter was William Nicholson, an artist of radically different sensibilities to Burra, who had developed a similarly strong passion for Spain since first visiting the place in 1933, following the break-up of his second marriage. In 1934 he was invited to Malaga to paint the portrait of the outgoing director of the London Zoo, Sir Peter Chalmers-Mitchell, in whose house he would later meet the writer Marguerite Steen. Steen, who had lived in Granada, was the author of *Matador*, a popular novel about bullfighting which a friend had given to Nicholson two years earlier as a way of first getting him into the Spanish mood. He and Steen fell in love, and went back to Spain the following year, when Nicholson eccentrically declared the country to be his second 'spiritual home'. Advised to leave in May because of the disintegrating political situation, he would never see the place again.

The strength of Nicholson's feelings towards Spain, so obviously tied up with those for Steen, have also been fancifully attributed to his life-long interest in Morris Dancing, which is sometimes thought to have been a legacy of the Moors. The impact of Spain on his art was in any case as subtle

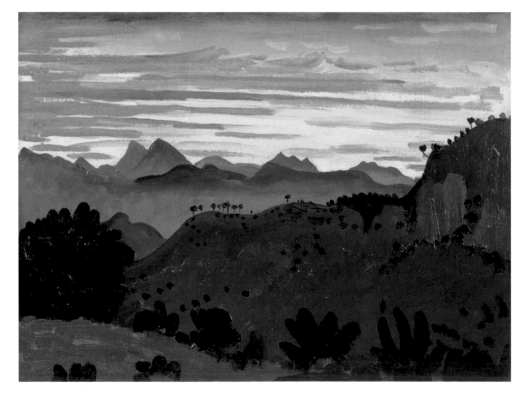

110 James Dickson Innes
Sunset, Sierra de Ronda
The Fine Art Society, London

111 Dora Carrington
Mountain Range at Yegen, Andalusia (Spanish Landscape with Mountains), 1924
Tate, London

capturing instead what he called 'the expanding mass.' Bomberg's Toledo landscapes are profoundly spiritual works whose apparently crazed zigzagging of brushstrokes is underlied by the same intellectual rigour and clarity to be found in El Greco himself.

The drama of the Spanish landscape clearly brought out the best in Bomberg; and when he and his wife Lillian returned to Spain in 1934 they sought out places as theatrical in their settings as Toledo, staying first in Cuenca, with its celebrated 'hanging houses', and then in Ronda, whose sublimely vertiginous gorge had overwhelmed artists since the time of Lewis, a century before. They were particularly impressed with Ronda [119], which Bomberg rendered as if it were some tragic, expressively distorted stage set. The gorge that cleft the town in two must have appeared now as an apt symbol of a country soon to fall apart.

When, twenty years later, Bomberg went back to Spain, he and Lillian rented an isolated house on the outskirts of Ronda, and from there enjoyed superb views of the gorge at sunset. Thought of locally as a slightly absurd figure, who spoke appalling Spanish, and went everywhere on a much loved donkey, Bomberg lived in Ronda until he fell fatally ill in 1957. In contrast to Lillian and most of their British contemporaries, he would never be lured by the superficial colour and glamour of the romantic Spain of old. What attracted him instead was his vision of a transcendental Spain whose landscape had a visceral force that mirrored his internal world.

as the art itself. The Spanish environment broadened slightly his colour range, and, so he claimed, presented him with new and unusual viewpoints. But most of his thirty or so Spanish works merely strengthened existing tendencies of his towards minimalism, as in his memorable *Plaza de Toros, Málaga* [117], which returns to the typically subdued, almost monochromatic colouring of his English years. Intended probably as a valentine to the bullfight-loving Steen, this painting succeeds as a very modern interpretation of a classic theme, exploiting as it does the abstract possibilities of a circular monument set against a spit of land tapering into the sea.

The one British artist of this period whose work was dramatically transformed by Spain was David Bomberg, who was responsible for what are perhaps the most exciting landscapes ever painted of this country. His career up to his arrival in Spain in August 1929 had been a checkered one. Famous in his youth for his daringly original abstractions, he then lost the support of the British avant-garde after being traumatized in the First World War and going on to paint in Palestine what were dismissed as conventional figurative landscapes. However, it was in Palestine that he first felt the pull of the

Mediterranean world, and had the sensation of seeing the sun as if for the first time. Of more tangible consequence was his encounter there with two women who showed him a reproduction of one of the Toledo paintings of El Greco, an artist still barely represented in Britain, 'If Toledo can inspire a painting of that quality', he is reported to have said, 'I am going there.'[5]

His sister Kitty provided him with some of the funds for the journey, which seems to have been further motivated by the enthusiasm for Spain of his old friend Sir Muirhead Bone, whose conventional graphic works of the country were exhibited earlier that year in London. Bomberg spent several months in Toledo [118], mainly on his own, working with a near manic intensity, and evolving a visionary new style. Toledo, with its spectacular situation above a bend in the River Tagus, was already a major focus for tourists; but Bomberg there produced works unlike any others executed by foreigners of Spain's famously picturesque corners. Dismissing the efforts of his romantic and other predecessors as 'merely visual drawing', and referring to the 'romantic fallacy' of trying to convey the 'illusion of distance', he abandoned the landscape artist's traditional perception of the world as a three-dimensional space in favour of

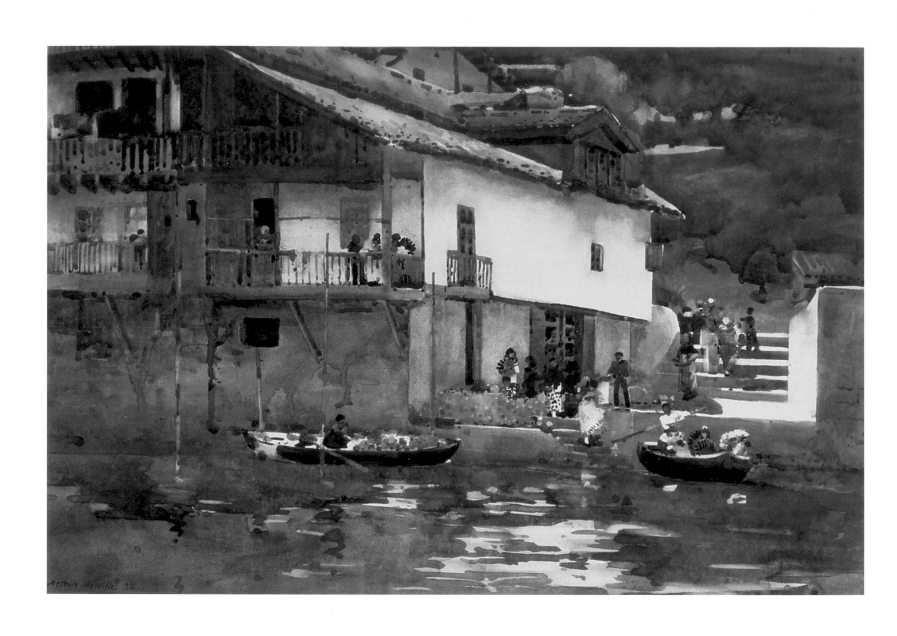

112 Arthur Melville *Orange Market, Saragossa*, 1892

The Fleming-Wyfold Art Foundation, London

113 John Singer Sargent *The Spanish Fountain*, 1912

Fitzwilliam Museum, Cambridge

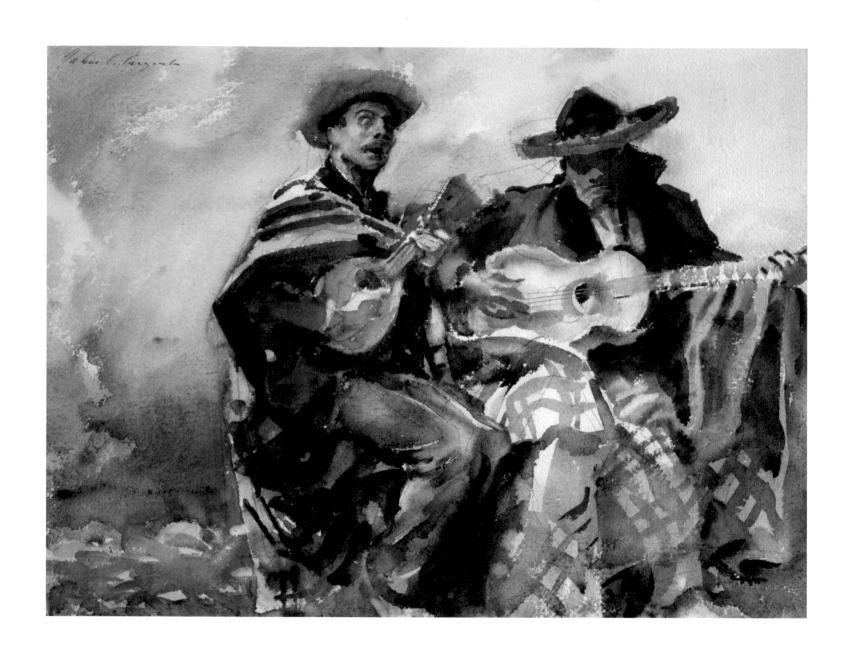

114 John Singer Sargent
The Blind Musicians, 1912
Aberdeen Art Gallery & Museums Collections

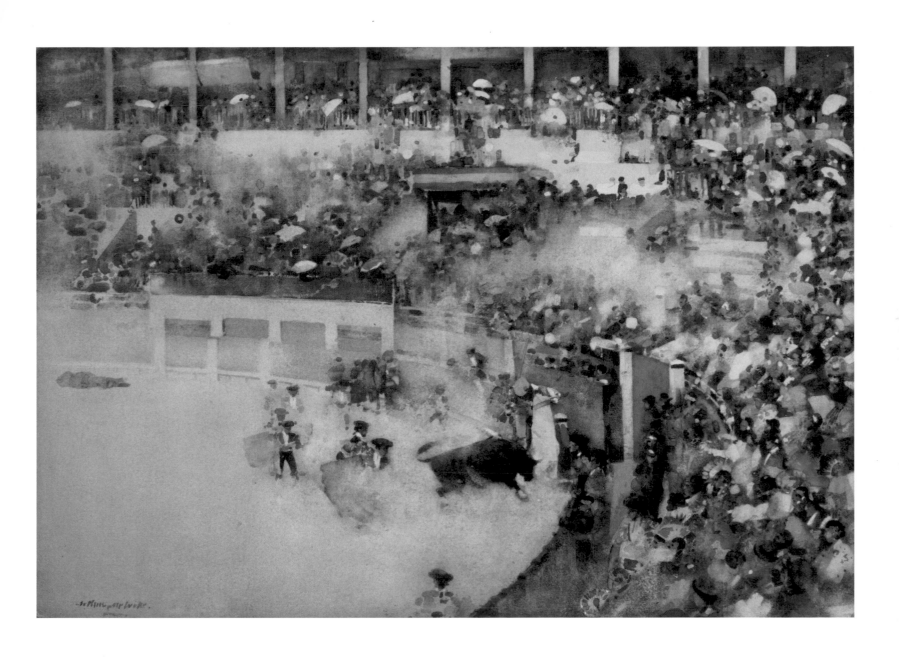

115 Arthur Melville
Little Bullfight: 'Bravo Toro', 1898
Victoria and Albert Museum, London

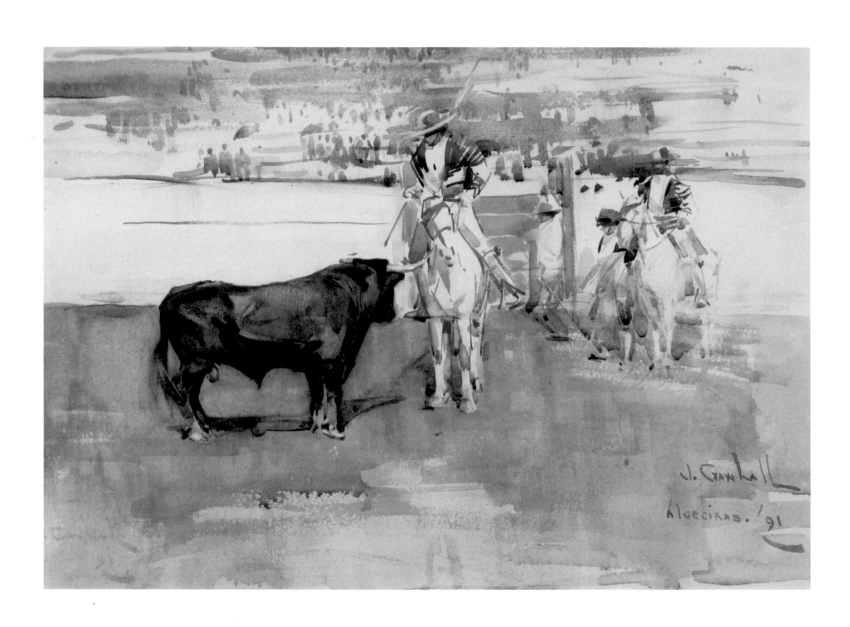

116 Joseph Crawhall
The Bullring, Algeciras, 1891
The Fleming-Wyfold Art Foundation, London

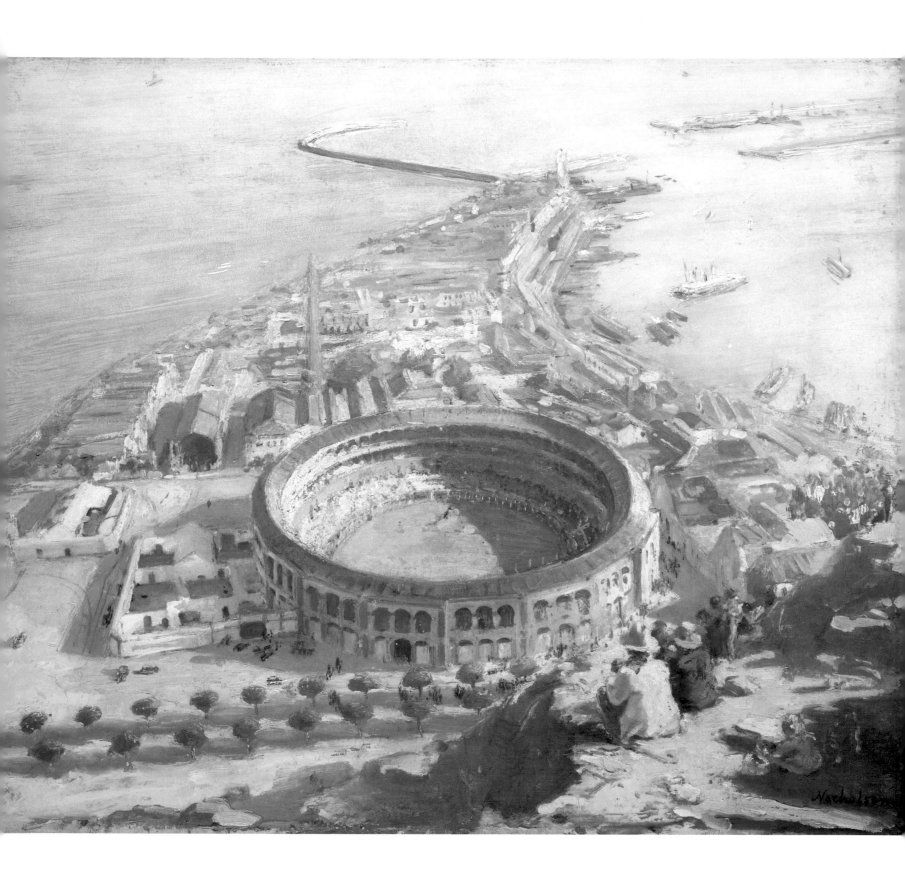

117 Sir William Nicholson
Plaza de Toros, Málaga, 1935
Tate, London

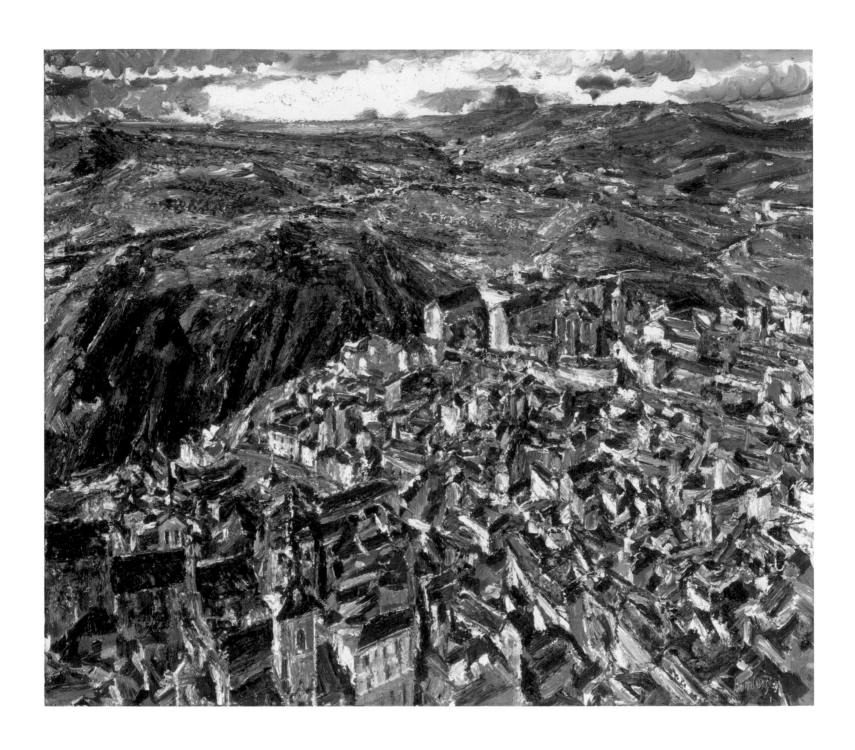

118 David Bomberg

Toledo from the Alcázar, 1929

Private collection

119 David Bomberg
The View of the Bridge and Tajo, Ronda, 1935
Private collection

7

BRITISH ARTISTS AND THE SPANISH CIVIL WAR
PAUL STIRTON

'I don't want to leave Spain not till I must.'
Thus Edward Burra closes a letter from
Granada in 1935.[1] It was his second visit to
Spain and, like many British artists of his
generation, the country and its people had
come to represent something profound
and personal. Burra was still painting his
favourite themes – elaborately dressed
figures in low-life bars and theatres – but the
Spanish versions became richer in meaning,
more vital and exotic; motifs with a stronger
resonance emanating from a culture in touch
with its senses and emotions. He particularly
liked flamenco singers, but found something
new in equally hackneyed subjects like the
bullfight and religious processions. In fact,
Burra had been painting Spanish themes
for some time. The so-called 'Duennas', stiff
cartoonish figures, appeared in his pictures
around 1930 inspired by his passion for early
Spanish art and the work of Picasso. Spain
seemed a spiritual or aesthetic concept, as
much as a physical or geographical entity, and
he was not disappointed when he encoun-
tered it for the first time. Not that Burra
was ignorant of the current state of Spanish
politics. He was only too aware of the tension
and incipient violence on the streets. *One
day while I was lunching with some Spanish
friends*, he reported to John Rothenstein ...
*smoke kept blowing by the restaurant window.
I asked where it came from. 'Oh, its nothing,'
someone answered with a gesture of impa-
tience, 'Its only a church being burnt.' That
made me feel sick. It was terrifying: constant
strikes, churches on fire, and pent up hatred
everywhere. Everybody knew that something
appalling was about to happen.*[2]

This haunted Burra, and it changed his
art. Instead of the fanciful prostitutes, spivs
and performers, a new cast of ominous
hooded figures alongside warriors with

instruments of medieval torture now took
centre stage. In large and very impressive
watercolours, like *The Watcher* [133], *The
Torturers* [121] and *War in the Sun* [132]
(another is explicitly titled *The Spanish Civil
War*) Burra turned his revulsion and fear into
a broader nightmare of age-old cruelty and
barbarism.

Burra seems to have entertained an equally
unworldly view of the politics at play. To him,
the Falangists would at least bring stability
back to his beloved Spain. This was not a
view shared by most of his British contempo-
raries. The announcement of the nationalist
uprising led by Franco's troops in Morocco in
July 1936 was met with an immediate call for
action to defend the Republic. The conflict
in Spain would not be allowed to remain an
isolated or local issue.

For the British left wing, this was a test
of the new policy of concerted action, the
'Popular Front', which had emerged in the
mid-1930s. The complementary instrument
of the 'Front' in the visual arts was the 'Artists
International Association' (AIA). Founded
in 1933, it evolved into a major force in
British cultural life with over 600 members.
In November 1935 an exhibition mounted
in London under the title *Artists Against
Fascism and War* was opened by Aldous
Huxley. Artists included Eric Gill, Augustus
John, Laura Knight, Barbara Hepworth and
John Piper. In addition, the AIA enlisted the
support of several leading European modern-
ists, such as Fernand Léger, Frans Masereel
and László Moholy-Nagy. The AIA was one
of the first pressure groups to support the
Republicans, when the British and French
governments were pursuing a policy of
non-intervention. The war was brought even
closer to home when an AIA member, the
painter Felicia Browne, was killed in August

120 Edward Burra
War in the Sun, 1938 (detail)
Private collection

on the Aragon Front, becoming the first British casualty of the war. Although British artists both fought and died in Spain, their response was not equivalent to that of poets and novelists. There are very few artworks as powerful as George Orwell's *Homage to Catalonia* (1938), or the poetry of W.H. Auden, Frances Cornford, and Stephen Spender, for whom the conflict was 'the Poet's war'. The contribution of British artists was on the home front.

From the start, the AIA raised money, produced posters and murals, and demonstrated against the British government. Some of this was surprisingly effective. 'Portraits for Spain' invited commissions from leading painters and the fee was to be donated to Spanish relief. One such, for a portrait by Augustus John, raised £500, which went towards an ambulance dispatched with much fanfare from the Houses of Parliament. W.H. Auden and Benjamin Britten devised a cabaret at Seymour Hall in March 1938 featuring the dancers Robert Helpman and Margot Fonteyn alongside a male striptease artist. There was a 'mass meeting' in support of Basque children at the Albert Hall in June 1937. Picasso and the novelist Heinrich Mann were to speak while Paul Robeson was to broadcast live from Moscow. Neither Picasso nor Mann appeared, but Robeson turned up unexpectedly and sang.

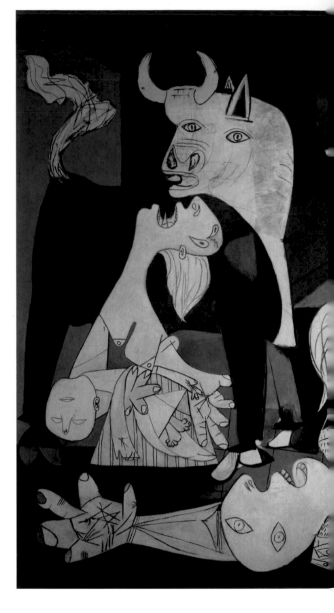

Despite high-profile events, the main activity of the AIA was organising exhibitions and acting as a mouthpiece for artists. In December 1936, the association held another exhibition, *Artists Help Spain*, which was also remarkable for its range and diversity. This may have given the impression of a broad sense of commitment to a common cause across different styles and groupings, but actually there were many divisions over aesthetics and politics. The dominant style adopted was broadly 'realist' since it was felt that this manner engaged with contemporary events while remaining widely accessible. As the Soviets were enforcing the policy of 'Socialist Realism', it is easy to see this tendency as part of a wider subservience of aesthetics to political aims. The AIA always

121 Edward Burra *The Torturers*, c.1935
Private collection

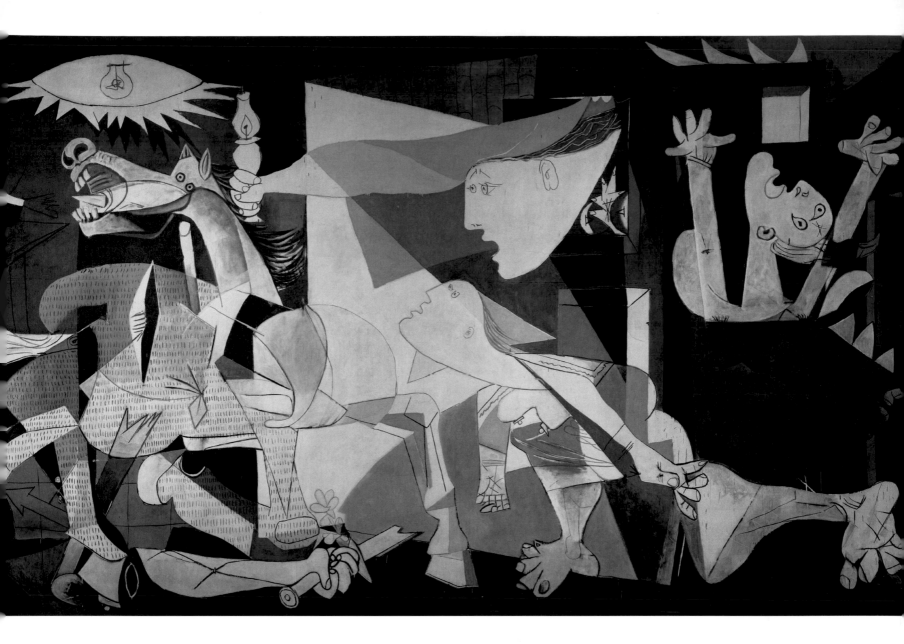

122 Pablo Picasso *Guernica*, 1937
Museo Nacional Centro de Arte Reina Sofía, Madrid

maintained it was independent of both the Labour and Communist parties but there was no doubt that there were strong affiliations. Even this, however, possibly misses the point. A realist art that embraced the dour naturalism of Euston Road painters like William Coldstream and Graham Bell, as well as the harsh caricatures of James Fitton or James Boswell, was hardly something shaped by ideologues. Furthermore, one might see descriptive figurative art as the dominant form in Britain in the 1930s. As Anthony Blunt remarked when reviewing the Royal Academy, London, summer exhibition of 1937, a 'new realism' was perceived as 'the only hope for European painting at the present time'.[3] This axis between left-wing politics and realist art raised many questions among

other artists who, while generally supportive of the campaign to aid the Republican cause in Spain, did not subscribe to one or other side in matters of style or politics. This issue was brought to a head with the English Surrealists.

There had been considerable interest in Surrealism among British artists and writers but the movement would become established here only in April 1936 when Roland Penrose drew many together to organise an exhibition. From the outset, it attracted some very important artists and critics. Paul Nash attended the first meeting in Penrose's house, as did Herbert Read and Henry Moore, and they were joined later by David Gascoyne, Man Ray, Stanley Hayter and Edward McKnight Kauffer. They quickly made contact with many of the leading continental Surrealists, notably André Breton, Paul Eluard and E.L.T. Mesens which ensured

that their first formal showing in London had a strong international representation. *The International Surrealist Exhibition* opened on 11 June 1936 at the New Burlington Galleries to widespread press coverage. Breton gave an opening speech, reprinted in the catalogue, and Salvador Dalí attended later, dressed in a diving suit from which he had to be rescued from imminent suffocation. Within a few weeks the Spanish Civil War erupted and the Surrealists immediately spoke out in support of the Republicans. Breton had made explicit links at the outset between Surrealism and the political struggle of the working classes. In his view, Surrealism was not about aesthetics alone; it was a strategy for political and psychic liberation from the constraints of bourgeois capitalism. Communism and Surrealism, so he thought, could be regarded as two sides of the same coin. It is not surprising that many of the

leading figures among English Surrealists, notably David Gascoyne and Roger Roughton, were also active members of the Communist Party of Great Britain.

Politics was brought to the fore; starting with a special supplement on Surrealism in the *Left Review* of July 1936, and developed further in the 'Declaration on Spain', published in the November issue of *Contemporary Poetry and Prose*. In this the British government was castigated for its policy of non-intervention and the authors called for active support and the arming of the Republicans. In the spirit of Popular Front politics, the Surrealists were invited to join the AIA in August of that year, which they accepted. This did not lead, however, to either a popular or a united front. The English Surrealists were unclear about their aims: one group favouring an imaginative or 'Romantic' aesthetic, and the other seeking greater political engagement. Matters were

further complicated by the hostility of the realists within the AIA who regarded the Surrealists as escapists at best, and, at worst, tools of the bourgeoisie. Outside attacks on the Surrealists had also not ceased since the initial announcement of their exhibition with many leading figures openly contemptuous. Under the headline 'The Coward Surrealists', Ezra Pound described them as 'no more revolutionary than the dim ditherings of the aesthetes in 1888', adding that 'the intellectual timidity of the pseudolutionists gives me a pain in the neck'. Roger Roughton, the editor of *Contemporary Poetry and Prose*, virtually a Surrealist house journal, retorted describing Pound as one of the 'expatriate admirers of fascism and capitalist quackery'.[4] Factional infighting continued, with the result that the next AIA exhibition in 1937, entitled *Peace, Democracy and Cultural Development*, required three separate selection committees; one for the realists, one for abstract art and a third for Surrealism.

The role of Picasso was deeply controversial. As the most famous modern artist in Europe, and also a Spaniard with affiliations to the Left, his position was constantly being sought. On this he was unequivocal: 'The Spanish struggle is the fight of reaction against the people, against freedom. ... I clearly express my abhorrence

of the military caste which has sunk Spain in an ocean of pain and death ...'.[5] But was Picasso's work appropriate to wage a war against Fascism? This issue crystallized in August 1937 when *Guernica* was first exhibited in the Spanish Pavilion at the *Paris Exposition Internationale*. A painting inspired by a humanitarian tragedy such as the mass bombing of Basque civilians in Guernica, raised more questions than any simple aesthetic view could answer. The picture demanded both political and aesthetic responses. Many in the AIA felt its formal language was inadequate to address the issues in the atrocity. Blunt was particularly forthright, stating 'It is not an act of public mourning, but the expression of a private brainstorm which gives no evidence that Picasso has realised the political significance of "Guernica".[6] A similar view was expressed in the AIA *Artists News Sheet* about *The Dream and Lie of Franco*, a set of two etchings in a comic-style narrative which Picasso had produced to raise funds for Spanish relief. This prompted the Surrealists to demand an apology, which they received, but it did little to cool inflamed tempers. In an attempt at pacification, a public debate was held in February 1938, pitching 'Realism against Surrealism', and involving several of the leading figures in each camp. This did

123 Programme, Exhibition of Picasso's *Guernica*, New Burlington Galleries, London, October 1938
Scottish National Gallery of Modern Art, Edinburgh

124 Clement Attlee at the opening ceremony of the exhibition of Picasso's *Guernica*, Whitechapel Art Gallery, January 1939
Scottish National Gallery of Modern Art, Edinburgh

not clear the air. In fact, after hearing their performance, Herbert Read felt emboldened to go on the offensive, describing the realists as 'the effete and bastard offspring of the Bloomsbury school of Needlework'.[7] The simmering rivalries continued, both inside and outside the AIA.

Nevertheless, British artists were in direct contact with Picasso. Stanley Hayter was based in Paris and organized several projects, such as the *Solidarité* suite of prints, which brought together Picasso and Joan Miró with other British artists. Roland Penrose was also a frequent visitor to Paris and both he and Henry Moore had visited Picasso's studio in May of 1937 when *Guernica* was being painted. He was also aware that Picasso was willing to exhibit the picture to raise awareness. Penrose opened negotiations to bring the picture to Britain. By the summer of 1938, he had secured the use of the New Burlington Galleries, the venue for *The International Surrealist Exhibition* two years earlier. The *Exhibition of Picasso's 'Guernica'* opened to the public on 4 October [123]. Besides the great painting itself, Picasso and his dealer, Paul Rosenberg, had provided over sixty preparatory studies. In addition, Picasso sent one of his most powerful recent paintings, *Weeping Woman* [127], depicting the photographer Dora Maar in a manner reminiscent of a fractured tragic mask. Although it attracted considerable publicity, the exhibition was not well attended. Despite this, *Weeping Woman* and the studies for *Guernica* were shown in Oxford and Leeds before being reunited with the main picture in January 1939 for another exhibition at the Whitechapel Art Gallery in the east end of London. To Penrose, this was a more fitting location for *Guernica*. Not only was the space more generous, it was located in the heart of a working class district noted for its tradition of militancy. In addition, the organisers enlisted the support of the Trades Union Congress and several leading political figures. The exhibition was opened by Clement Attlee [124], leader of the opposition Labour Party and well known as an ardent anti-Fascist and supporter of the International Brigades. More than 15,000 people saw the picture in its first week alone, thereby raising considerable aid for Spain. But the cause was dwindling as the remaining pockets of Republican resistance fell to the Nationalists.

Reports of the war in 1939 were dominated by stories of towns overrun, of atrocities committed and of confusion in the Republican ranks. There was also a steady trickle of volunteers returning, many wounded and mostly depressed at the conduct of the war and the future for democracy in Europe.

One artist who drew something more profound from these years than the endless disputes that marked the AIA, was Henry Moore. Unaligned but Left in sympathy, Moore had written on the role of artists in the current crisis, 'Unless he is prepared to see all thought pressed into one reactionary mould, by tyrannical dictatorships – to see the beginning of another set of dark ages – the artist is left with no choice but to help in the fight for the real establishment of Democracy against the menace of Dictatorships.'[8] In 1938, Moore had produced a drawing and lithograph of a face enclosed within a mesh of metal wire entitled *Spanish Prisoner* [130]. This evolved into *The Helmet* [131] which in turn became one of his enduring motifs – the *Helmet Head* series of 1950–75. Moore described how he was drawn to the idea of a soft form enclosed within a hard metallic coating reminiscent of a crustacean. He also remarked on his early interest in armour. However, a casual comment that it may have been provoked by Wyndham Lewis suggests a different line of thinking.[9] Wyndham Lewis was also concerned with Spain but he did not respond like the politically engaged artists of the AIA. Instead, he was closer to the right-wing sympathizers of Franco who saw the Falange as a return to order in a world of civil unrest and moral degradation. Lewis's main artistic response was the curious and enigmatic picture *The Siege of Barcelona*. Turning his back on contemporary events, he depicted a medieval town in which soldiers in parade armour disport themselves around a fortified tower. Lewis denied any direct link between contemporary events and this subject, but in 1939, the year Barcelona fell to the Nationalists, he changed the title to *The Surrender of Barcelona* [128].

It would be too glib to sum up three very different British artists as sharing a common visual language. But equally there may be some underlying significance to the fact that Burra, Moore and Wyndham Lewis all chose to distil their sense of destruction and danger in pictorial and symbolic devices derived

from medieval warfare. Not for the first time, have outsiders been fascinated by what they saw as the primitive, the elemental and the cruel in Spanish culture. By 1938 the signs of a larger conflict may have been apparent to some and certainly feared by many more. In that sense the Spanish Civil War not only prefigured events in the wider world, but British responses to Spanish culture provided some of the iconography of a new age of barbarism.

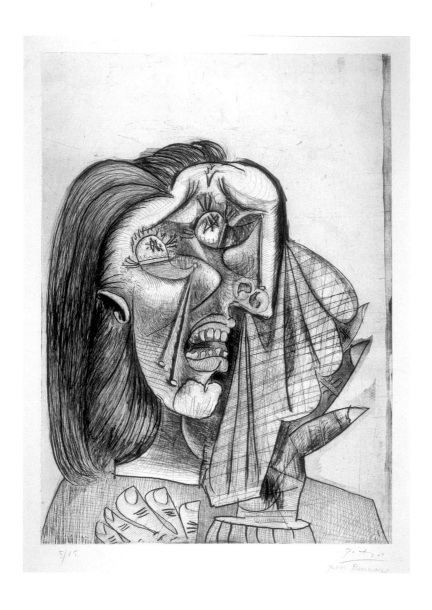

125 Pablo Picasso
Weeping Woman I, 1937
Scottish National Gallery of Modern Art, Edinburgh

126 Pablo Picasso
Weeping Woman, 1937
Tate, London

127 Pablo Picasso
Weeping Woman, 1937
Tate, London

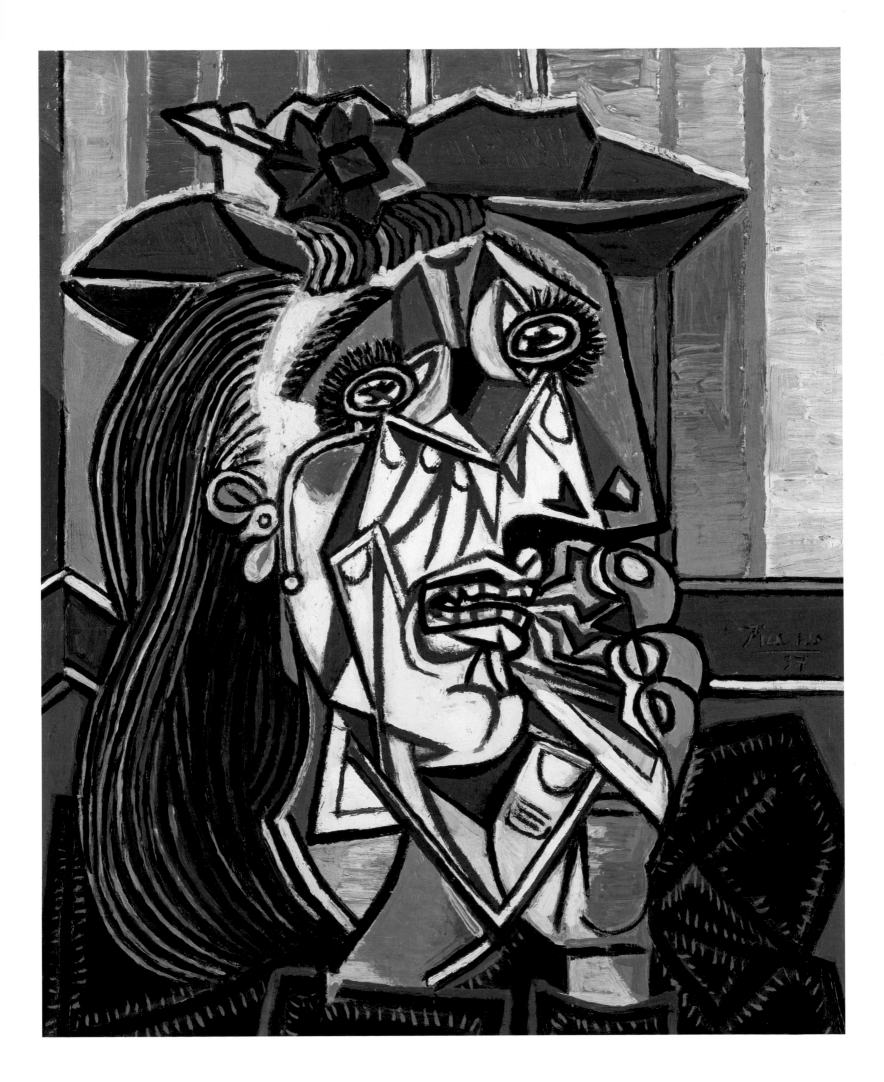

128 Percy Wyndham Lewis
The Surrender of Barcelona, 1934–7
Tate, London

129 John Armstrong
Pro Patria, 1938
Imperial War Museum, London

130 Henry Moore
Spanish Prisoner, c.1939
Henry Moore Foundation

131 Henry Moore
The Helmet, 1939–40
Scottish National Gallery of Modern Art, Edinburgh

132 Edward Burra *War in the Sun*, 1938
Private collection

133 Edward Burra *The Watcher, c.*1937
Scottish National Gallery of Modern Art, Edinburgh

1556

• Charles V, King of Spain abdicates and Philip II becomes King of Spain. He rules until 1598.

1588

• The English defeat the Spanish Armada.

FRANCISCO DE ZURBARÁN
1598–1664

DIEGO VELÁZQUEZ
1599–1660

1604

• The Treaty of London ends many years of Anglo-Spanish war and draws up peace terms between England and Spain.

1605

• Charles Howard, 1st Earl of Nottingham, formerly English commander against the Spanish Armada, leads a magnificent embassy of 400 to Spain.

BARTOLOMÉ ESTEBAN MURILLO 1617–1682

1621

• Philip IV becomes King of Spain and rules until 1665.

1623

• Charles, Prince of Wales, accompanied by George Villiers, 1st Duke of Buckingham, masquerading as 'Jack and Tom Smith' respectively, visit Madrid to woo the Spanish Infanta, María. The negotiations were unsuccessful and they return to London in October.

• Thomas Middleton's play *The Spanish Gipsie* dramatises two stories by Cervantes.

1624

• Middleton's controversial satirical play *A Game at Chesse*, attacking the Spanish ambassador, is closed down after only nine days by James VI & I.

1625

• Buckingham manoeuvres England into an indecisive five-year war with Spain. It begins with the appearance of the English fleet off Cadiz in October; an event recalled by the painter

Zurbarán in the Hall of Realms at the *Buen Retiro* Palace in Madrid.

1631

• Sir Arthur Hopton becomes ambassador to Spain and sends dispatches to Charles I with news of court painters in Madrid.

1633

• Vicente Carducho's *Dialogos de la pintura* is published.

1649

• Francisco Pacheco's *El arte de la pintura* is published in Seville. Pacheco is Velázquez's father-in-law.

• Charles I, King of Great Britain and Ireland, is executed in London. Philip IV of Spain, through his agent Alonso de Cárdenas, buys extensively at the sales in London of the '*King's Goods*'.

1656–7

• Velázquez completes *Las Meninas*.

1662

• Charles II, King of Great Britain and Ireland, marries Catherine of Braganza. This secures the independence of Portugal from Spain, and inaugurates the special bond between Britain and Portugal.

1664

• Sir Richard Fanshawe becomes British ambassador to Spain of whom it was said 'no man knew the court better or was so well versed in the language'. A poet and litterateur, Fanshawe translates Gongora, amongst other Spanish writers.

1693

• Important Murillo paintings, confiscated from the Jacobite Duke of Melford, sold in London.

1700

• Charles II, the degenerate last Austrian Habsburg ruler of Spain, dies and is succeeded by Philip V.

1701–14

• War of the Spanish Succession in which armies of principal combatants are commanded by the Duke of Berwick and the Earl of Peterborough respectively.

1721

• Sir Robert Walpole first prime minister of Great Britain. He has fine examples of Murillo in his collection.

1724

• Antonio Palomino, the so-called 'Spanish Vasari' publishes *El museo pictórico y escala óptica. Tomo tercero; El Parnaso español pintoresco laureado*.

1739

• Abridged English translation of Antonio Palomino.

1742

• Charles Jenkins's *The Life and Exploits of the Ingenious Gentleman Don Quixote de la Mancha*, lavishly illustrated by John Vanderbank, is published.

FRANCISCO DE GOYA
1746–1828

1749

• Sir Benjamin Keene, an enthusiast for Spanish painting, becomes British ambassador to Spain.

1756

• Zurbarán's *Jacob and his Twelve Sons* installed at the Bishop of Durham's palace, Bishop Auckland, in County Durham.

1756–63

• The Seven Years' War ends with Spain's imperial greatness diminished and Britain's enhanced.

1759

• Charles III, becomes King of Spain and rules until 1788.

1769

• William Robertson's *The History of the Reign of the Emperor Charles V*, an immensely successful book, and a significant moment in the burgeoning British interest in Spanish culture, is published.

1775

• Richard Twiss's *Travels through Portugal and Spain* is published.

1776

• Adam Smith's *An Enquiry into the Nature and Causes of the Wealth of Nations*, which offers a post-mortem on the

134 Francisco de Zurbarán
Asher (detail)
The Lord Bishop of Durham, Auckland Castle, County Durham

collapse of the Spanish economy, is published.

1771

• Lord Grantham, an enthusiastic student of Spanish painting, becomes British ambassador to Spain.

1779

• Charles III of Spain issues a law forbidding the export of paintings by deceased Spanish masters.

1779

• Henry Swinburne's *Travels through Spain in the Years 1775 and 1776* is published.

1782

• Richard Cumberland's *Anecdotes of Eminent Painters of Spain During the Sixteenth and Seventeenth Centuries* is published.

SIR DAVID WILKIE 1785–1841

1791

• Joseph Townshend's *Journey through Spain in the Years 1786 and 1787* is published.

DAVID ROBERTS 1796–1864

1799

• Goya's *Los Caprichos* are published but were censored and immediately withdrawn.

JOHN FREDERICK LEWIS 1805–1876

1808–14

• The Peninsular War: British, Spanish and Portuguese forces fight a prolonged campaign to liberate the Iberian Peninsula from French occupation.

1808

• The Siege of Saragossa, later the subject of Sir David Wilkie's famous painting *The Defence of Saragossa*. Goya, however, observed the carnage and the desperate courage of his fellow Spaniards, which fed into *The Disasters of War* etchings.

• French occupy Madrid. Abdication of Charles IV of Spain. Joseph Bonaparte becomes King of Spain. A British expeditionary force lands in Portugal.

1808–33

• The tyrant Ferdinand VII *de jure* King of Spain.

1809

• Death of Sir John Moore, a British commander in Spain, at Corunna.

• Goya begins work on his *The Disasters of War (Los Desastres de la Guerra)*.

1811

• Byron's first two cantos of *Childe Harold's Pilgrimage*, his account of a tour of the Iberian Peninsula, is published

• Dulwich Picture Gallery is founded, including fine holding of paintings by Murillo, including *The Flower Girl*.

1812

• The British defeat the French at the Battle of Salamanca.

• The Constitution of Cadiz inaugurates the first democratic experiment in Spanish politics.

• Goya paints a portrait of the Duke of Wellington (National Gallery, London) and an equestrian portrait of Wellington (Apsley House collection, London).

1813

• The British rout the French at Vitoria and Wellington is rewarded by the Spanish crown with a large collection of pictures, which form the Apsley House collection in London.

1814

• Ferdinand *de facto* ruler of Spain. Repudiates the Constitution of Cadiz, and reigns as a reactionary.

• Arthur Wellesley created 1st Duke of Wellington.

• Goya paints *The Second of May 1808*, *The Third of May 1808*, and, *Portrait of Ferdinand VII*.

1815

• James Murphy's *The Arabian Antiquities of Spain* is published.

JOHN PHILLIP 1817–1867

1819

• The Museo Nacional del Prado in Madrid is founded.

1820–3

• *Trienio* – three years of Liberal constitutional government in Spain.

1823

• The French army, known as 'The Ten Thousand Sons of St Louis', invades Spain and ousts the Liberals. Ferdinand VII is restored to the throne.

1823–32

• Robert Southey's *History of the Peninsular War* is published.

1824

• Goya spends his last years in exile in France, apart from a brief trip to Madrid in 1827, until his death in Bordeaux in April 1828.

1826

• The popular American writer, Washington Irving, moves to Spain. He writes *The Life and Voyages of Christopher Columbus* (1828), *A Chronicle of the Conquest of Granada* (1829) and *Tales of the Alhambra* (1832).

1827

• Sir David Wilkie spends time in Spain 'discovering' the secret of Velázquez. Paints *The Defence of Saragossa* (1829) and meets and makes friends with Irving, who inspires Wilkie with Spanish themes.

1830–3

• Richard Ford lives in Andalusia and, for part of that time, rents apartments in the Alhambra, Granada.

1832–3

• J.F. Lewis and David Roberts painting independently in Spain.

1833–40

• Civil War in Spain between the supporters of the infant monarch, Isabella II, Ferdinand VII's daughter and her regent, María Cristina widow of Ferdinand VII. The Cristinos fought against the Carlists the followers of Ferdinand's brother, the extreme reactionary, Don Carlos.

1833–9

• Lord Clarendon British ambassador to Spain plots with the British foreign secretary, Lord Palmerston, to acquire pictures from the Escorial for the National Gallery in London, from a bankrupt Spanish government.

1834

• Owen Jones arrives in Spain and begins a study of the Alhambra.

1835

• Sir George De Lacy Evans, a British veteran of the Napoleonic wars, recruits upwards of perhaps 12,000 British volunteers as a British expeditionary force, to fight in northern Spain for the Cristinos.

• Baron Taylor, picture agent of King Louis-Philippe of France, scours Spain for paintings.

• The Spanish regime institutes policies of *exclaustración* ejection of monks and nuns from their buildings and *desamortización* sale of monastic assets. Thus many paintings become available. The Museo Naçional de Pinturas y Esculturas is established in July 1838 to contain the works. (Not to be confused with the Prado, the Spanish royal art gallery).

• Thomas Roscoe begins his series of *Landscape Annuals* illustrated with engravings of Spanish scenes.

1836

• J.F. Lewis's *Sketches of Spain and Spanish Character* is published.

1837

• The American, William Hickling Prescott, blind from youth, has his book, *History of the Reign of Ferdinand and Isabella,* published. It is the first of many on Spain, which make its author the best-selling historian of that country in the English language. Prescott never visits Spain.

1838

• The Galerie Espagnole opens at the Musée du Louvre: a monument to the remnant of Napoleonic rapine, and collections of ex-patriot British in Andalusia.

1840–2

• Pascual de Gayangos publishes in London, *The History of the Mohammedan Dynasties*. It is the first book in English to attempt a sympathetic understanding of the culture of a celebrated Spanish ethnic minority.

1842–5

• Owen Jones's lavish architectural *Plans, Elevations, Sections and Details of the Alhambra* is published.

• Robert Browning's *The Soliloquy of the Spanish Cloister* is published.

1845

• Richard Ford's *A Hand-Book for Travellers in Spain and Readers at Home* is published. This is followed by *Gatherings from Spain* (1846) which becomes part of the canon of English travel writing.

1846

• The National Gallery in London acquires the most ambitious of Velázquez's landscapes, *Philip IV Hunting Wild Boar 'La Tela Real'*.

1848

• Sir Edmund Head's *A Handbook of the History of the Spanish and French Schools of Painting* is published. William Stirling (from 1872 known as, Sir William Stirling Maxwell) publishes *Annals of the Artists of Spain*, which is a compendium of potted biographies of Spanish artists, significant and obscure alike, from 1000 to 1800.

• The Galerie Espagnole closes after only ten years.

1850

• The Spanish-educated Cardinal Wiseman becomes the first arch-bishop of Westminster. The catholic hierarchy, absent in England for three hundred years, is thus restored.

• Charles Clifford, the pioneer photographer of Spain, arrives to begin his memorial of Spain's past imperial greatness and remains there until his death in 1863.

1851

• John 'Spanish' Phillip pays the first of three visits to Spain.

• *The Great Exhibition* is held in Hyde Park, London, from May to October.

1853

• The National Gallery in London acquires Zurbarán's *St Francis in Meditation*, the most notorious of all images of Spanish religiosity. Its acquisition provokes a furious row.

1854

• The Alhambra Court is re-created at the Crystal Palace in London, its erection supervised by Owen Jones. This vulgarisation of Islamic ornament eventually degenerates into the proliferation of Alhambra Music Halls in late Victorian London.

1855

• William Stirling's *Velazquez and his Works* is published. This is the first monograph in English on the artist.

1856

• Owen Jones's *The Grammar of Ornament* is published.

1857

• Manchester Art Treasures Exhibition showcases Spanish paintings for the first time to a mass British audience.

1863

• Goya's *Disasters of War* published thirty-five years after the artist's death.

1864

• John Phillip exhibits his most exuberant and ambitious Spanish subject, *La Gloria,* at the Royal Academy in London.

1865

• Edouard Manet visits Madrid.

1866

• The novelist George Eliot visits the Alhambra and Granada. She studies Velázquez intently at the Prado, Madrid, but her notes are now lost.

1868

• John Everett Millais exhibits *Souvenir of Velasquez* as his Royal Academy 'Diploma Piece'.

• Revolution in Spain. Isabella II of Spain abdicates. A republic follows and years of chaos.

1869

• Sir Austen Henry Layard becomes British ambassador to Spain. Layard works closely with Sir Henry Cole, first director of the Victoria and Albert Museum, to create a cast collection of Spanish artwork at the museum.

1873

• James McNeill Whistler evokes Velázquez in his *Arrangement in Grey and Black No.2: Portrait of Thomas Carlyle*. This work becomes the most celebrated example of the influence of Velázquez on British avant-garde art despite the fact that the painter never visited Spain.

1876

• Whistler paints *Arrangement in Black No.3: Sir Henry Irving as Philip II of Spain*.

1879

• John Singer Sargent visits Spain and paints *El Jaleo* (1882), the most powerful of all evocations of flamenco, and *The Daughters of Edward Darley Boit* (1881), a homage to *Las Meninas*.

PABLO PICASSO 1881–1973

1882

• The National Gallery in London buys Velázquez's *Philip IV of Spain in Brown and Silver*, and, from the Hamilton Palace sale, *St Jerome as Cardinal*, its first El Greco.

1884–91

• Joseph Crawhall visits Spain frequently.

1888

• Carl Justi's *Diego Velázquez und sein Jahrhundert*, a new departure in Velázquez's scholarship, is published.

DAVID BOMBERG 1890–1957

1890

• Arthur Melville pays his first visit to Spain and returns every year until his death there from cholera in 1904.

1891

• Arthur Melville and Frank Brangwyn travel together in Spain.

• Glasgow Corporation buys Whistler's *Arrangement in Grey and Black No.2: Portrait of Thomas Carlyle*.

1894

• The Bowes Museum opens in County Durham with the largest holding of Spanish art in the British Isles. Sargent paints a portrait of Graham Robertson, an exercise in the spirit of Velázquez full-length portraits of single figures.

1895

• R.A.M. Stevenson's *The Art of Velasquez* is published.

1895–6

• *Spanish Art Exhibition* is held at the New Gallery, London.

1896

• The National Gallery in London buys its first painting by Goya.

1898

• Spain suffers national humiliation at the hands of the United States with the loss of Cuba and her other remaining colonies. This induces a crisis of identity in Spanish culture.

• Arthur Melville paints his Spanish masterpiece, *Bravo Toro*.

1900

• Sir William Rothenstein's *Goya* is published; the first monograph in English on the artist.

1902

• William Strang illustrates *Don Quixote* with a series of celebrated etchings.

1904

• Archer Milton Huntington founds The Hispanic Society of America in New York.

1906

• The National Gallery, London, acquires *The Rokeby Venus*, the only known nude painted by Velázquez.

1920

• The National Gallery, London, buys El Greco's *Agony in the Garden of Gethsemane*. The celebrated Bloomsbury critic, Roger Fry declares in rapture; 'not even the cinema star can push expression further than this'.

1923

• Gerald Brenan arrives in Spain.

1929

• David Bomberg visits Spain for the first time. Consequently his painting is transformed.

1930–6

• A plethora of British writers wander through Spain prior to the Spanish Civil War: V.S.Pritchett, Walter Starkie, Norman Lewis and Laurie Lee amongst others. Lee's memoir, *As I Walked Out One Summer Morning*, published in

1969, epitomises the romance and 'otherness' of Spain for the British intelligentsia.

1932

• Edward Burra meets up with the novelist Malcolm Lowry in Granada.

• Ernest Hemingway's *Death in the Afternoon,* 'the bible of the Spanish bullfight', is published.

1933

• William Nicholson visits Spain.

• Artists' International Association is formed.

1935

• *Artists Against Fascism and War* exhibition is held in London.

1936–39

• The Spanish Civil War.

1936

• *Artists Help Spain* exhibition held in London.

• Declaring that 'someone has to kill Fascists', George Orwell joins the POUM militia on the Aragon front. Badly wounded and hunted by the communists. He is spirited out of Spain a year later.

1937

• W.H. Auden fights for the Republicans but is disillusioned and returns to London.

• Picasso paints *Guernica,* which is exhibited at the Spanish Pavilion at the Paris International exhibition where it raises sympathy for the Left in Spain.

1938

• George Orwell's *Homage to Catalonia* is published.

1939

• Clement Attlee, Leader of the Opposition, opens an exhibition at the Whitechapel Art Gallery, London, which has *Guernica* as its centrepiece.

1943

• Gerald Brenan's *Spanish Labyrinth* is published.

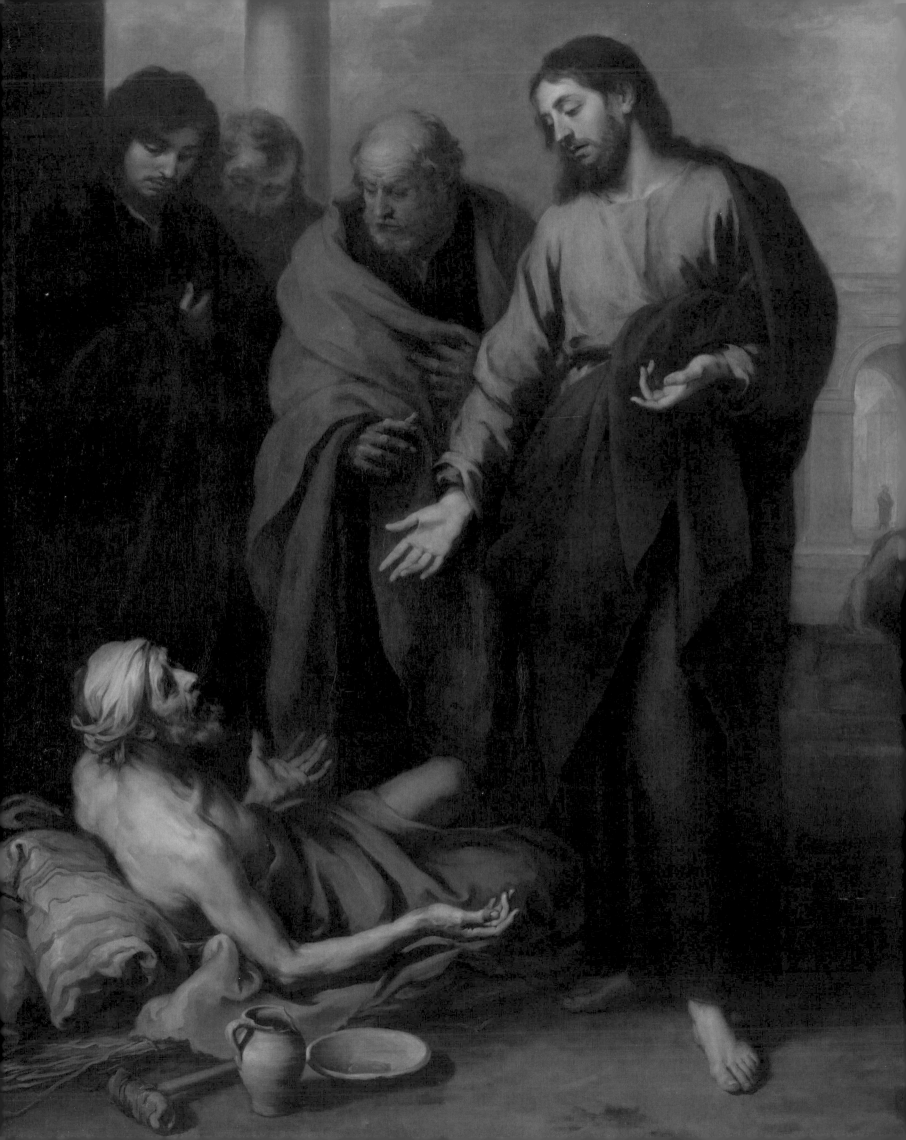

THE DISCOVERY OF SPAIN
EXHIBITION CHECKLIST

GEORGE DENHOLM ARMOUR
1864–1949

• *Entrance of the Bull*, c.1891
Watercolour on paper, 29 x 49cm
The Fleming-Wyfold Art Foundation,
London

JOHN ARMSTRONG
1893–1973

• *Pro Patria*, 1938 [plate 129]
Tempera on board, 75.8 x 93.6cm
Imperial War Museum, London

JOHN BALLANTYNE
1815–1897

• *John Phillip in his Studio*, c.1864
[plate 2]
Oil on canvas, 71.1 x 92.1cm
Scottish National Portrait Gallery,
Edinburgh

JOSÉ BÉCQUER 1810–1840

• *Richard Ford as a Majo*, 1832
[plate 46]
Watercolour on paper, 26.3 x 16.8cm
Private collection

DAVID BOMBERG 1890–1957

• *Toledo from the Alcázar*, 1929
[plate 118]
Oil on canvas, 67.3 x 76.2cm
Private collection

• *Rooftops, Ronda*, 1935
Black charcoal on paper, 62 x 75.5cm
Private collection

• *Street Scene, Ronda with the Church of
the Virgin of La Paz*, 1935
Oil on canvas, 77 x 69cm
Private collection

• *The View of the Bridge and Tajo, Ronda*,
1935 [plate 119]
Oil on canvas, 50 x 60cm
Private collection

SIR MUIRHEAD BONE
1876–1953

• *The Torre de Comares from the Peinador
de la Reina, Alhambra*, 1929
Watercolour on paper, 53.5 x 36.3cm

Kelvingrove Art Gallery and Museum,
Glasgow

• *The Vega of Granada from the Carmen
de la Canada*, 1929
Watercolour on paper, 39.5 x 53.2cm
Kelvingrove Art Gallery and Museum,
Glasgow

• *The Court of the Lions, the Alhambra*,
c.1930–6 [plate 63]
Watercolour on paper, 37.7 x 27cm
Kelvingrove Art Gallery and Museum,
Glasgow

• *Old Spain*, volume 1, 1936
Book, 53 x 35.5cm
Private collection

FRANK BRANGWYN
1867–1956

• *Zaragoza: The Citadel of El Pilar and
Puente di Piedra*
Watercolour on paper, 36 x 41cm
McManus Galleries & Museum,
Dundee

EDWARD BURRA 1905–1976

• *Red Cloaked Figure*, 1936
Watercolour on paper, 111.5 x 56.7cm
Courtesy of the Derek Williams Trust,
on loan to Amgueddfa Genedlaethol
Cymru – National Museum of Wales

• *The Watcher*, c.1937 [plate 133]
Watercolour and pencil on paper,
102 x 67cm
Scottish National Gallery of Modern
Art, Edinburgh

• *War in the Sun*, 1938 [plate 132]
Watercolour on paper, 106.5 x 157.5cm
Private collection

VICENTE CARDUCHO
1576/8–1638

• *Dream of Saint Hugh, Bishop of
Grenoble*, 1626–32 [plate 8]
Oil on canvas, 57 x 45.5cm
National Gallery of Scotland,
Edinburgh

JOHN CAREY c.1754–1835

• *Map of Spain and Portugal*, 1801
Engraving with watercolour,
45.7 x 51.6cm
National Gallery of Scotland,
Edinburgh

DORA CARRINGTON
1893–1932

• *Mountain Range at Yegen, Andalusia
(Spanish Landscape with Mountains)*,
1924 [plate 111]
Oil on canvas, 68.6 x 78.7cm
Tate, London

CHARLES CLIFFORD
1821–1863

• *Arco de Carbon, Granada*, 1860s
Albumen print, 78.7 x 57.7cm
Victoria and Albert Museum, London

• *Corridor Leading to the Hall of Justice,
the Alhambra*, 1860s [plate 59]
Albumen print, 78.7 x 57.7cm
Victoria and Albert Museum, London

• *Torre del Vino, Granada*, 1860s
[plate 58]
Albumen print, 78.7 x 57.7cm
Victoria and Albert Museum, London

• *View of Granada, from the Albaicín*,
1860s [plate 60]
Albumen print, 57.7 x 78.7 cm
Victoria and Albert Museum, London

RAFAEL CONTRERAS
active 1860s

• *Lateral Arch in the Hall of the Comares,
the Alhambra*, c.1865 [plate 57]
Architectural model, constructed
from painted stucco and marble,
83.5 x 51 x 10.5cm
Victoria and Albert Museum, London

JOSEPH CRAWHALL
1861–1913

• *The Bullring, Algeciras*, 1891 [plate 116]
Watercolour on paper, 29 x 42cm
The Fleming-Wyfold Art Foundation,
London

135 Bartolomé Esteban Murillo
Christ at the Pool of Bethesda, 1667–70
(detail)
National Gallery, London

PHILIP HENRY DELAMOTTE
1820–1889

• *The Alhambra Court at the Crystal Palace at Sydenham*, 1854
Albumen print, 42.3 x 57.5cm
Victoria and Albert Museum, London

HARRIET FORD 1859–1939

• *The Patio del Mexuar, the Alhambra*, 1831 [plate 62]
Pencil and wash on paper, 37.3 x 51cm
Private collection

FRANCISCO DE GOYA Y LUCIENTES 1746–1828

• *El Médico (The Doctor)*, 1776–80
Oil on canvas, 95.8 x 120.2cm
National Gallery of Scotland, Edinburgh

• *Self-portrait*, 1797 [plate 12]
Etching, aquatint, drypoint and burin on paper, 21.5 x 15cm
National Gallery of Scotland, Edinburgh

• *Don Juan Antonio Meléndez Valdés*, 1797 [plate 29]
Oil on canvas, 73.3 x 57.1cm
The Bowes Museum, Barnard Castle, County Durham

• *Qué valor! (What courage!)*, plate 7 of *Los Desastres de la Guerra (The Disasters of War)*, 1809–14 [plate 22]
Etching, aquatint, drypoint, burin and burnisher on paper, 15.5 x 21cm
National Gallery of Scotland, Edinburgh

• *Siempre sucede (It always happens)*, Plate 8 of *Los Desastres de la Guerra (The Disasters of War)*, 1809–14
Etching and drypoint on paper, 17.5 x 22cm
National Gallery of Scotland, Edinburgh

• *Qué hay que hacer más? (What more can be done?)*, plate 33 of *Los Desastres de la Guerra (The Disasters of War)*, 1809–14 [plate 24]
Etching, drypoint, burin and burnisher on paper, 15.5 x 20.5cm
National Gallery of Scotland, Edinburgh

• *Por una navaja (On account of a knife)*, plate 34 of *Los Desastres de la Guerra (The Disasters of War)*, 1809–14
Etching, drypoint, burin and burnisher on paper, 15.5 x 20.5cm
National Gallery of Scotland, Edinburgh

• *No se puede saber por qué (One can't tell why)*, plate 35 of *Los Desastres de la Guerra (The Disasters of War)*, 1809–14 [plate 23]
Etching, drypoint and burin on paper, 14.5 x 21cm
National Gallery of Scotland, Edinburgh

• *Tampoco (Not in this case)*, plate 36 of *Los Desastres de la Guerra (The Disasters of War)*, 1809–14
Etching and burin on paper, 15 x 21.5cm
National Gallery of Scotland, Edinburgh

• *Esto es peor (This is worse)*, plate 37 of *Los Desastres de la Guerra (The Disasters of War)*, 1809–14
Etching and drypoint on paper, 15.5 x 20.5cm
National Gallery of Scotland, Edinburgh

• *Bárbaros! (Barbarians!)*, plate 38 of *Los Desastres de la Guerra (The Disasters of War)*, 1809–14
Etching, burnished aquatint, burin and burnisher on paper, 15.5 x 20.5cm
National Gallery of Scotland, Edinburgh

• *Grande hazaña! Con muertos! (A heroic feat! With dead men!)*, plate 39 of *Los Desastres de la Guerra (The Disasters of War)*, 1809–14 [plate 25]
Etching and drypoint on paper, 15.5 x 20.5cm
National Gallery of Scotland, Edinburgh

• *Algún partido saca (He gets something out of it)*, plate 40 of *Los Desastres de la Guerra (The Disasters of War)*, 1809–14
Etching, drypoint and burin on paper, 17.5 x 21.5cm
National Gallery of Scotland, Edinburgh

• *Contra el bien general (Against the common good)*, plate 71 of *Los Desastres de la Guerra (The Disasters of War)*, 1809–14 [plate 26]
Etching and burnisher on paper, 17.5 x 22cm
National Gallery of Scotland, Edinburgh

• *Las resultas (The consequences)*, plate 72 of *Los Desastres de la Guerra (The Disasters of War)*, 1809–14
Etching on paper, 17.5 x 22cm
National Gallery of Scotland, Edinburgh

• *Murió la verdad (Truth has died)*, plate 79 of *Los Desastres de la Guerra (The Disasters of War)*, 1809–14
Etching on paper, 17.5 x 22cm
National Gallery of Scotland, Edinburgh

• *Si resucitará? (Will she rise again?)*, Plate 80 of *Los Desastres de la Guerra (The Disasters of War)*, 1809–14
Etching on paper, 17.5 x 22cm
National Gallery of Scotland, Edinburgh

• *Arthur Wellesley, 1st Duke of Wellington (1769–1852)*, 1812 [plate 17]
Red chalk over pencil on paper, 23.5 x 17.7cm
The British Museum, London

• *The Duke of Wellington*, 1812–14 [plate 18]
Oil on mahogany, 64.3 x 52.4cm
National Gallery, London

EL GRECO 1541–1614

• *Lady in a Fur Wrap*, c.1577–80 [plate 87]
Oil on canvas, 62 x 59cm
Stirling Maxwell Collection, Pollok House, Glasgow

• *Tears of St Peter*, 1580s [plate 88]
Oil on canvas, 108 x 89.6cm
The Bowes Museum, Barnard Castle, County Durham

• *An Allegory (Fábula)*, c.1585–95 [plate 89]
Oil on canvas, 66 x 88cm
National Gallery of Scotland, Edinburgh

• *Portrait of a Man*, c.1590s [plate 86]
Oil on canvas, 73.3 x 46.5cm
Stirling Maxwell Collection, Pollok House, Glasgow

• *Christ Blessing ('The Saviour of the World')*, c.1600 [plate 90]
Oil on canvas, 73 x 56.5cm
National Gallery of Scotland, Edinburgh

ATTRIBUTED TO EL GRECO

• *Saint Jerome as Cardinal*, 1580–1600 [plate 84]
Oil on canvas, 59 x 48cm
National Gallery, London

STUDIO OF EL GRECO

• *Agony in the Garden of Gethsemane*, 1590s [plate 85]
Oil on canvas, 102 x 131cm
National Gallery, London

WILLIAM HAZLITT 1778–1830

• *Charles Lamb*, 1804 [plate 101]
Oil on canvas, 76.2 x 62.2cm
National Portrait Gallery, London

JOHN WILLIAM INCHBOLD
1830–1888

• *Springtime in Spain: Near Gordella*, 1866 [plate 49]
Oil on canvas, 30.5 x 46cm
Birmingham Museums and Art Gallery

OWEN JONES 1809–1874

• *Plans, Elevations, Sections and Details of the Alhambra*, 1842–5 [plate 53]
Private collection

• *Grammar of Ornament, Illustrated by Examples from Various Styles of Ornament*, 2nd edition, 1868 [plate 52]
Eight plates: Interlaced Ornaments, Plate XXXIX; Spandrels of Arches, Plate XL; Lozenge Diapers, Plate XLI; Moresque Ornament, from the Alhambra, Plate XLI*; Square Diapers, Plate XLII; Moresque Ornament, from the Alhambra, Plate XLII*; Moresque Ornament, from the Alhambra, Plate XLIIJ; Moresque Ornament, from the Alhambra: Mosaics, Plate XLIII
Chromolithographs on paper
National Gallery of Scotland, Edinburgh

SIR THOMAS LAWRENCE
1769–1830

• *John, Lord Mountstuart (1767–1794)*, 1794 [plate 28]
Oil on canvas, 238.8 x 147.3cm
Private collection, Mount Stuart

FREDERIC, LORD LEIGHTON
1830–1896

• *Puerta de los Vientos, near Ronda*, c.1886/9
Oil on canvas, 21.3 x 41.9cm
Tate, London

JOHN FREDERICK LEWIS
1805–1876

• *The Alhambra, Granada*, 1832 [plate 61]
Watercolour and gouache on buff paper, 25.7 x 36cm
The British Museum, London

• *Spanish Fiesta*, 1836 [plate 41]
Watercolour and bodycolour on paper,
66.1 x 86.4cm
The Whitworth Art Gallery,
The University of Manchester

• *Courtyard of the Alhambra*, 1832–3
[plate 55]
Watercolour and bodycolour over traces
of black chalk, with white heightening on
paper laid down on card, 25.9 x 35.8cm
Fitzwilliam Museum, Cambridge

• *Houses at Granada*, 1832
Pencil with gouache on paper,
27 x 36.7cm
The British Museum, London

JOHN FREDERICK LEWIS
AFTER VELÁZQUEZ

• *Philip IV on Horseback*, c.1832–3
Watercolour and gouache on paper,
22.5 x 25.4cm
Royal Scottish Academy Collections,
Edinburgh

• *Villa Medici (Pavillion of Cleopatra/
Ariadne)*, c.1832–3
Watercolour on paper, 16.4 x 13.6cm
Royal Scottish Academy Collections,
Edinburgh

• *The Dwarf Don Diego de Acedo, El Primo*,
c.1832–3
Watercolour and gouache on paper,
18 x 13.7cm
Royal Scottish Academy Collections,
Edinburgh

• *Las Meninas (lower half)*, c.1832–3
Watercolour and gouache on paper,
19.1 x 27.2cm
Royal Scottish Academy Collections,
Edinburgh

• *Villa Medici, Grotto, Loggia Façade*,
c.1832–3
Watercolour and gouache on paper,
13 x 13.5cm
Royal Scottish Academy Collections,
Edinburgh

• *Prince Baltasar Carlos on Horseback*,
c.1832–3 [plate 99]
Watercolour and gouache on paper,
19.2 x 16.2cm
Royal Scottish Academy Collections,
Edinburgh

• *Landscape with St Anthony Abbot and
St Paul the Hermit*, c.1832–3 [plate 100]
Watercolour and gouache on paper,
24.9 x 20.1cm
Royal Scottish Academy Collections,
Edinburgh

ATTRIBUTED TO JUAN
BAUTISTA MARTÍNEZ DEL
MAZO c.1612–1667

• *Don Adrián Pulido Pareja*, after 1647
[plate 72]
Oil on canvas, 203.8 x 114.3cm
National Gallery, London

ARTHUR MELVILLE
1855–1904

• *A Spanish Sunday; Going to the
Bullfight*, 1891
Oil on canvas, 82 x 98cm
University of Dundee Museum
Services

• *The Contrabandista*, 1892
Oil on canvas, 99.7 x 76.2cm
Private collection

• *A Mediterranean Port*, 1892
[plate 109]
Watercolour on paper, 51.3 x 78.2cm
Private collection

• *Orange Market, Saragossa*, 1892
[plate 112]
Watercolour on paper, 50.5 x 76cm
The Fleming-Wyfold Art Foundation,
London

• *Little Bullfight: 'Bravo Toro'*, 1898
[plate 115]
Watercolour on paper, 55.9 x 77.5cm
Victoria and Albert Museum, London

• *The Alhambra at Granada*
Watercolour over graphite on paper,
52.2 x 73.3cm
Fitzwilliam Museum, Cambridge

SIR JOHN EVERETT MILLAIS
1829–1896

• *Souvenir of Velasquez*, 1868
[plate 102]
Oil on canvas, 102.7 x 82.4cm
Royal Academy of Arts, London

HENRY MOORE 1898–1986

• *Spanish Prisoner*, c.1939 [plate 130]
Lithograph on paper
Henry Moore Foundation

• *The Helmet*, 1939–40 [plate 131]
Lead, 29.1 x 18 x 16.5cm
Scottish National Gallery of Modern
Art, Edinburgh

BARTOLOMÉ ESTEBAN
MURILLO 1617–1682

• *Issac Blessing Jacob*, 1640s
Oil on canvas, 91 x 155cm
Wellington Collection, Apsley House,
London

• *The Flower Girl*, c.1665–70 [plate 77]
Oil on canvas, 121.3 x 98.7cm
Dulwich Picture Gallery, London

• *A Young Man with a Basket of Fruit
(Personification of 'Summer')*,
c.1665–70 [plate 76]
Oil on canvas, 102 x 81.5cm
National Gallery of Scotland,
Edinburgh

• *Christ at the Pool of Bethesda*, 1667–70
[plate 75]
Oil on canvas, 237 x 261cm
National Gallery, London

• *Two Peasant Boys (Invitation to a Game
of Ball)*, c.1670 [plate 74]
Oil on canvas, 164.9 x 110.5cm
Dulwich Picture Gallery, London

SIR WILLIAM NICHOLSON
1872–1949

• *Matedero, Segovia*, 1935
Oil on canvas, 37.7 x 45.7cm
Fitzwilliam Museum, Cambridge

• *Plaza de Toros, Málaga*, 1935
[plate 117]
Oil on wood, 64.8 x 77.7cm
Tate, London

JOHN PHILLIP 1817–1867

• *An Old Doorway and House at Segovia*,
1856–7 [plate 39]
Watercolour on paper, 36.8 x 52cm
National Gallery of Scotland,
Edinburgh

• *A Street Scene in Toledo*, 1856–7
[plate 38]
Chalk and watercolour on paper,
36 x 51.3cm
National Gallery of Scotland,
Edinburgh

• *The Evil Eye*, 1859 [plate 40]
Oil on canvas, 75.5 x 63cm
Hospitalfield, Arbroath

• *Spanish Boys Playing at Bullfighting*,
1860–1 [plate 45]
Oil on canvas with chalk underdrawing,
136 x 214cm
National Gallery of Scotland,
Edinburgh

• *Spanish Boys Playing at Bullfighting*,
1860–1
Charcoal, heightened with white
Gouache on blue paper, 53.5 x 73.8cm
National Gallery of Scotland,
Edinburgh

• *La Bomba*, 1863 [plate 47]
Oil on canvas, 91.9 x 114.2cm
Aberdeen Art Gallery & Museums
Collections

• *'La Gloria': A Spanish Wake*, 1864
[plate 42]
Oil on canvas, 145.4 x 219.2cm
National Gallery of Scotland,
Edinburgh

JOHN PHILLIP
AFTER VELÁZQUEZ

• Partial copy of *Las Meninas*, 1850s
[plate 1]
Oil on canvas, 185 x 148cm
Royal Academy of Arts, London

• *Las Hilanderas (The Spinners)*, 1850s
Oil on canvas, 136.4 x 155.7cm
The Robert Gordon University,
Aberdeen

• *The Surrender of Breda*, 1850s
Oil on canvas, 93.5 x 111.7cm
Royal Scottish Academy Collections,
Edinburgh

PABLO PICASSO 1881–1973

• *Weeping Woman*, 1937 [plate 127]
Oil on canvas, 60.8 x 50cm
Tate, London

• *Weeping Woman*, 1937 [plate 126]
Pencil and crayon on paper,
66.8 x 54cm
Tate, London

• *Weeping Woman I*, 1937 [plate 125]
Etching, aquatint and drypoint and
scraper on paper, 77.2 x 56.9cm
Scottish National Gallery of Modern
Art, Edinburgh

JAMES PRYDE 1866–1941

• *The Doctor*, 1909 [plate 105]
Oil on canvas, 85.7 x 71.9cm
Tate, London

Attributed to JUSEPE DE
RIBERA 1591–1652

• *Saint Andrew*, c.1632 [plate 9]
Oil on canvas, 129.5 x 101cm
Perth Museum and Art Gallery

DAVID ROBERTS 1796–1864

• *Interior of Seville Cathedral*, 1830s [plate 43]
Watercolour on paper, 37.5 x 24.1cm
National Gallery of Scotland, Edinburgh

• *Chapel of the Nunnery of the Virgin at Carmona*, 1833 [plate 48]
Watercolour on paper, 26 x 37.4cm
National Gallery of Scotland, Edinburgh

• *The Moorish Tower at Seville called the Giralda*, 1833 [plate 56]
Oil on canvas, 198.1 x 137.2cm
The Abbot of Downside

• *Entrance to the North Transept, Cathedral of Burgos*, 1835 [plate 44]
Oil on mahogany, 52.1 x 46cm
Tate, London

• *The Alcázar, Segovia*, 1836
Watercolour and bodycolour over pencil on paper, 39.7 x 26cm
Birmingham Museums and Art Gallery

AFTER DAVID ROBERTS

• *Entrance to the Hall of Ambassadors, Alcázar at Seville*
Engraving by E. Challis from Thomas Roscoe's *The Tourist in Spain: The Landscape Annual for 1836*, London, 14 x 10cm
National Gallery of Scotland, Edinburgh

• *Seville Cathedral*
Engraving by W. Wallis from Thomas Roscoe's *The Tourist in Spain: The Landscape Annual for 1838*, London, London, 15 x 10cm
National Gallery of Scotland, Edinburgh

JOHN SINGER SARGENT 1856–1924

• *Portrait of W. Graham Robertson*, 1894 [plate 103]
Oil on canvas, 230.5 x 118.7cm
Tate, London

• *The Blind Musicians*, 1912 [plate 114]
Watercolour on paper, 39.4 x 53cm
Aberdeen Art Gallery & Museums Collections

• *The Spanish Fountain*, 1912 [plate 113]
Watercolour, pencil and gouache on paper, 53.3 x 34.9cm
Fitzwilliam Museum, Cambridge

DIEGO RODRIGUEZ DE SILVA Y VELÁZQUEZ 1599–1660

• *An Old Woman Cooking Eggs*, 1618 [plate 70]
Oil on canvas, 100.5 x 119.5cm
National Gallery of Scotland, Edinburgh

• *A Spanish Gentleman, probably José Nieto, Chamberlain to Queen Mariana of Austria, Wife of Philip IV*, 1635–45 [plate 71]
Oil on canvas, 76.3 x 65.3cm
Wellington Collection, Apsley House, London

AFTER DIEGO RODRIGUEZ DE SILVA Y VELÁZQUEZ 1599–1660

• *King Philip IV of Spain (1605–1665)* [plate 73]
Oil on canvas, 51.5 x 46cm
National Gallery of Scotland, Edinburgh

JAMES ABBOTT McNEILL WHISTLER 1834–1903

• *Brown and Gold (Self-portrait)*, c.1895–1900 [plate 104]
Oil on canvas, 95.8 x 51.5cm
Hunterian Museum & Art Gallery, University of Glasgow

SIR DAVID WILKIE 1785–1841

• Study for *The Spanish Posada: A Guerilla Council of War*, 1828 [plate 13]
Pencil and watercolour on paper, 19 x 21.8cm
National Gallery of Scotland, Edinburgh

• *The Defence of Saragossa*, 1829 [plate 21]
Oil on canvas, 94 x 141cm
The Royal Collection

• *The Guerilla's Departure*, 1829 [plate 19]
Oil on canvas, 92.7 x 81.9cm
The Royal Collection

• *The Guerilla's Return*, 1830 [plate 20]
Oil on canvas, 92.7 x 81.9cm
The Royal Collection

• *The Spanish Mother*, 1833–4 [plate 27]
Oil on canvas, 99 x 127cm
Private collection

PERCY WYNDHAM LEWIS 1882–1957

• *The Surrender of Barcelona*, 1934–7 [plate 128]
Oil on canvas, 83.8 x 59.7cm
Tate, London

FRANCISCO DE ZURBARÁN 1598–1664

• *St Francis in Meditation*, 1635–9 [plate 82]
Oil on canvas, 152 x 99cm
National Gallery, London

• *The Immaculate Conception with Saint Joachim and Saint Anne*, early 1640s [plate 83]
Oil on canvas, 255.5 x 177cm
National Gallery of Scotland, Edinburgh

From the series: *Jacob and his Twelve Sons*

• *Asher*, 1640s [plate 80]
Oil on canvas, 198 x 102cm
The Lord Bishop of Durham, Auckland Castle, County Durham

• *Joseph*, 1640s [plate 79]
Oil on canvas, 198 x 102cm
The Lord Bishop of Durham, Auckland Castle, County Durham

• *Levi*, 1640s [plate 81]
Oil on canvas, 198 x 102cm
The Lord Bishop of Durham, Auckland Castle, County Durham

• *Zebulun*, 1640s [plate 78]
Oil on canvas, 198 x 102cm
The Lord Bishop of Durham, Auckland Castle, County Durham

ARCHIVAL MATERIAL

• Spanish Civil War archive material from the Penrose Collection at the Scottish National Gallery of Modern Art

'Visit the Exhibition of Picasso's Guernica' card

Installation photograph of the *Guernica* exhibition, New Burlington Galleries, London, 1938 (tangential view of the painting)

Installation photograph of the *Guernica* exhibition, New Burlington Galleries, London, 1938 (view of the studies for the painting)

Guernica exhibition poster

Guernica exhibition catalogue

Declaration on Spain, issued by the Surrealist Group in England

In Spain Now: A first-hand Story of the Fight against Fascism and of the Use of Workers' Power for Socialism, published by the Labour Party

Spain and Culture, featuring a reproduction of Picasso's drawing dedicated to the mothers and children of Spain

Letter from Fenner Brockway requesting that Roland Penrose be given assistance during his visit to Spain

BIBLIOGRAPHY

ABERDEEN 2005

Jennifer Melville, *Phillip of Spain; The Life and Art of John Phillip* (exhibition catalogue), Aberdeen, 2005

ADELSON 1997

Warren Adelson (ed.), *Sargent Abroad: Figures and Landscapes*, New York, 1997

ALVAREZ LOPERA 1987

José Alvarez Lopera, *De Ceán a Cossío. La fortuna crítica del Greco en el siglo XIX*, Madrid, 1987

ALVAREZ MILLAN AND HEIDE 2008

Cristina Alvarez Millan and Claudia Heide (eds), *Pascual de Gayangos; A Nineteenth-Century Spanish Arabist*, Edinburgh, 2008

ANGULO INIGUEZ 1980

Diego Angulo Iñiguez, *Murillo*, 3 vols, Madrid, 1980

AYMES 2005

Jean René Aymes, *Ilustración y revolución francesa en España*, Milenio, 2005

BATICLE AND MARINAS 1981

Jeannine Baticle and Cristina Marinas, *La Galerie Espagnole de Louis-Philippe au Louvre, 1838–1848*, Paris, 1981

BERESFORD 1998

Richard Beresford, *Dulwich Picture Gallery Complete Illustrated Catalogue*, London, 1998

BERUETE 1906

Aureliano Beruete, *Velázquez*, Paris 1897 (English edition), London, 1906

BESAS 1988

Peter Besas, *The Written Road to Spain: The Golden Decades of Travel: 1820–1850*, Madrid, 1988

BONE 1936

Sir Muirhead Bone, *Old Spain*, London, 1936

BRAHAM 1966

Allan Braham, 'Goya's Portrait of the Duke of Wellington in the National Gallery', *Burlington Magazine*, February 1966, pp.78–83

BROOKE 2003

Xanthe Brooke, 'A Masterpiece in Waiting: the Response to *Las Meninas* in Nineteenth-Century Britain', in S. Stratton-Pruitt (ed.) *Velázquez's Las Meninas*, Cambridge, 2003, pp.47–79

BROUGHAM 1808

Lord Brougham, 'Don Pedro Cevallos on the French Usurpation of Spain', *Edinburgh Review*, vol.13, no.25, October 1808, pp.215–34

BROWSE 1956

Lillian Browse, *William Nicholson*, London, 1956

BYRON 1812

Lord Byron, *Childe Harold's Pilgrimage. A Romaunt* [Cantos I and II], London, 1812

CALDESI & MONTECCHI 1858

Signori Caldesi & Montecchi, *Photographs of the Gems of the Art Treasures Exhibition, Manchester, 1857*, 2 vols, London and Manchester, 1858

CANAL 2000

Jordi Canal, *El carlismo. Dos siglos de contrarrevolución en España*, Madrid, 2000

CAUSEY 1985

Andrew Causey, *Edward Burra: Complete Catalogue*, Oxford, 1985

CHAPPELL 1985

William Chappell (ed.), '*Well Dearie!*': *The Letters of Edward Burra*, London, 1985

CUMBERLAND 1782

Richard Cumberland, *Anecdotes of Eminent Painters in Spain*, 2 vols, London, 1782

CORK 1987

Richard Cork, *David Bomberg*, New Haven and London, 1987

CUNNINGHAM 1843

Allan Cunningham, *The Life of Sir David Wilkie*, 3 vols, London, 1843

DE SALAS, GLENDINNING AND PEREZ SANCHEZ 1976

Xavier de Salas, Nigel Glendinning and Alfonso E. Pérez Sánchez, *The Golden Age of Spanish Painting*, London, 1976

FERRY 2007

Kathryn Ferry, 'Owen Jones and the Alhambra Court at the Crystal Palace' in Glaire D. Anderson and Mariam Rosser-Owen (eds), *Revisiting Al-Andalus: Perspectives on the Material Culture of Islamic Iberia and Beyond*, Leiden, 2007, pp.225–243

FINALDI 1994

Gabriele Finaldi, 'Zurbarán's *Jacob and his Twelve Sons*: A Reunion at the National Gallery', *Apollo*, no.392, 1994, pp.1–16

FONTANELLA 1981

Lee Fontanella, *La historia de la fotografía en España desde sus orígenes hasta 1900*, Madrid, 1981

FONTANELLA 1983

Lee Fontanella, *Photography in Spain in the Nineteenth Century*, Dallas, 1983

FONTANELLA 1999

Lee Fontanella, *Clifford en España: un fotógrafo en la corte de Isabel II*, Madrid, 1999

FORD 1837

Richard Ford, *An Historical Enquiry into the Unchangeable Character of a War in Spain*, London, 1837

FORD 1845

Richard Ford, *A Hand-Book for Travellers in Spain and Readers at Home*, London, 1845

FORD 1853

Richard Ford [unsigned], 'Reports on the Sales of the Louis Philippe and Standish Collections', The *Athenaeum*, 14 May, 21 May, 28 May, 4 June, 11 June 1853

FORD 1853A

Richard Ford, *Apsley House and Walmer Castle*, London, 1853

FORD 1970

Richard Ford, *Gatherings from Spain* (1846), London, 1970

FRY 1913

Roger Fry, 'Some Pictures by El Greco', *Burlington Magazine*, October 1913, pp.3–4

FRY 1926

Roger Fry, 'El Greco', The *Athenaeum*, 1920, reprinted in *Vision and Design*, London, 1926, pp.205–13

GALE 1996

Iain Gale, *Arthur Melville*, Edinburgh, 1996

GARCIA FELGUERA 1991

M. de los Santos García Felguera, *Viajeros, eruditos y artistas. Los europeos ante la pintura española del Siglo de Oro*, Madrid, 1991

GARLICK 1989

Kenneth Garlick, *Sir Thomas Lawrence*, Oxford, 1989

GIBSON 1971

Charles Gibson (ed.), *The Black Legend: Anti-Spanish Attitudes in the Old World and the New*, New York, 1971

GIMENEZ CRUZ 1997

Antonio Giménez Cruz, *¡Cosas de Los Ingleses! La España vivida y sonada en la correspondencia entre George Borrow y Richard Ford*, Madrid, 1997

GIMENEZ CRUZ 2002

Antonio Giménez Cruz, *La España Pintoresca de David Roberts; El viaje y los grabados del pintor*, Malaga, 2002

GLASGOW 1990

Vivien Hamilton, *Joseph Crawhall, 1861–1913: One of the Glasgow Boys* (exhibition catalogue), Glasgow Museums and Art Galleries, London, 1990

GLENDINNING 1964

Nigel Glendinning, 'Goya and England in the Nineteenth Century', *Burlington Magazine*, January 1964, pp.4–14

GLENDINNING 1977

Nigel Glendinning, *Goya and his Critics*, New Haven and London, 1977

GLENDINNING 1989

Nigel Glendinning, 'Nineteenth-century British Envoys in Spain and the Taste for Spanish Art in England', *Burlington Magazine*, February 1989, pp.117–126

HARRIS 1990

Enriqueta Harris, 'Las Meninas at Kingston Lacy', *Burlington Magazine*, February 1990, pp.125–130

HASKELL 1976

Francis Haskell, *Rediscoveries in Art: Some Aspects of Taste and Collecting in England and France*, London, 1976

HEAD 1834

Edmund Head, 'Noticias de los Quadros', *Foreign Quarterly Review*, vol.13, no.26, May 1834, pp.237–71

HEAD 1848

Edmund Head, A *Hand-Book of the History of the Spanish and French Schools of Painting*, London, 1848

HILL 1994

Jane Hill, *The Art of Dora Carrington*, London, 1994

HILLGARTH 2000

J.N. Hillgarth, *The Mirror of Spain 1500–1700: The Formation of a Myth*, Michigan, 2000

HILLS 1986

Patricia Hills (ed.), *John Singer Sargent*, New York, 1986

HITCHCOCK 1974

Richard Hitchcock (ed.), *Letters to Gayangos by Richard Ford; transcribed and annotated by Richard Hitchcock*, Exeter, 1974

HOWARTH 2007

David Howarth, *The Invention of Spain*, Manchester, 2007

HRVOL FLORES 2006

Carol A. Hrvol Flores, *Owen Jones. Design, Ornament, Architecture, and Theory in an Age in Transition*, New York, 2006

HUGO 1829

Victor Hugo, *Les Orientales* [1829] with an introduction by Elisabeth Barineau, 2 vols, Paris, 1952–4

IRVING 1832

Washington Irving, *Tales of the Alhambra*, London, 1832

IRVING 1986

Washington Irving, *The Alhambra by Washington Irving* with an introduction by Elizabeth Robins Pennell, London, 1986, p.14

JACOBS 2000

Michael Jacobs, *The Alhambra*, London, 2000

JAMESON 1842

Anna Jameson, *Handbook to the Public Galleries of Art in and near London*, London, 1842

JAMESON 1844

Anna Jameson, *Companion to the Most Celebrated Private Galleries of Art in London*, London, 1844

JONES 1842–5

Owen Jones, *Plans, Elevations, Sections, and Details of the Alhambra*, London, 1842–5

JONES 1854

Owen Jones, *The Alhambra Court in the Crystal Palace*, London, 1854

JONES 2001

Owen Jones, *Grammar of Ornament*, London, 2001 [first published in 1856]

KAUFFMAN 1982
Michael Kauffmann, *Catalogue of Paintings in the Wellington Museum*, Victoria and Albert Museum, London, 1982

KURTZ 2003
Gerardo Kurtz, 'Charles Clifford and the Alhambra', *Images in Time. A Century of Photography at the Alhambra 1840–1940*, Granada, 2003

LEWIS 1978
Michael Lewis, *John Frederick Lewis R.A. 1805–1876*, Leigh-on-Sea, 1978

LIPSCHUTZ 1972
Ilse Hempel Lipschutz, *Spanish Painting and the French Romantics*, Cambridge Mass., 1972

LONDON 1895–6
Exhibition of Spanish Art, New Gallery, London, 1895–6

LONDON 1974
Brinsley Ford, *Richard Ford in Spain* (exhibition catalogue) London, 1974

LONDON 1981
Allan Braham, *El Greco to Goya: The Taste for Spanish Paintings in Britain and Ireland* (exhibition catalogue), National Gallery, London, 1981

LONDON 1994
Richard Dorment, Margaret Macdonald *et al.*, *James McNeill Whistler* (exhibition catalogue), Tate Gallery, London, 1994

LONDON 2000
Robert Hewison, Ian Warrell and Stephen Wildman, *Ruskin, Turner and the Pre-Raphaelites* (exhibition catalogue) Tate Gallery, London, 2000

LONDON 2001
Xanthe Brooke and Peter Cherry, *Murillo: Scenes from Childhood* (exhibition catalogue), Dulwich Picture Gallery, London, 2001

LONDON 2002
Nicholas Tromans, *Sir David Wilkie; Painter of Everday Life* (exhibition catalogue), Dulwich Picture Gallery, London, 2002

LONDON 2005
Sanford Schwartz *et al.*, *The Art of William Nicholson* (exhibition catalogue), Royal Academy, London, 2005

LONDON 2006
Libby Horner, *Frank Brangwyn, A Mission to Decorate Life* (exhibition catalogue), Fine Art Society, London, 2006

LOPEZ-REY 1979
José López-Rey, *Velázquez: The Artist as a Maker, with a Catalogue Raisonné of his Extant Works*, Lausanne, 1979

MACARTNEY 2002
Hilary Macartney, 'La colección Stirling Maxwell en Pollok House, Glasgow', *Goya*, no.291, 2002, pp.345–56

MACFIE 2002
A.L. Macfie, *Orientalism*, London, 2002

MACCLARON 1990
K. MacClaron, 'William Bankes and his Collection of Spanish Paintings at Kingston Lacy', *Burlington Magazine*, February, 1990, pp.114–25

McCONKEY 1993
Kenneth McConkey, *Sir John Lavery*, Edinburgh, 1993

McCONKEY 2003
Kenneth McConkey, 'A Thousand Miles towards the Sun: British Artist-travellers to Spain and Morocco at the Turn of the Twentieth Century', *Visual Culture in Britain*, vol. 4, no.1, 2003, pp.26–43

MACKENZIE 1995
John MacKenzie, *Orientalism. History, Theory and the Arts*, Manchester, 1995

MACLAREN AND BRAHAM 1970
Neil Maclaren and Allan Braham, *National Gallery Catalogues; The Spanish School*, London, 1970 (revised)

MADRID 1982–3
Bartolomé Esteban Murillo 1617–1682 (exhibition catalogue), Museo Nacional del Prado, Madrid, and Royal Academy, London, 1982–3

MADRID 2002
Jonathan Brown and John Elliott, *The Sale of the Century: Artistic relations between Spain and Great Britain 1604–1655* (exhibition catalogue), Museo Nacional del Prado, Madrid, 2002

MAYER 1936
August Mayer, *Velázquez: A Catalogue Raisonné of the Pictures and Drawings*, London, 1936

MONROE 1970
James T. Monroe, *Islam and the Arabs in Spanish Scholarship*, Leiden, 1970

MORRIS AND RADFORD 1983
Lynda Morris and Robert Radford, *AIA: The Story of the Artists International Association 1933–1953*, Oxford, 1983

MOUNT 1969
Charles Merrill Mount, *John Singer Sargent, A Biography*, New York, 1969

MULCAHY 1988
Rosemarie Mulcahy, *Spanish Paintings in the National Gallery of Ireland*, Dublin, 1988

MURPHY 1815
James Cavanagh Murphy, *The Arabian Antiquities of Spain*, London, 1815

NEWALL 1996
Christopher Newall, 'Leighton and the Art of Landscape' in Stephen Jones, *et al.*, *Frederic, Lord Leighton:Eminent Victorian Artist*, London, 1996

NEW YORK 1992
Jerrilynn D. Dodds (ed.), *Al Andalus: The Art of Islamic Spain* (exhibition catalogue), The Metropolitan Museum of Art, New York, 1992

NEW YORK 2003
Gary Tinterow and Geneviève Lacambre (eds), *Manet/Velázquez: The French Taste for Spanish Painting* (exhibition catalogue) The Metropolitan Museum of Art, New York, 2003

ORMOND 2006
Richard Ormond, *John Singer Sargent, Figures and Landscapes, 1874 – 1882*, London and New Haven, 2006

OVIEDO 1999
Hugh Brigstocke, 'El Descrubrimiento del Arte Español en Gran Bretaña', in *Torno a Velázquez* (exhibition catalogue), Museo de Bellas Artes de Asturias, Oviedo, 1999

PALOMINO 1739
Antonio Palomino de Castro y Velasco, *An Account of the Lives and Works of the Most Eminent Spanish Painters, Sculptors and Architects*, London, 1739

PALOMINO 1987
Antonio Palomino de Castro y Velasco, *Lives of the Eminent Spanish Painters and Sculptors*, trans. Nina Ayala Mallory, Cambridge, 1987

PEARCE 1997
Fiona Pearce (ed.), *Art and Sunshine: The Work of Hercules Brabazon Brabazon*, London, 1997

PRESTON 2006
Paul Preston, *The Spanish Civil War: Reaction, Revolution and Revenge*, London, 2006

RAQUEJO 1986
Tonia Raquejo, 'Arab Cathedrals: Moorish architecture as seen by British travellers', *The Burlington Magazine*, August 1986, pp. 555–563

RAQUEJO 1988
Tonia Raquejo, 'La Alhambra en el Museo Victoria & Albert', *Separata de Cuadernos de Arte e Iconografia*, tomo 1, numero 1, Madrid, 1988, pp. 202–44

REMY 1999
Michel Remy, *Surrealism in Britain*, Aldershot, 1999

RICKETTS 1907
Charles S.Ricketts, *The Art of the Prado*, Boston, 1907

ROBERTSON 1988
Ian Robertson, *Los Curiosos Pertinentes, viajeros ingleses por España desde la accesión de Carlos III hasta 1855*, second edition, Madrid, 1988

ROBERTSON 2004
Ian Robertson, *Richard Ford 1796–1858; Hispanophiile, Connoisseur and Critic*, Norwich, 2004

ROBINSON 1896
Sir Charles Robinson [J.C. Robinson], *Jael and Sisera: Notice of a Picture by Velasquez heretofore undescribed*, London, 1896

RONDA 2004
Richard Cork and Michael Jacobs, *David Bomberg en Ronda* (exhibition catalogue), Museo Joaquín Peinado, Ronda, 2004

ROSCOE 1835–8
Thomas Roscoe, *The Tourist in Spain, The Landscape Annual*, 4 vols, London, 1835–8

ROTHENSTEIN 1900
Sir William Rothenstein, *Goya*, London, 1900

RUSKIN 1851–3
John Ruskin, *The Stones of Venice*, 3 vols, London, 1851–3

SAID 1991
Edward Said, *Orientalism*, London, 1991 (first edition 1978)

SCHARF 1857
Sir George Scharf, *Catalogue of the Art Treasures of the United Kingdom*, Manchester, 1857

SIM 1984
Katherine Sim, *David Roberts 1769–1864*, London, 1984

SOUGEZ 2003
Marie-Loup Sougez, 'The Alhambra, the ideal camera shot' in *Images in Time. A Century of Photography at the Alhambra 1840–1940*, Granada, 2003

SPARROW 1910
William Shaw Sparrow, *Frank Brangwyn and his Work*, London, 1910

STALEY 2001
Allen Staley, *The Pre-Raphaelite Landscape*, New Haven and London, 2001

STEEN 1943
Marguerite Steen, *William Nicolson*, London, 1943

STEVENSON 1895
R.A.M. Stevenson, *The Art of Velasquez*, London, 1895

STEVENSON 2007
Jane Stevenson, *Edward Burra: A Twentieth-Century Eye*, London, 2007

STIRLING 1855
William Stirling (William Stirling Maxwell), *Velazquez and his Works*, London, 1855

STIRLING 1848
William Stirling (William Stirling Maxwell), *Annals of the Artists of Spain*, 3 vols, London, 1848

STIRLING 1891
William Stirling (William Stirling Maxwell), *Annals of the Artists of Spain*, 3 vols, London, 1848; second edition, 4 vols, in Robert Guy (ed.) *The Works of Sir William Stirling Maxwell*, 6 vols, London, 1891

SUTTON 1962
Denys Sutton, 'R.A.M.Stevenson, Art Critic', in Denys Sutton, Theodore Crombie and R.A.M. Stevenson *Velasquez* [1895] London, 1962

SWEETMAN 1991
John Sweetman, *The Oriental Obsession, Islamic inspiration in British and American art and architecture, 1500–1920*, Cambridge, 1991

SYMMONS 1971
Sarah Symmons, 'John Flaxman and Francisco Goya: Infernos Transcribed', *Burlington Magazine*, September 1971, pp.508–12

THORE 1842
Théophile Étienne Joseph Thoré, 'Musée Standish', *Le Cabinet de l'Amateur et de l'Antiquaire*, 1, 1842

THORP 2003–7
Nigel Thorp *et al.* (eds), *The Correspondence of James McNeill Whistler*, on-line edition, University of Glasgow, 2003–7 (http://www. whistler.arts.gla.ac.uk/correspondence)

TROMANS 1997
Nicholas Tromans, 'J. F. Lewis's Carlist War Subjects', *Burlington Magazine*, November 1997, pp.760–5

TROMANS 2007
Nicholas Tromans, *Sir David Wilkie. The People's Painter*, Edinburgh, 2007

VAN HENSBERG 2004
Gijs Van Hensbergen, *Guernica; the Biography of a Twentieth-Century Icon*, London, 2004

VOLTAIRE 1883–5
François-Marie de Voltaire, *Oeuvres Completes*, Paris, 1883–5

WETHEY 1962
Harold Wethey, *El Greco and his School*, 2 vols, Princeton, 1962

WILKINSON 2002
Alan Wilkinson (ed.), *Henry Moore: Writings and Conversations*, London, 2002

YOUNG 1988
Eric Young, *Catalogue of Spanish Paintings*, Bowes Museum, Bernard Castle, Durham, second edition, 1988

NOTES AND REFERENCES

The Quest for Spain
David Howarth · pp.13–27

1. Sir John Throckmorton to William Trumbull, Flushing, 11 April 1612, Historic Manuscripts Commission, 75, *Downshire Ms.* vol. III (1938), p.275.

2. Jonathan Brown and John Elliott (eds), *The Sale of the Century: Artistic relations between Spain and Britain, 1604–1655*, New Haven, London and Madrid, 2002, p.27: Account book of Lord Cottington, 1623: 'Paid unto a Painter for drawing the Princes Picture. Signified by Mr. Porter for the Prince 1,100 [reales]'.

3. In addition, Swinburne also published, *Views of Spain* (1794), abridged in 1806 as *Picturesque Tour Through Spain* (reprinted 1823).

4. There are no references to Velázquez in the index to Oliver Millar (ed), *Abraham Van der Doort's Catalogue of the Collections of Charles 1*, vol. 37, Walpole Society, 1958–1960, Glasgow, 1960. Charles I is recorded as having returned from Spain with only Italian paintings. He was, however, the recipient of some pictures from Lord Cottington who had been ambassador to Spain. The only other Spanish artist who appears in the index is the obscure Pedro Orrente.

5. For the British response to this type of Murillo see London 2001.

6. William Robertson, *The History of the Reign of the Emperor Charles V*, 3 vols, 1769.

7. Susan Jenkins, " 'The Spanish Gift' at Apsley House", *English Heritage Review*, vol. 2, 2007, pp.113–27.

8. Henry Wellesley, 1st Baron Cowley, youngest brother of Wellington, was ambassador to Spain from 1811 to 1821. Wellington's elder brother, William, wrote to him from London that Benjamin West, President of the Royal Academy, had told him: '*the Corregio and the Julio Romano ought to be framed in diamonds and that it was worth fighting the battle for them*'.

9. It is considered that Goya may have witnessed the uprising in Madrid against the French on 2 May 1808. Thus, the revolt and its aftermath resulted in the famous pair of Goya oil paintings, which depict the tumult and the retribution meted out by the French.

10. Bacon finished his cycle after the *Innocent X* in 1954. It has recently been established that Bacon subsequently had a face to face encounter with the three-quarter length of Innocent X in the Doria Pamphili Palace in Rome, but not until 1964. I am grateful to Martin Hammer for this information.

11. Lee Fontanella in Dictionary of National Biography [http://www.oxfordnd.com/view/ article/73911].

12. London 1974, pp.24–6.

13. I am grateful to Joanna Soden for permission to consult her Ph.D. thesis. The information contained in this essay on the Lewis watercolours after Velázquez derives from this source. Joanna Soden, 'Tradition, Evolution, Opportunism: The Role of The Royal Scottish Academy in Art Education 1826–1910', Ph.D., University of Aberdeen, 2006. See also: John Sweetman, 'John Frederick Lewis and The Royal Scottish Academy I: the Spanish connection', *Burlington Magazine*, May 2005, pp.310–15.

14. In Paris in the winter of 1837–8, the English artist John Frederick Lewis, having spent considerable time in Spain, painted a watercolour of an episode in Murillo's career [*Pillage of a Convent in Spain by Guerilla Soldiers*]. As Patrick Noon determined, Lewis looked specifically to a modern French painting of artistic biography, Horace Vernet's *Raphael at the Vatican* (1833), for his spatial configuration, while he exploited contemporary interest in Spanish art during the Galerie Espagnole's debut', Alisa Luxenberg, *The Galerie Espagnole and the Museo Nacional 1835–1853: Saving Spanish Art, or the Politics of Patrimony*, Ashgate, 2008, pp.235–6.

15. *La Revista Española* was supportive of Roberts's plans to publicise the heritage of Spain. The review recommended that Roberts should look at various monuments and copy famous works, like San Antonio de la Florida with its famous frescoes by Goya, see note 14, Luxenberg, p.108.

16. Suzanne L. Stratton-Pruitt, *Spanish Paintings from American Collections*, Kimbell Art Museum, Fort Worth, 2002, no.33.

17. Head 1834, pp.237–272.

18. The French critic Delécluze, judged Murillo to be the most genuinely Spanish of the old masters, because he never left Spain and, thus, was free from foreign influence': see note 14, Luxenberg, p.25.

19. I am grateful to Gabriele Finaldi for this interesting suggestion.

20. Of thirty-five pictures listed in the National Gallery, London, 'Spanish School' catalogue (1970), over half were acquired in the twenty-five year period, 1882–1906.

21. Stirling 1891, vol. 1, pp.421–2.

22. Howarth 2007, p.135.

23. Although Millais never visited Madrid, his daughter Carrie stayed with the ambassador, Sir Clare Ford (grandson of Richard), in 1890 when she visited the Prado. Ford wrote to Carrie's mother, Effie Gray, the wife of Ruskin and Millais: ' *The moment Carrie cast her eye on the Velazquez's she exclaimed 'How like Papa's style and I think she is right for to my mind Sir John has got a lot of Velazquez that prince of Painters'.* Quoted in Peter Funnell *et al. Millais Portraits*, cat. no.36, National Portrait Gallery, London, 1999.

24. For Grantham's passion for Velázquez, and Grantham's ambitions as an art historian, see: Nigel Glendinning, Enriquetta Harris and Francis Russell, "Lord Grantham and the Taste for Velazquez, 'The Electric Eel of the Day'", *Burlington Magazine*, October 1999, pp.598–605. Also, see Howarth 2007, pp.122–5.

25. For Ponz's role as a guide to Lord Chichester on his travels in Spain see: B.L. Add. Ms.33,100.

26. *The Art Journal*, 1864, pp.160–1.

27. He was descended from King Robert II of Scotland and once startled a woman by declaring: 'I ought , madam, if I had my rights to be king of this country'.

28. Of Brenan's *Spanish Labyrinth*, published in 1943, Hugh Trevor-Roper wrote to Bernard Berenson on 17 February 1954: 'It is really an astonishing work. The richness of the historical knowledge, the heroic intellectual integrity, the rejection of all ready-made formulae, the monumental learning behind it, the burning lucidity of the style – it made everything else written on Spain seem pitifully shoddy. I was immensely impressed on reading it: there is still nothing like it; and although it ostensibly deals with the Civil War of 1936–9 only, I make my best pupils studying 16th and 17th century Spain read it, for I think there is more profound analysis of 16th century Spain between the lines of Brenan's book than in the explicit statements of any work written directly on the subject'. Richard Davenport-Hines (ed.), *Letters from Oxford: Hugh Trevor-Roper to Bernard Berenson*, London, 2006, pp.141–2.

29. Hill 1994, pp.83–4.

30. Wiseman wrote a long, forty-three page article in the December 1848 edition of *The Dublin Review* for his friend the editor, the Irish patriot, Daniel O'Connell. The article, entitled 'Spanish and English National Art', offered a critique of Stirling's *Annals of the Artists of Spain*, which had been published that year. For this and other art criticism see: His Eminence Cardinal Wiseman, *Essays on Various Subjects in Three Volumes*, 3 vols, London, 1853, pp.393–438.

31. A.H.Layard, 'Velasquez', *Quarterly Review*, 133, October 1872, pp.451–87.

32. Humphrey Carpenter, *W.H.Auden: A biography*, London, 1981, p.213.

33. *Ibid.*, p.215.

34. See Richard Davenport Hines, *Auden*, New York, 1995, pp.168–9.

35. *Ibid.*, p.166.

36. For an assessment of the response of Lewis to the Spanish Civil War: see Julian Evans, *Semi Invisible Man: the Life of Norman Lewis*, London, 2008, chp 6, 'Spain', and review by Jeremy Treglown, *Times Literary Supplement*, 9 July 2008.

37. Madeleine Korn, 'Collecting paintings by Matisse and by Picasso in Britain before the Second World War', *Journal of the History of Collections*, vol. 16, no.1, 2004, pp.111–29.

38. *Ibid.*, p.120.

39. Sonia Orwell and Ian Angus (eds), *The Collected Essays, Journalism and Letters of George Orwell*, 4 vols, Harmondsworth, 1968, vol. 1, *An Age Like This, 1920–1940*, p.590.

The Age of Goya
Nicholas Tromans · pp.29–45

1. Glendinning 1964, pp.4–14.

2. Braham 1966, pp.78–83.

3. To Hugh Irvine, 3 December 1812 (Ms. National Trust for Scotland, Drum Castle).

4. Nicholas Tromans '"Like Splendid Dreams Realised": Sir David Wilkie's Image of Spain', *British Art Journal*, vol.3, no.3, September 2002, pp.36–42.

5. Byron 1812, Canto 1.

6. Brougham 1808, pp.215–34.

7. *Examiner*, 7 July 1822, p.428.

8. Tromans 1997, pp.760–5.

9. *An Historical Enquiry into the Unchangeable Character of a War in Spain*, London: 1837; Thomas Bean, 'Richard Ford as Picture Collector and Patron in Spain', *Burlington Magazine*, February 1995, pp.96–107.

The Spanish Picturesque
Claudia Heide · pp.47–63

1. Garlick 1989, p.241, no.582.

2. Voltaire 1883–5, vol.I, p.390–1.

3. For eighteenth-century travellers, see Robertson 1988.

4. Irving 1986, p.14.

5. For a biography of Ford, see Robertson 2004.

6. London 1974, p.60, no.75: Three portraits of Richard Ford in Spanish dress.

7. Ford 1970, p.94.

8. Robertson 2004, p.214.

9. Besas 1988, p.17.

10. On Wilkie, see Tromans 2007.

11. Gimenez Cruz 2002, chp.1.

12. Richard Ford quoted by Sim 1984, p.68.

13. *Ibid.*, p.70.

14. *Ibid.*, pp.94–6.

15. *Idem.*

16. The first volume was dedicated to Granada (1835), the second (1836) more broadly to Andalusia, the third (1837) comprised views of the north: *Castile and Biscay*, and the fourth (1838) entitled *Spain and Morocco*, included selected views of Spain and Morocco.

17. Ford 1970, p.357.

18. *Ibid.,* p.350.

19. London 2000, p.50.

20. For example, George Washington Wilson published and sold pictures taken by different travellers: *Catalogue of Landscape, Architectural and Figure Photographs in Gibraltar, South of Spain and Morocco,* Aberdeen, c.1900. See Sougez 2003, p.25.

21. Queen Isabella's three trips were to Castile, Leon, Asturias and Galicia (1858), the Balearic Islands, Catalonia and Aragon (1860) and Andalusia and Murcia (1862). On Clifford, see Fontanella 1999.

22. Newall 1996, pp.47–8 and cats.36 and 38.

23. Staley 2001, pp.161 and 163.

24. Aberdeen 2005, p.66.

25. *Ibid.,* p.49.

A Dream of the South: Islamic Spain
Claudia Heide · pages 65–79

1. I am grateful to Dr Mariam Rosser-Owen for help in the preparation of this essay.

2. On Al-Andalus, see New York 1992.

3. The term 'Moorish' derives from Latin 'maurus', which means 'brown'. It is first adopted in Spanish historiography as a distancing device ('them and us'), and was used in the nineteenth century to refer to North African Arabs for the same reason.

4. Hugo 1829, vol. 1, preface.

5. Irving 1832, ebook@Adelaide, 2004 (http://ebooks.adelaide.edu.au/i/irving/washington/i72a/part2.html)

6. William Stirling to Hannah-Ann, 3 January 1843, Mitchell Library, Glasgow, T-SK 29.1.66.

7. For the most influential account of western attitudes to the East, see Said 1991.

8. Howarth 2007, p.4 .

9. Sim 1984, p.91

10. London 1974, p.53 (no.33).

11. Richard Twiss, *Travels through Portugal and Spain* (1775).

12. Andrew Schulz, 'The Porcelain of the Moors': The Alhambra Vases in Enlightenment Spain', *Hispanic Research Journal*, vol. 9, no.5, December 2008, *Exoticism and Nationalism*, pp.405–8.

13. Christopher Wren had died in 1723. His Parentelia was published in 1750 by his grandson.

14. *Ibid.,* pp.555–6.

15. On Murphy, see Michael Stevens, 'Spanish Orientalism: Washington Irving and the Romance of the Moors', Dissertation, Georgia State University, 2007, pp.72–99. (www: etd.gsu.edu/theses/available/etd-11202007-125500/unrestricted/stevens_michael_200712_phd.pdf)

16. Edmund Burke, *A Philosophical Enquiry into the Origin of our Ideas of the Sublime and the Beautiful*, 1756.

17. Irving 1986, p.151.

18. Charles Stewart, 3rd Marquess of Londonderry, quoted by Tonia Raquejo, 'La Alhambra en el Museo Victoria & Albert', *Separata de Cuadernos de Arte e Iconografia*, tomo 1, numero 1, Madrid, 288, p.270.

19. Howarth 2007, p.198.

20. Lewis 1978, p.66, no.142.

21. On Roberts and other artists representing the Alhambra, also see Jacobs 2000, chp 3.

22. Hrvol Flores 2006, pp.16–32.

23. On Gayangos, see Alvarez Millan and Heide 2008.

24. Kurtz 2003, pp.38–9.

25. See note 5, chp 16.

26. See Raquejo 1988, pp.208–9.

27. *Ibid.,* p.208.

28. *Ibid.,* plate XCI.

29. Jones 2001, p.185

30. See Raquejo 1988, p.221 ff.

31. *Ibid.,* pp.212–13

32. Hrvol Flores 2006, pp.184–6.

33. The Alhambra Court did not, as some have stated, form part of the 1851 Crystal Palace. Ferry 2007, p.225.

34. Jones 1854, pp.33–4; see Ferry 2007, p.230.

35. *Ibid.,* p.239.

36. *Ibid.,* p.241.

The British 'Discovery' of Spanish Golden Age Art
Hilary Macartney · pages 81–105

1. Head 1834, p.239.

2. Stirling 1891, vol.I, p.78.

3. Palomino 1739, pp.iii–iv.

4. For the history of the series, see Finaldi 1994.

5. London 2001, pp.56–7.

6. Ruskin 1851–3, vol.II, pp.192–3.

7. For the fullest history of Wellington's Spanish collection, see Kauffman 1982, pp.5–10.

8. Kauffman 1982, no.183.

9. Palomino 1987, p.141; Cumberland 1782, vol.2, p.6.

10. Ford 1853, 11 June.

11. For the Murillo *Self-portrait*, see Christie & Manson, London, 20–21 May 1853, lot 329; Angulo 1980, vol. II, no.413. For Wilkie's copy, formerly in the collection of the Earl of Leven, Melville House, Fife, see Stirling 1891, vol. III, p.1067, no.3.

12. Christie & Manson, 6–7 May, 1853, lot 50; Maclaren and Braham 1970, no.230.

13. William Coningham, Letter to *The Times*, 10 May 1853; Richard Ford and William Stirling, Letter to *The Times*, 14 May 1853.

14. Royal Academy, London, 1865, no.156.

15. Christie & Manson, London, 6–8 March 1851; Ancien Galerie Lebrun, Paris, 19–22 May 1852.

16. Jameson 1844, p.xxxiv.

17. Caldesi & Montecchi 1858, nos.61, 71, 75; López-Rey 1979, nos.320, 362.

18. Cunningham 1843, vol.2, p.503, letter from Wilkie to Thomas Phillips, R.A., 14 February 1828.

19. Jameson 1844, p.178.

20. Mulcahy 1988, no.667.

21. Robinson 1896, p.14.

22. London 1895–6, cat. no.12; Robinson, Letters to *The Times*, 4, 14 & 20 January 1896; and Robinson 1896.

23. Beruete 1906, pp.xxviii–xxix.

24. London 1895–6, cat. no.19; López-Rey 1979, no.362; Mayer 1936, no.488. For Brabazon, see Pearce 1997.

25. London 1895–6, cat. nos, 692, 713, 159. For the *St Martin and the Beggar* (Sarasota: Ringling), see also Wethey 1962, no.x-404.

26. See Alvarez Lopera 1987, pp.19–23.

27. Fry 1913, pp.3–4.

28. Fry 1926, pp.205, 206–7; Maclaren and Braham 1970, no.3476.

The Cult of Velázquez
Paul Stirton · pp.107–17

1. Whistler to Henri Fantin-Latour, 14/21 October, 1862. Library of Congress, Manuscript Division, Pennell Whistler Collection, PWC 1/33/6.

2. 'Velasquez, Velasquez, Velasquez, étudiez sans relâche Velasquez'. E. Charteris, *John Sargent*, New York, 1927, p.28.

3. Walter Sickert interviewed in *The Sun*, 8 September 1889. (From A. G. Robins, *Walter Sickert: The Complete Writings on Art*, Oxford, 2000, p.56).

4. Stevenson 1895. Revised second edition, *Velasquez*, in the series 'Great Masters of Painting and Sculpture', London, 1899.

5. The American painter Birge Harrison recalled that 'Bob' was 'endevoring to demonstrate to himself and to others his right to be ranked seriously as a landscape painter, and wasting considerable quantities of perfectly good pigment in the effort'. B. Harrison, 'With Stevenson at Grez', *Century Magazine*, December 1916, p.308.

Colour and Light: From Sargent to Bomberg
Michael Jacobs · pp.119–31

1. Glasgow 1990.

2. Sparrow 1910, p.23.

3. *Ibid.,* p.24.

4. Stevenson 2007, p.187.

5. These and the other quotes from Bomberg are taken from a taped conversation held in June 2004 between the author Michael Jacobs and Bomberg's close friend and pupil, the artist Miles Richmond.

British Artists and the Spanish Civil War
Paul Stirton · pp.133–45

1. Chappell 1985, p.90.

2. J. Rothenstein, *Edward Burra*, Penguin Modern Painters, London, 1945, p.15.

3. Anthony Blunt, review of the Royal Academy exhibition, *The Spectator*, 8 May 1937.

4. *Contemporary Poetry and Prose*, no.7, November 1936, p.136.

5. Press statement from May 1937, quoted in Roland Penrose, *Picasso; His Life and Work* (third edition) London, 1981, p.315.

6. Anthony Blunt, Review of the Paris International Exhibition, *The Spectator*, 6 August, 1937.

7. Herbert Read, *The London Bulletin*, April 1938.

8. Wilkinson 2002, p.131.

9. 'Moore on his Methods', *Christian Science Monitor*, Boston, 24 March 1967.

INDEX AND CREDITS

Collection credits

4 Meadows Museum, Southern Methodist University, Dallas, Algur H. Meadows Collection, MM.74.02; **11** Museo de Arte de Ponce. The Luis A. Ferré Foundation, Inc., Ponce, Puerto Rico; **43, 48** Miss Helen Guiterman Bequest, through The Art Fund, 2008; **63** Purchased with the aid of the Local Museums Purchase Fund, 1982; **70** Purchased with the aid of The Art Fund and a Treasury Grant 1955; **76** Purchased by Private Treaty with the aid of The Art Fund 1999; **86, 87** Mrs Anne Maxwell Macdonald. Gift, 1967; **89** Accepted in lieu of tax, with additional funding from the National Heritage Memorial Fund, The Art Fund and Gallery funds 1989; **93** The Metropolitan Museum of Art, Rogers Fund, 1910 (10.86); **95** Gift of Mary Louisa Boit, Julia Overing Boit, Jane Hubbard Boit, and Florence D. Boit in memory of their father, Edward Darley Boit 19.124; **109** Presented by Mrs M.D. Lindsay, 1927; **115** Given by Mrs Arthur Melville; **125** Accepted by H.M. Government in lieu of Inheritance Tax on the Estate of Joanna Drew and allocated by H.M. Government to the Scottish National Gallery of Modern Art 2005; **129** Purchased with the assistance of the National Heritage Memorial Fund and The Art Fund, 1995; **131** Purchased with help from the National Heritage Memorial Fund, The Art Fund (Scottish Fund) and the Henry Moore Foundation 1992